# *HOT* AIR 1

*An Explosive Collection of Top Airbrush Illustration*

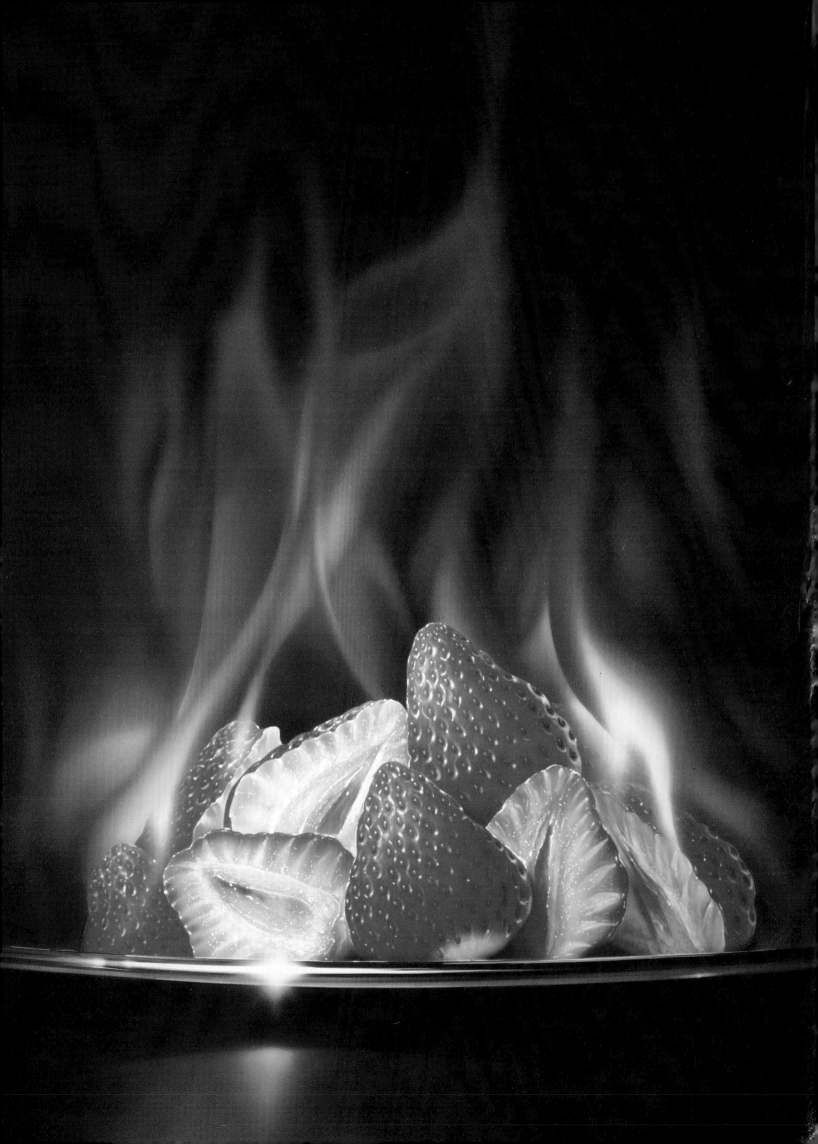

# *HOT* AIR 1

## An Explosive Collection of Top Airbrush Illustration

*With a Foreword by*
*Charlie White III*

*Werner Steuer*

**NORTH LIGHT BOOKS**

*Cincinnati, Ohio*

## DEDICATION

I would like to dedicate this book to my parents, Elise and Johannes Steuer.

**Hot Air 1.** Copyright © 1990 by Werner Steuer. Printed and bound in
Hong Kong. All rights reserved. No part of this book may be reproduced in
any form or by any electronic or mechanical means including information
storage and retrieval systems without permission in writing from the pub-
lisher, except by a reviewer, who may quote brief passages in a review.
Published by North Light Books, an imprint of F&W Publications, Inc.,
1507 Dana Avenue, Cincinnati, Ohio 45207. First edition.

94 93 92 91 90    5 4 3 2 1

Library of Congress Cataloging in Publication Data

Hot air 1/ [compiled by] Werner Steuer.
      p.  cm.
    ISBN 0-89134-345-8
     1. Airbrush art.    I. Steuer, Werner.
NC915. A35H68   1990
741.6 — dc20                  90-31291
                                  CIP

Editorial development and content editing by Diana Martin.
Designed by Clare Finney.

Pages 181-182 constitute an extension of this copyright page.

## ACKNOWLEDGMENTS

I would like to express my appreciation to all the artists who shared my enthusiasm and, by submitting their beautiful art, made this book possible. I want to thank all those artists who discussed their suggestions and their concerns with me in person or over the phone, thereby helping me approach new artists or consider aspects of this field that I would never have thought of without them. Thanks for the words of encouragement and for being just great people to work with.

I also gratefully acknowledge the assistance of the following individuals and institutions who supported me in so many ways:

Joseph Allegretti, Managing Editor of *Airbrush Action*, Lakewood, New Jersey

Ralph Gorton of Just Looking Gallery, Palo Alto and San Luis Obispo, California

Norbert Guthier, BFF of Foto Design, Frankfurt am Main, West Germany

OK Harris Gallery, New York, New York

Nancy Hoffman Gallery, New York, New York

Margarethe Hubauer GmbH, Hamburg, West Germany

Greg Mantz of Pacific Wave Film Production Group, San Francisco, California

Louis K. Meisel Gallery, New York, New York

C. Michael Mette, Publisher, *Airbrush Zeitung,* Henstedt-Ulzburg, West Germany

Robert Morris of The Image Bank, New York, New York

Randy Pate of The Source, Burbank, California

Joachim Soyka of The Image Bank, Munich, West Germany

Clifford S. Stieglitz, Publisher of *Airbrush Action*, Lakewood, New Jersey

William Urban, Editor and Publisher, Portland, Oregon

Tony Yamada of Partners, Sherman Oaks, California

My special thanks go to Diana Martin and David Lewis of North Light Books whose guidance throughout the process of preparing this book helped make my work quite enjoyable.

# FOREWORD

I find it quite incredible that twenty years ago you could count on one hand the number of artists using the airbrush. Today the numbers are burgeoning, and there are dozens of books and periodicals dedicated to the airbrush. How did the airbrush become such a popular creative tool? The artwork in *Hot Air* will make the answer apparent.

The airbrush has long had to fight for credibility as a valid illustration and fine art tool. Critics couldn't believe that you could paint a picture in an incredible way without having to put a handbrush to canvas.

These critics are now silenced as the airbrush takes a leading position as a creative tool. The strength of the airbrush and its success today lie in its versatility. It lets you create a multitude of differing effects both alone and in combination with special masks, techniques, and mediums. *Many* effects are best produced with the airbrush; metallic surfaces are a prime example.

The artists using the airbrush are as versatile as the tool itself. Over time many types of artists have mastered the airbrush, and the results have been as many different styles as there are artists, from hyper-realistic to graphic to abstract.

As you'll see in this exciting book there seems to be no limit to the possibilities of this tool.

Charlie White III

# CONTENTS

# INTRODUCTION

I'm sure many of you can relate to my experiences as an airbrush artist. Being a self-taught "airbrusher," I was an impatient type of guy who wanted to do it all—right away. I was intrigued by surrealists like Dali and Magritte—my first smooth gradation was a blue sky, my first three-dimensional object a gigantic apple sitting in a very basic landscape consisting of a few snow drifts. Rather than getting into airbrush technique step-by-step, I was thrilled by the possibility of creating certain effects, like a perfect gradation, really fast and composing full-blown images right away. I thought, "If I can do an apple, then I should also be able to render people and if I can do people, I can do anything!"

What I needed most for this "holistic approach" was a good background in traditional drawing, painting, perspective, and color theory, and to study the work of other airbrush artists. So I kept buying airbrush instruction books merely for the pictures, not reading the instructions at all. By trial and error I invented my own little tricks and was thrilled again and again if a desired texture came out well or if a mood I wanted to express was reflected in my art. Seeing how someone else did puffy-looking clouds or managed to do really "chromey" looking chrome helped me come closer to perfecting my skills in a shorter period of time.

Unfortunately, in the seventies there were not too many books out that showed a comprehensive body of artwork in different styles and combinations of media and technique, rather than just teaching step-by-step airbrushing. Frankly, I couldn't find any book with an extensive section of great art to serve as a reference tool in my attempt to figure it all out. I was sure I wasn't the only airbrush artist dealing with this problem, so I conceived the idea of compiling a book that offers just what we'd all been looking for: a vast collection of artwork with an emphasis on variety in style, subject matter, and combination of media and techniques.

To really cover the diversity of images, I felt such a book needed to show art from different countries as well as from both the fields of commercial art and fine art. You'll notice that to make specific types of imagery more quickly accessible, I have structured the book into four categories:

*Advertising Art:* Usually done to sell or promote a product or service, in most cases this art is strongly art directed by an advertising agency. This category includes advertisements, promotional posters, billboards, packaging, and point-of-purchase (P-O-P) displays.

*Editorial Art:* This type of work consists mostly of visualizing the content or parts of a story to capture the attention of potential readers. Included in this category you will

find book and magazine covers, book and magazine illustrations, calendars, greeting cards, game boards, and non-promotional posters.

*Self-Promotional Art:* This is artwork artists did for their own portfolios or just for the fun of it. In more than one case, pieces intended for self-promotion were later picked for various commercial applications.

*Fine Art:* These works were created by artists to make a statement or as a means of self-expression. The works you'll see here are quite diverse in respect to how strongly the demand of the market (collectors, galleries, museums, publishers) influenced the final appearance of the image. In other words, some of the art is apparently more geared to sell than others.

This book includes 200 pieces of art by 101 artists. What connects all the artwork shown? The high quality of its overall appearance, as well as its technical perfection and its basic concept. And, of course, all the pieces display the use of the airbrush at its best. In most of these pieces the airbrush is applied to such an extent that you'll spot it right away. Other images will demand you take a closer look, since they may show the airbrush used for an underpainting only, the final touch up, or combination of these.

You will find the majority of the art shown here is current, except a very few pieces from the seventies. I felt these were legendary since they were strongly influential at their time, giving direction to how the airbrush was going to be applied as a tool at design schools and in advertising. Some information about the artists and the art is included to familiarize you with each individual piece shown.

Since the focus of this book is on commercial illustration and fine art, I decided not to feature airbrush work that was done to decorate three-dimensional objects such as motorbike gas tanks, guitars, cars, T-shirts, skateboards, surfboards, cow and alligator skulls, ceramics, fingernails or human bodies. The reason is that I feel what you see done on a two-dimensional illustration board or canvas also could have been applied to three-dimensional objects, depending on their size, shape, and texture.

I have compiled this book not only as a source of information and inspiration for the professional airbrush illustrator or enthusiast, but also for everyone who simply appreciates well-done commercial illustration and great fine art.

Enjoy!

*Werner Steuer*

# ADVERTISING

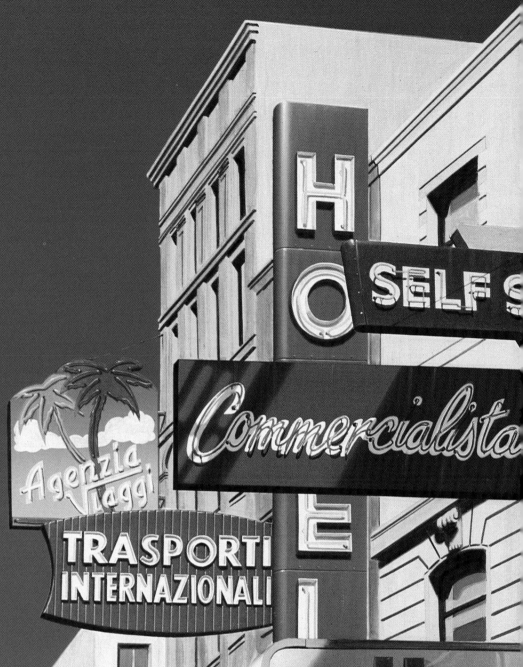
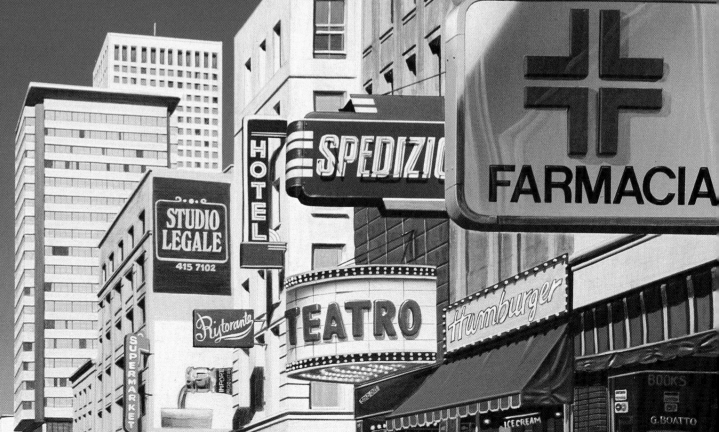

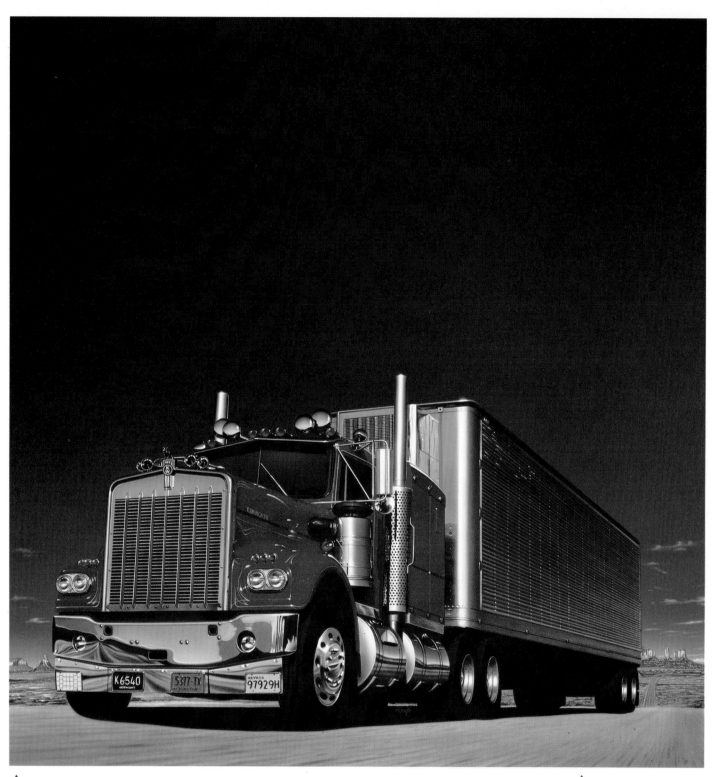

▲

**Artist:** *Guerrino Boatto*
*Mestre, Venice, ITA*

**Client:** *Honeywell Information*
*Systems Italia, Milan, ITA*
*Full spread advertisement*

**Untitled,** *19 3/4 x 27 1/2 in.*
*(500mm x 700mm), Liquitex*
*acrylics on Schoellershammer*
*illustration board, Paasche V#1*
*airbrush. Combined with*
*handbrush work.*

▲

**Artist:** *Guerrino Boatto*
*Mestre, Venice, ITA*

**Client:** *West Cigarettes*
*Hamburg, W. GER*
*Promotional poster*

**Untitled,** *23 1/2 x 31 1/2 in.*
*(600mm x 800mm), Liquitex*
*acrylics on Schoellershammer*
*illustration board, Olympos and*
*Paasche V#1 airbrushes.*
*Combined with handbrush work.*

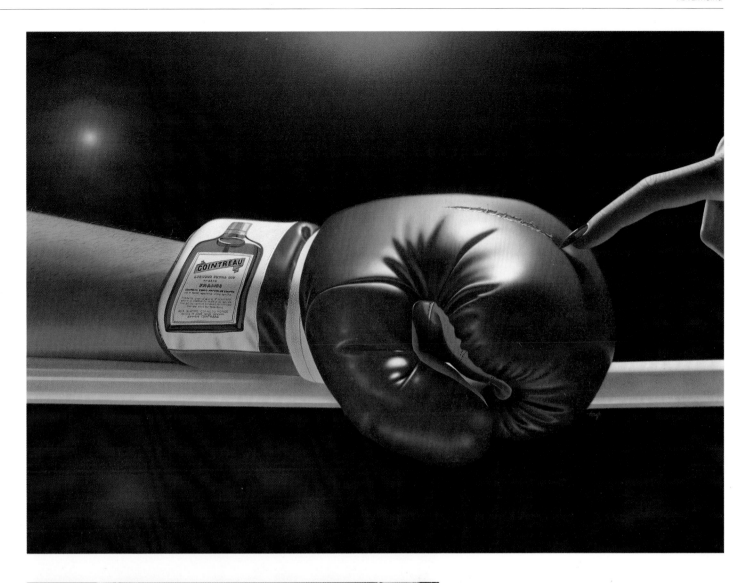

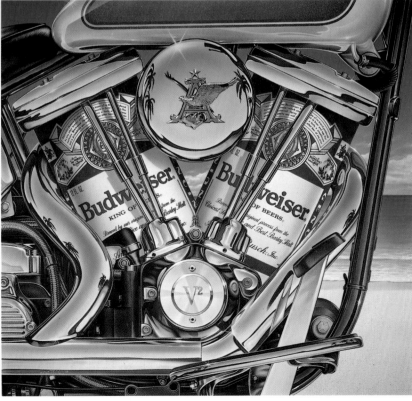

© Wayne Watford 1988.

▲
**Artist:** Guerrino Boatto
Mestre, Venice, ITA

**Client:** Cointreau and
Young & Rubicam, Milan, ITA
Magazine advertisement for
Cointreau liquor

**Untitled,** 19 3/4 x 27 1/2 in.
(500mm x 700mm), Liquitex
acrylics on Schoellershammer
illustration board, Olympos and
Paasche V#1 airbrushes.
Combined with handbrush work.

◄
**Artist:** Wayne Watford
Phoenix, Arizona, USA

**Client:** Anheuser Busch
St. Louis, Missouri, USA
Poster

**"Budweiser Harley,"** 24 x
22 in. (609mm x 559mm),
Liquitex acrylics on Frisk CS10
illustration board, Paasche AB
and Iwata HP-C airbrushes.

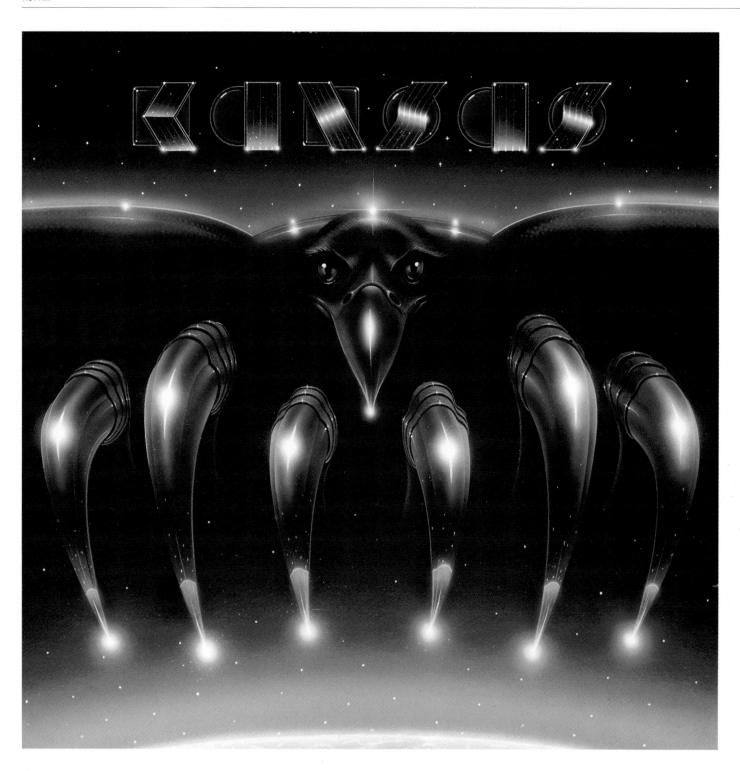

▲

**Artist:** *Peter Lloyd*
*Taos, New Mexico, USA*

**Client:** *Kirschner Records*
*Los Angeles, California, USA*
*Cover art for the Kansas album*
*"Songs For America"*

**"Songs For America,"** *16 x*
*16 in. (406mm x 406mm), Nova*
*acrylics and Rotring opaque ink*
*on Crescent 3-weight hot-press*
*illustration board, Paasche V#1*
*airbrush. Combined with*
*Prismacolor colored pencils and*
*some handbrush work.*

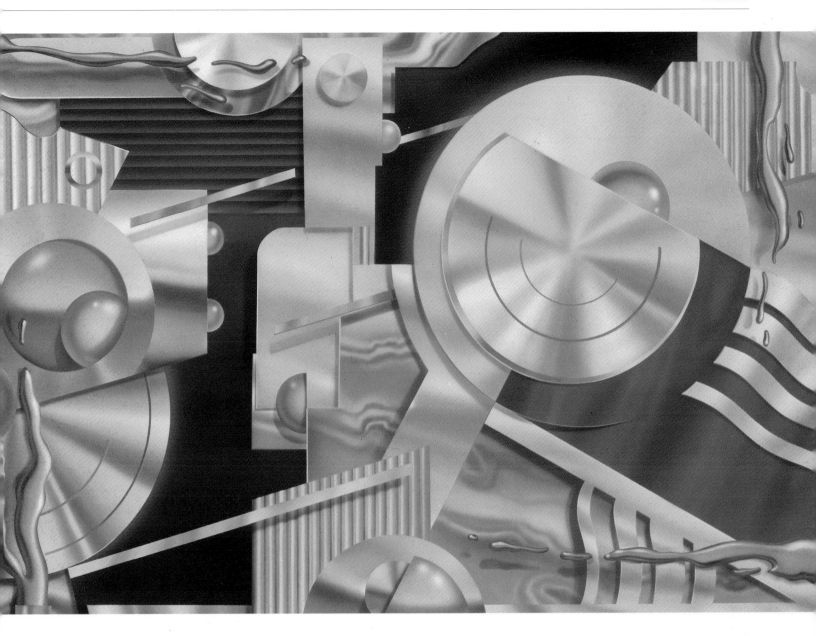

▲
**Artist:** *Charlie White III*
*Los Angeles, California, USA*

**Client:** *Braum Press*
*Houston, Texas, USA*
*Promotional poster*

**"Incredible Dream Machine,"** *20 x 30 in. (508mm x 762mm), Liquitex acrylics on Crescent illustration board, Iwata HP-C airbrush.*

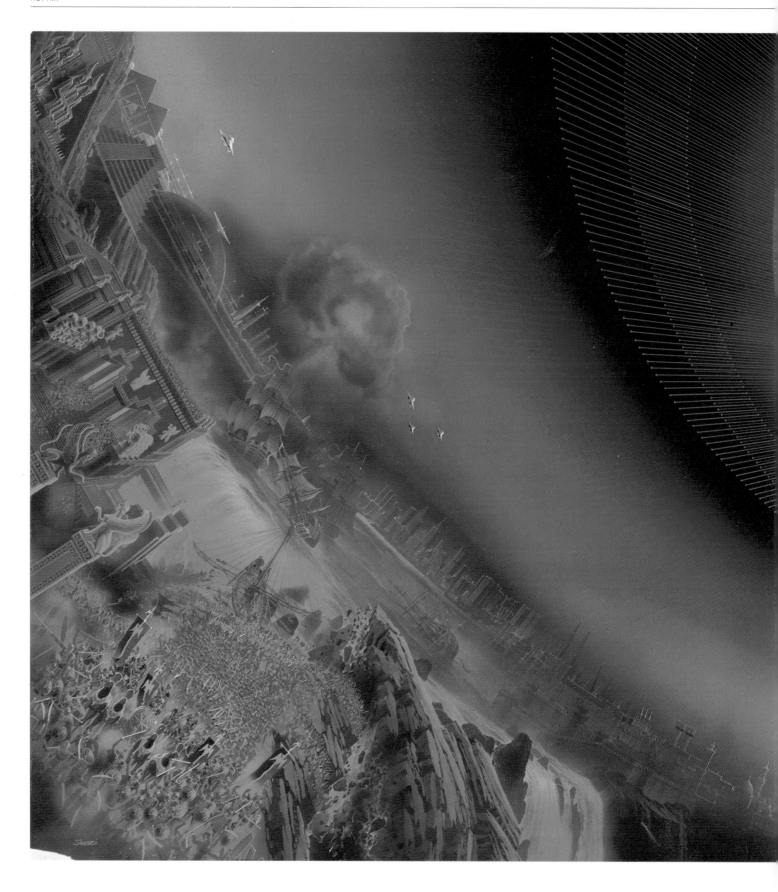

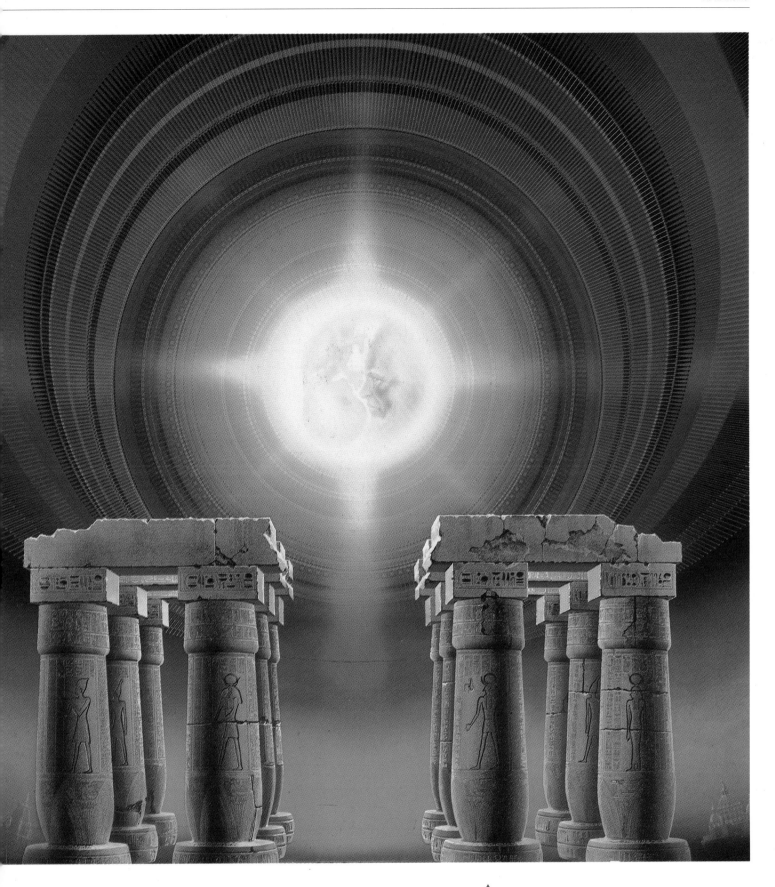

**Artist:** Shusei Nagaoka
Sherman Oaks, California, USA

**Client:** RV-Group
Los Angeles, California, USA
Album cover

**"I Am,"** 20 x 39 1/2 in. (508mm x 1003mm), Liquitex acrylics on cold-press illustration board, Izumiya Y-2 airbrush. Combined with handbrush work.

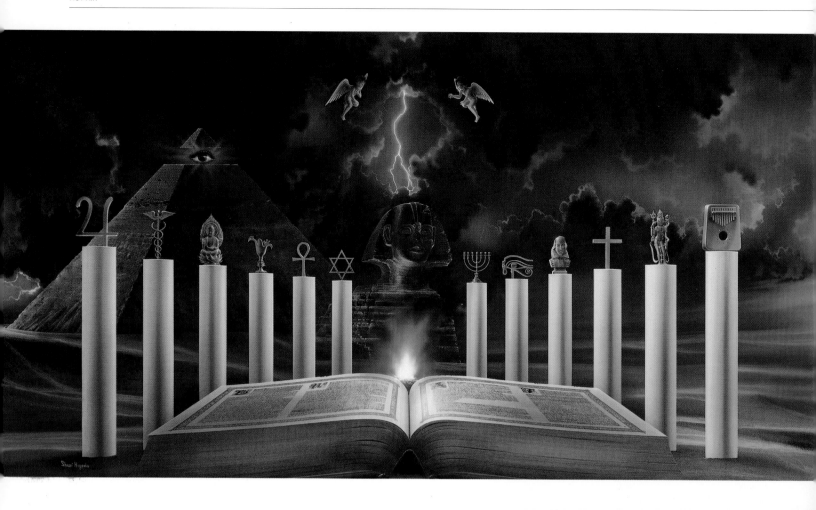

▲

**Artist:** *Shusei Nagaoka*
*Sherman Oaks, California, USA*

**Client:** *RV-Group*
*Los Angeles, California, USA*
*Album cover*

**"All 'n' All,"** *22 x 76 3/4 in.*
*(559mm x 1948mm), Liquitex*
*acrylics on cold-press*
*illustration board, Izumiya Y-2*
*airbrush. Combined with*
*handbrush work.*

▶

**Artist:** *Shusei Nagaoka*
*Sherman Oaks, California, USA*

**Client:** *RV-Group*
*Los Angeles, California, USA*
*Album cover*

**"Maze,"** *20 x 39 1/2 in. (508mm*
*x 1003mm), Liquitex acrylics on*
*cold-press illustration board,*
*Izumiya Y-2 airbrush.*
*Combined with handbrush work.*

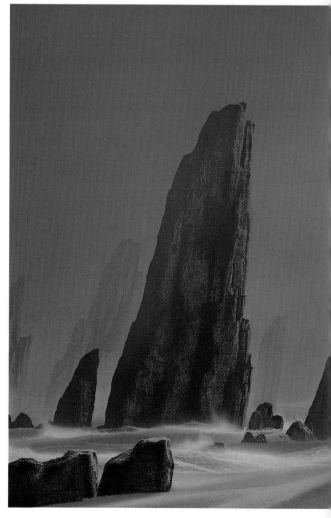

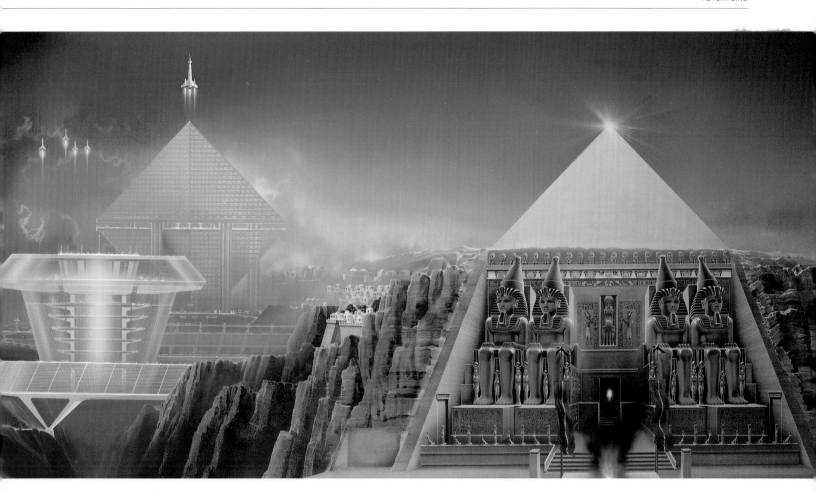

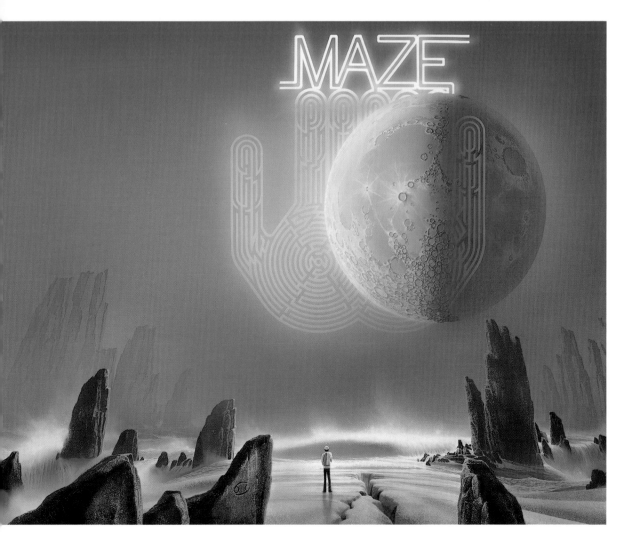

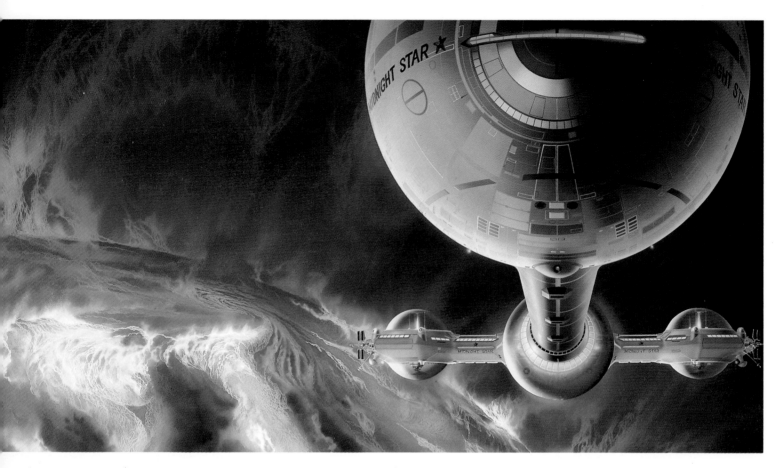

▲

**Artist:** *Shusei Nagaoka*
*Sherman Oaks, California, USA*

**Client:** *RV-Group*
*Los Angeles, California, USA*
*Album cover*

**"Midnight Star,"** *20 1/2 x*
*39 1/2 in. (520mm x 1003mm),*
*Liquitex acrylics on cold-press*
*illustration board, Izumiya Y-2*
*airbrush. Combined with*
*handbrush work.*

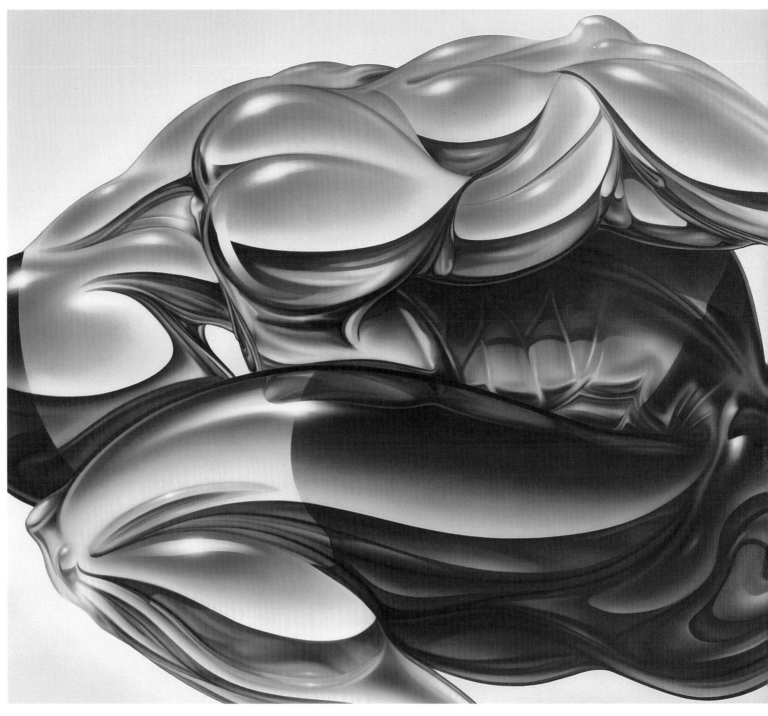

▲
**Artist:** Jeff LeFever
Laguna Beach, California, USA

**Client:** Pacific Fitness
Norwalk, California, USA
Poster for work-out equipment

**Untitled,** 40 x 36 in. (1016mm
x 914mm), Com-Art airbrush
paint on Frisk CS10 illustration
board, Olympos micron
MP-200C airbrush.

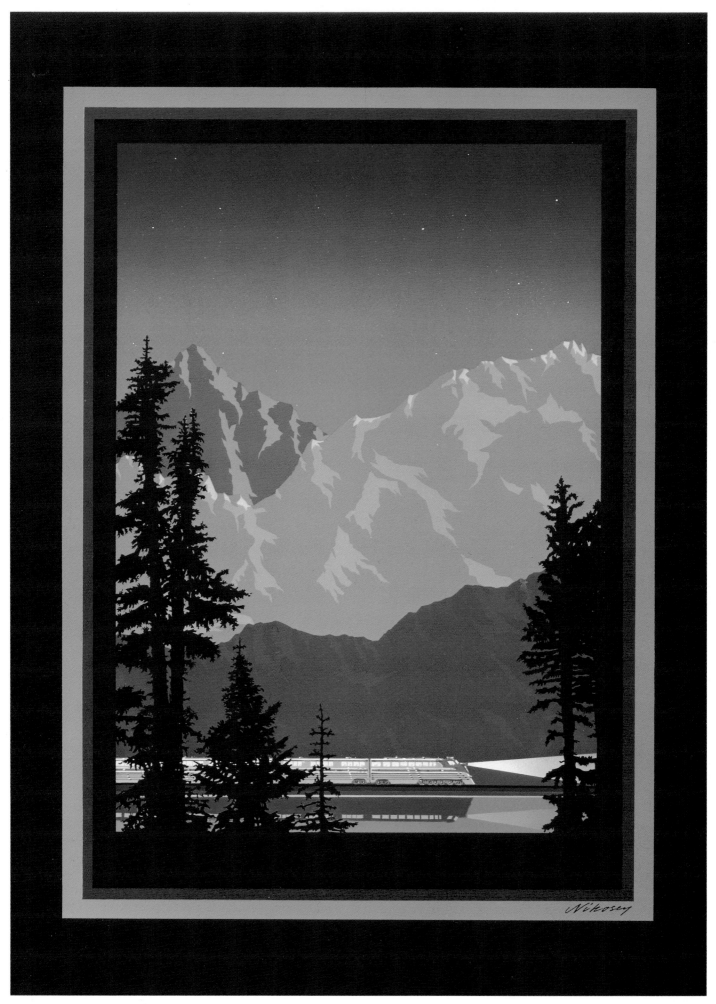

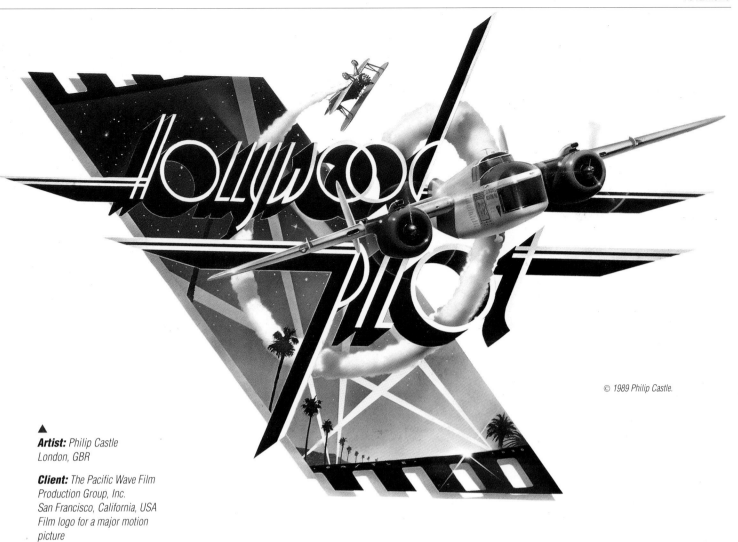

© 1989 Philip Castle.

▲
**Artist:** Philip Castle
London, GBR

**Client:** The Pacific Wave Film
Production Group, Inc.
San Francisco, California, USA
Film logo for a major motion
picture

**"Hollywood Pilot,"** 20 x
30 in. (508mm x 762mm),
Academy Line water-based
airbrush color on Oram &
Robinson illustration board,
DeVilbiss Aerograph Super 63
airbrush.

◄
**Artist:** Tom Nikosey
Bell Canyon, California, USA

**Client:** Allstate Insurance
Chicago, Illinois, USA
Promotional piece, unpublished

**"Night Train,"** 16 x 20 in.
(406mm x 508mm), Cel-Vinyl
water-based animator's paint on
Bainbridge hot-press, Iwata
HP-SB airbrush.

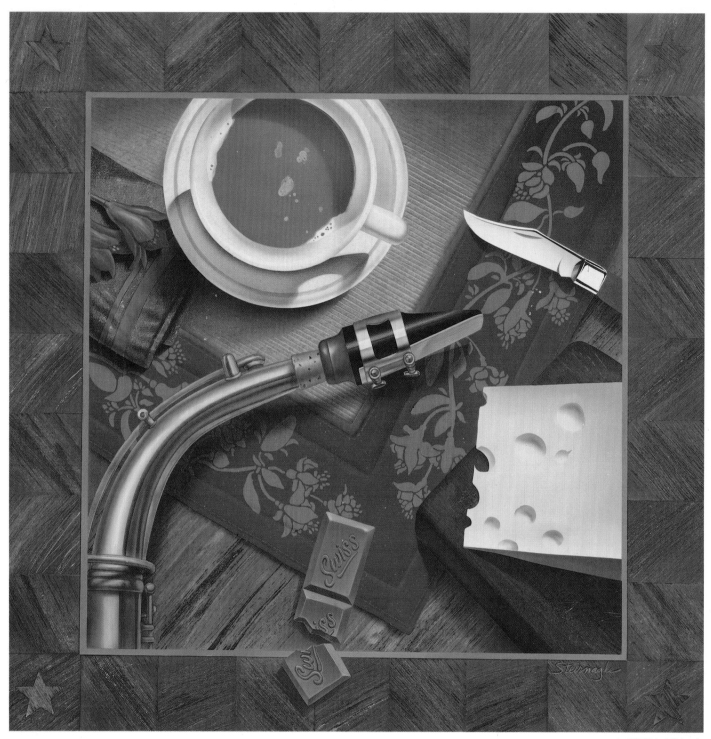

▲

**Artist:** Michael Steirnagle
San Diego, California, USA

**Client:** University of Texas at
El Paso, El Paso, Texas, USA
Album cover

**"Sax With Chocolate,"** 15 x
15 in. (381mm x 381mm), Com-
Art transparent and Liquitex
acrylics on Crescent 100
illustration board, Iwata HP-BC
airbrush. Combined with
handbrush work.

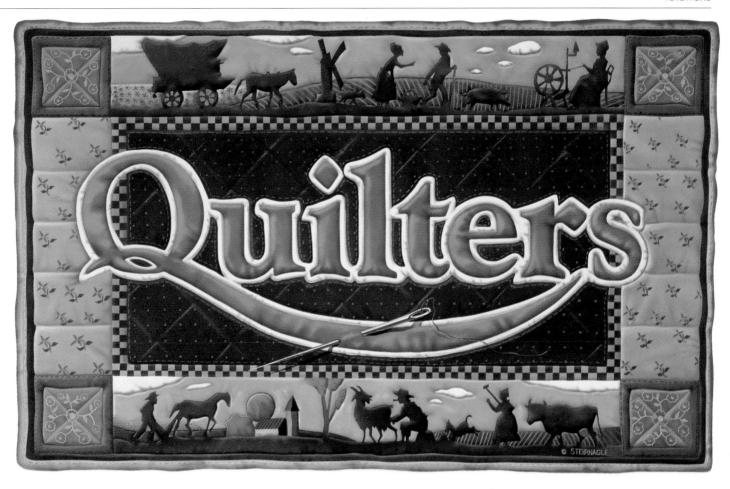

▲
**Artist:** Michael Steirnagle
San Diego, California, USA

**Client:** Fallon McElligott & Rice
Minneapolis, Minnesota, USA
Poster

**"Quilters,"** 35 x 22 1/2 in.
(889mm x 571mm), Com-Art
Airbrush Medium on Crescent
100 illustration board, Iwata
HP-BC airbrush.

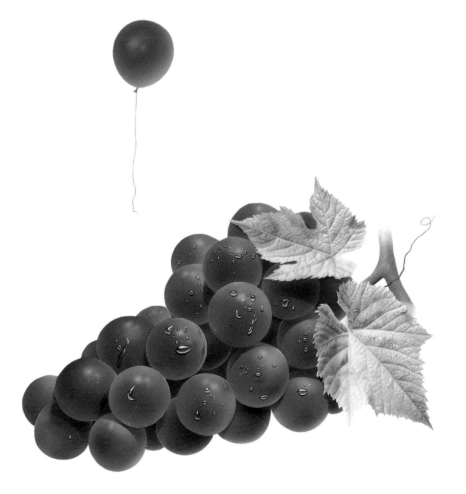

▶
**Artist:** Yu Kasamatsu
Fuchu-shi, Tokyo, JPN

**Client:** Uchimi Sangyo
Tokyo, JPN
Poster

**"Grapes,"** 20 1/4 x 14 1/4 in.
(515mm x 364mm), Liquitex
acrylics on Crescent 310
illustration board, Olympos
Handicon airbrush.

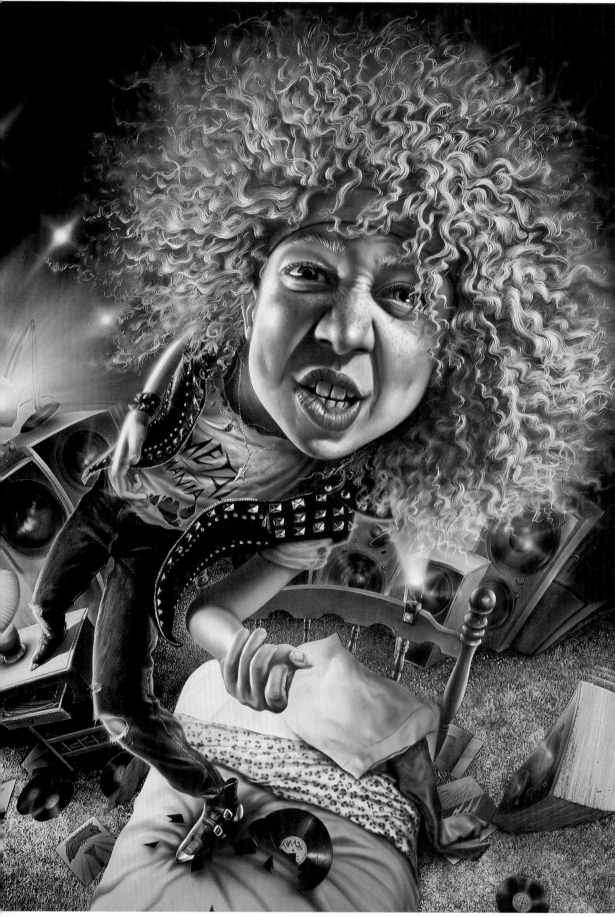

◀

**Artist:** *Mark A. Fredrickson*
*Tucson, Arizona, USA*

**Client:** *Levi Strauss*
*San Francisco, California, USA*
*Poster promoting Levi's jeans*

*"**Head Banger**," 20 x 27 in.*
*(508mm x 685mm), Com-Art*
*transparent acrylic on Frisk*
*CS10 illustration board, Paasche*
*AB and Iwata HP-C airbrushes.*
*X-Acto knife used to create*
*highlights, hair, and textures.*

▶

**Artist:** *Phil Evans*
*Amsterdam, NETH*

**Client:** *Compaq Computer B.V.*
*Gouda, NETH*
*Promotional poster featuring*
*renowned Dutch driver*

*"**Racing Technology**," 31 1/2*
*x 21 3/4 in. (800mm x 550mm),*
*Talens gouache and Winsor &*
*Newton acrylics on*
*Schoellershammer 4G*
*illustration board, DeVilbiss*
*Aerograph Super 63, DeVilbiss*
*Aerograph Sprite, and Paasche*
*AB airbrushes.*

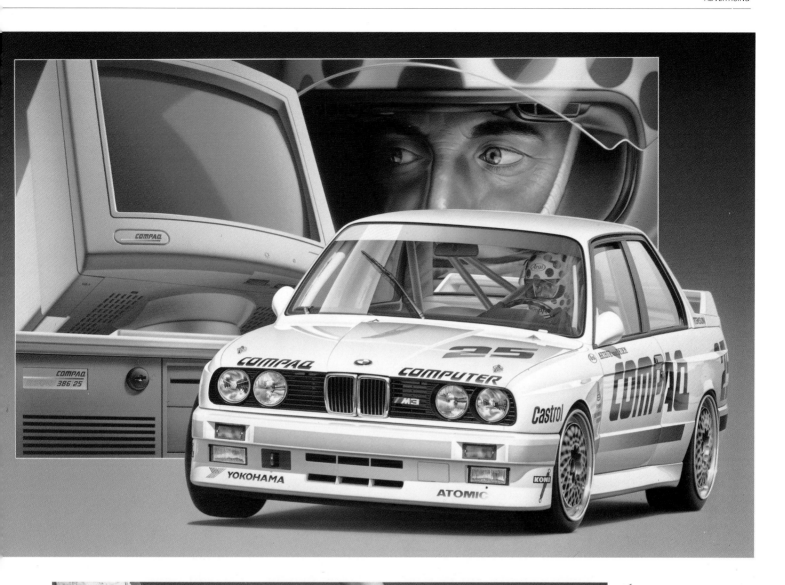

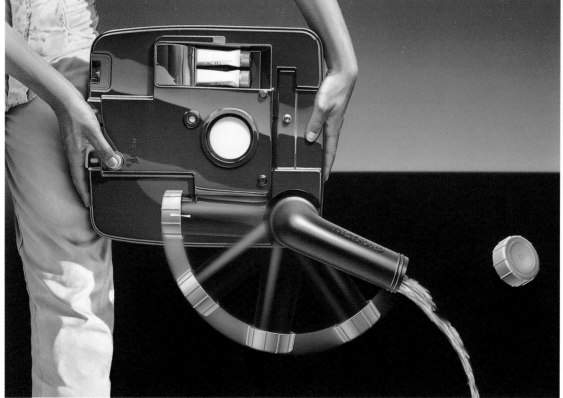

◄

**Artist:** Phil Evans
Amsterdam, NETH

**Client:** Thetford B.V.
Etten-Leur, NETH
Advertisement for portable toilets

**"Porta Potti,"** 23 1/2 x 15 3/4
in. (600mm x 400mm),
Schminke gouache on
Schoellershammer 4G
illustration board, DeVilbiss
Aerograph Super 63, DeVilbiss
Aerograph Sprite, and Paasche
AB airbrushes. Combined with
colored pencils and handbrush
work. Scraping and erasing paint
created texture of jeans.

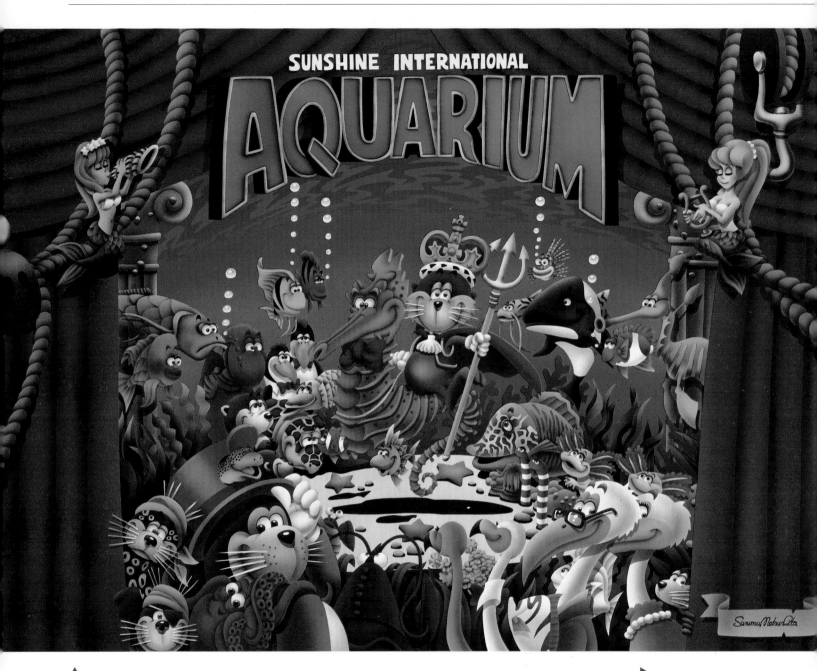

▲
**Artist:** Susumu Matsushita
Shibuya-ku, Tokyo, JPN

**Client:** Sunshine City
Tokyo, JPN
Advertisement and poster for an
aquarium

**"Sunshine International
Aquarium,"** 20 1/4 x 28 3/4 in.
(515mm x 728mm), Winsor &
Newton color ink and Holbein
color ink on Crescent 205
illustration board, Olympos
100B airbrush.

© Light & Shadows, Inc., Susumu Matsushita.

▶
**Artist:** Dave Malone
Portland, Oregon, USA

**Client:** Frisk
Atlanta, Georgia, USA
Magazine advertisement and
poster

**Untitled,** 20 x 30 in. (508mm x
762mm), Com-Art airbrush
colors on Frisk CS10 illustration
board, Iwata HP-C airbrush.
Combined with gouache and
handbrush work.

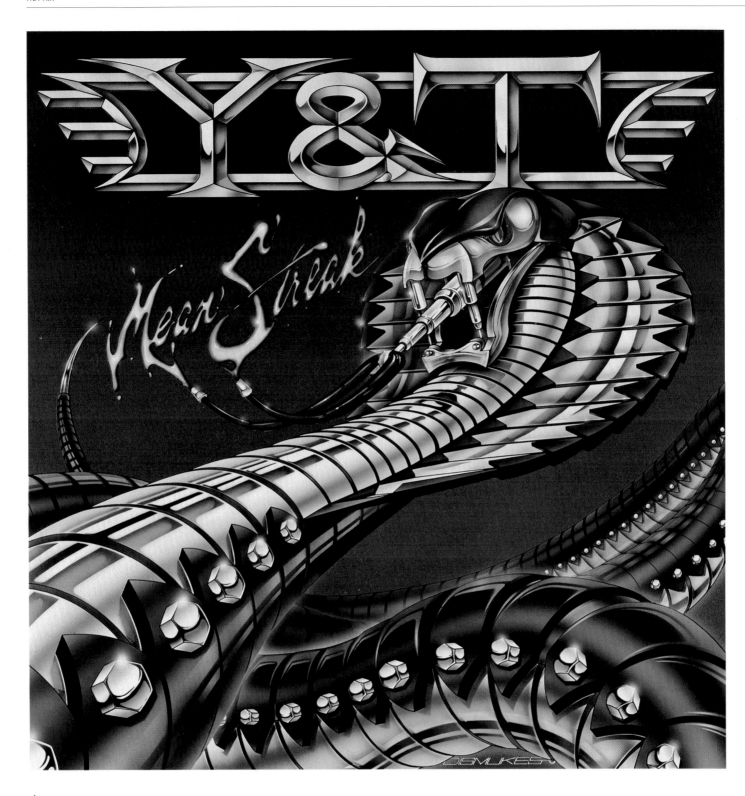

▲
**Artist:** *John Taylor Dismukes*
*Hollywood, California, USA*

**Client:** *A & M Records*
*Los Angeles, California, USA*
*Album cover, T-shirt, and banner*

**"Mean Streak,"** *30 x 30*
*(762mm x 762mm), Pelikan inks*
*and acrylics on Pearl Print*
*illustration board, Iwata HP-A*
*and Iwata HP-B airbrushes.*

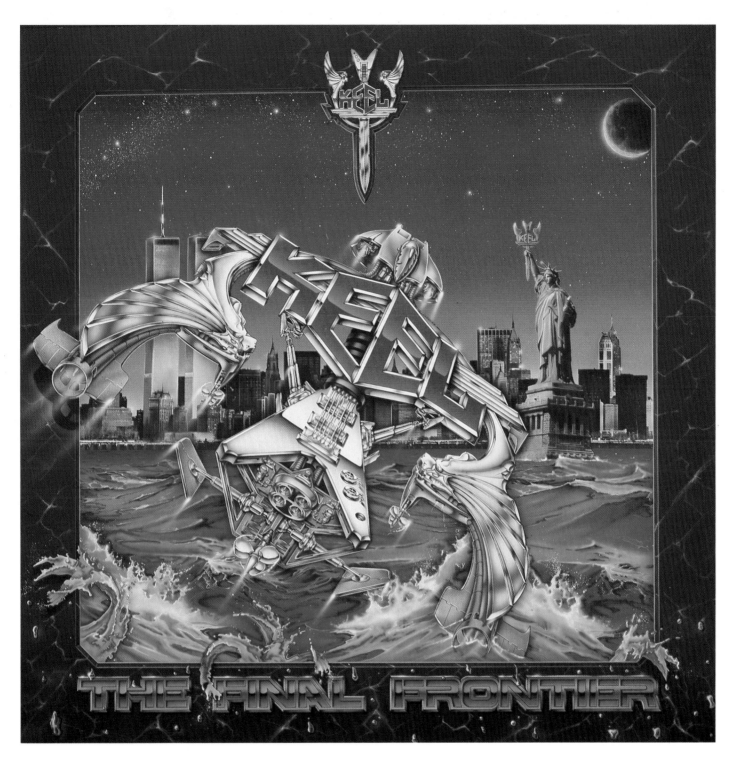

▲
**Artist:** John Taylor Dismukes
Hollywood, California, USA

**Client:** MCA Records
Los Angeles, California, USA
Album cover, T-shirt, and banner

**"Keel, The Final Frontier,"**
30 x 30 in. (762mm x 762mm),
Liquitex acrylics on hot-press
illustration board, Iwata HP-A
and Iwata HP-B airbrushes.

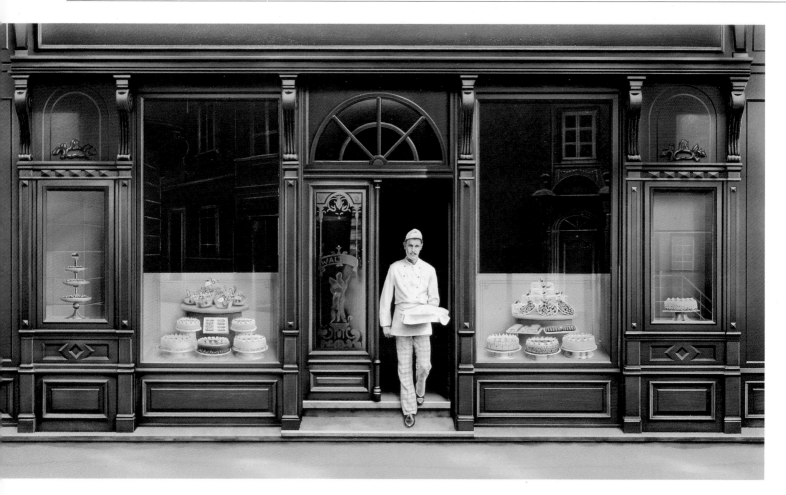

 **Artist:** *Rainer Ekkert*
*Essen, W. GER*

**Client:** *Fanfare, Inc.*
*Vienna, AUS*
*Packaging for cakes*

**"Old Vienna Bakery,"** *15 3/4*
*x 33 1/2 in. (400mm x 850mm),*
*Schmincke Aerocolor on*
*Zanders Parole illustration*
*board, EFBE and Iwata*
*airbrushes.*

▶ **Artist:** *Rainer Ekkert*
*Essen, W. GER*

**Client:** *Ariola Soft*
*Guetersloh, W. GER*
*Advertising campaign for*
*computergame on floppy disk*

**"Golf Computergame,"**
*19 3/4 x 23 1/2 in. (500mm x*
*600mm), Schmincke Aerocolor*
*on Zanders Parole illustration*
*board, EFBE and Iwata*
*airbrushes. Combined with*
*handbrush work.*

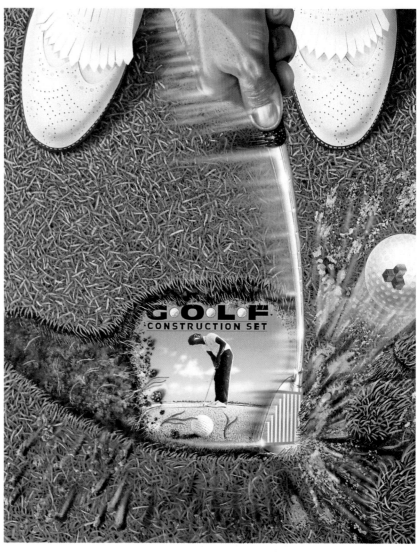

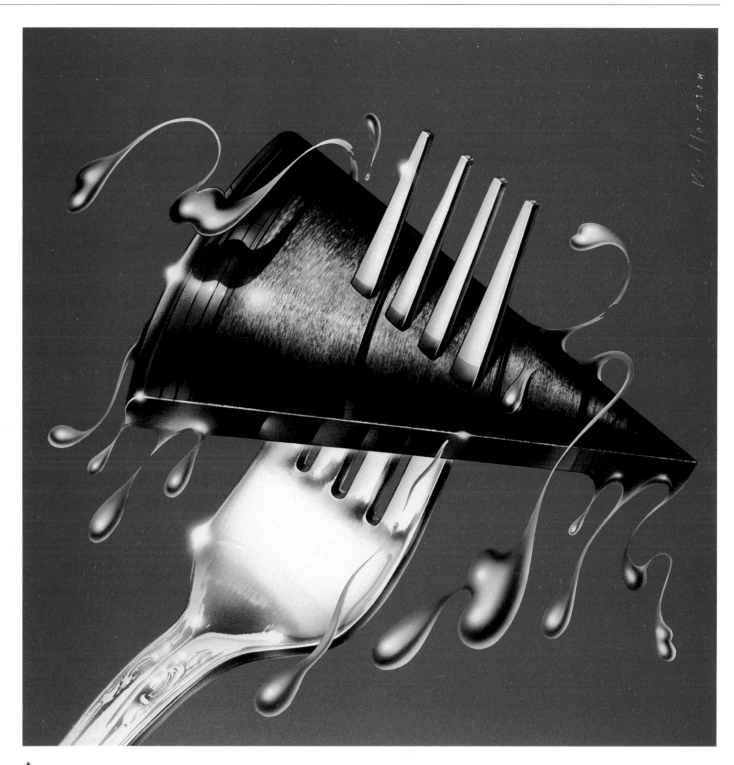

▲
**Artist:** *David Willardson*
*Glendale, California, USA*

**Client:** *Capitol Records*
*Los Angeles, California, USA*
*Album cover*

**"Fork it Over,"** *18 x 18 in.*
*(457mm x 457mm), Liquitex*
*acrylics on Strathmore*
*illustration board, Iwata HP-C*
*airbrush.*

▶
**Artist:** Wil Cormier
Altadena, California, USA

**Client:** Reed & Carnrick
Piscataway, New Jersey, USA
Advertisement for medicine that
relieves gas pain

**"Gas Buster,"** 12 x 15 in.
(305mm x 381mm), Liquitex
acrylics on Crescent cold-press
illustration board, Iwata HP-B
and Iwata HP-C airbrushes.
Combined with handbrush work.

**Ad Agency:** MED
Communication.

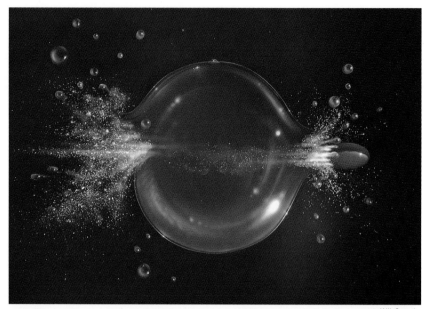

© Wil Cormier.

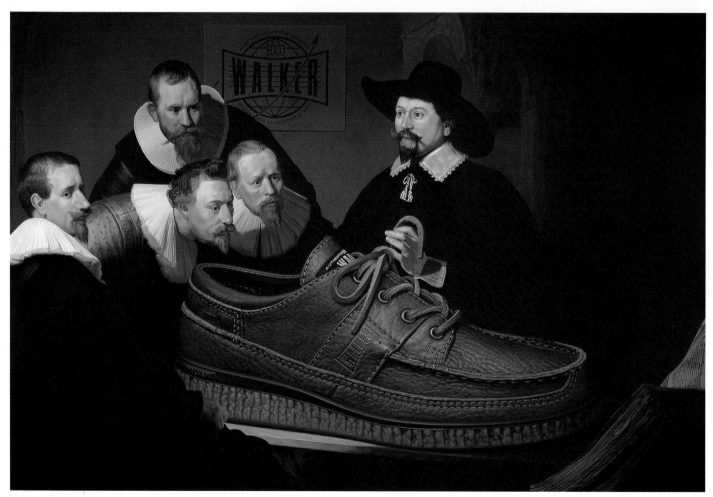

© Takashi Ohno.

▲
**Artist:** Takashi Ohno
Kita-ku, Tokyo, JPN

**Client:** Achilles
Tokyo, JPN
Advertisement

**"Ecco Shoes,"** 31 x 22 3/4 in.
(790mm x 580mm), Liquitex
acrylics on Crescent illustration
board, Olympos HP-100A
airbrush. Combined with
handbrush work.

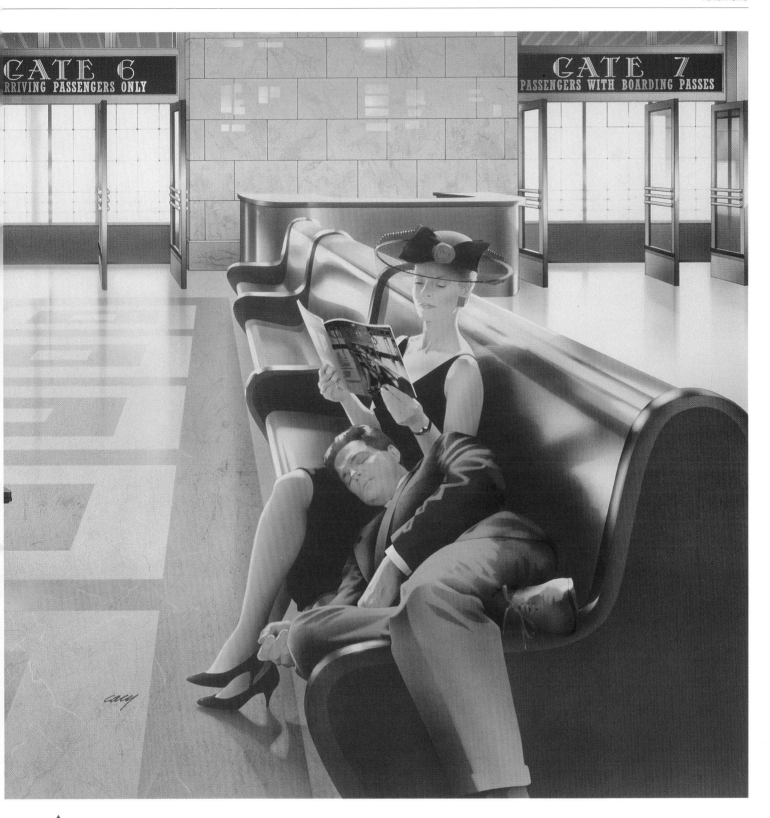

▲
**Artist:** Michael Cacy
Portland, Oregon, USA

**Client:** Choices
Portland, Oregon, USA
Catalog cover

**"Choices,"** 16 x 16 in.
(406mm x 406mm), Com-Art
opaque and Com-Art transparent
colors on Strathmore medium
surface 2-ply paper, Iwata HP-C
airbrush. Marble effects achieved
by blotting a wad of paper towel
into a tray of paint and dabbing
impressions onto exposed areas
of the rendering.

**Designer:** David Wachs.

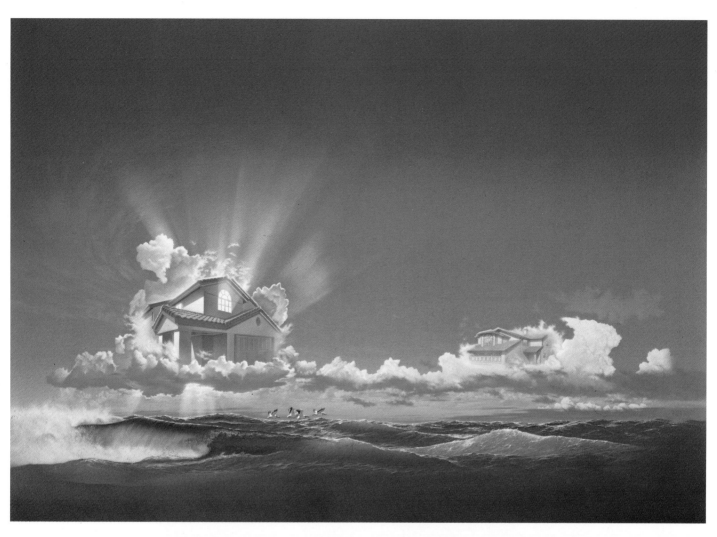

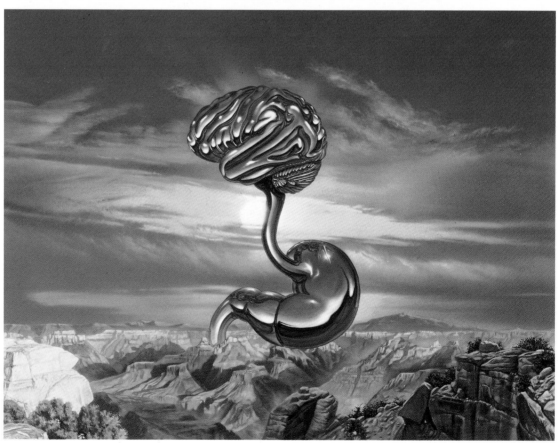

▲
**Artist:** Chris Hopkins
Edmonds, Washington, USA

**Client:** Mame Awards
Newport Beach, California, USA
Advertisement and poster for
awards for builders and
architects

**"Mame,"** 20 x 30 in. (508mm x
762mm), Liquitex acrylics on
Crescent 100 cold-press
illustration board, Iwata HP-C
airbrush.

▶
**Artist:** Chris Hopkins
Edmonds, Washington, USA

**Client:** A. H. Robins
Alexandria, Virginia, USA
Advertisement and brochure for
pharmaceutical supplies

**"Untitled,"** 20 x 24 in.
(508mm x 609mm), Liquitex
acrylics on Crescent 100 cold-
press illustration board, Iwata
HP-C airbrush. Combined with
wet-into-wet acrylic handbrush
painting.

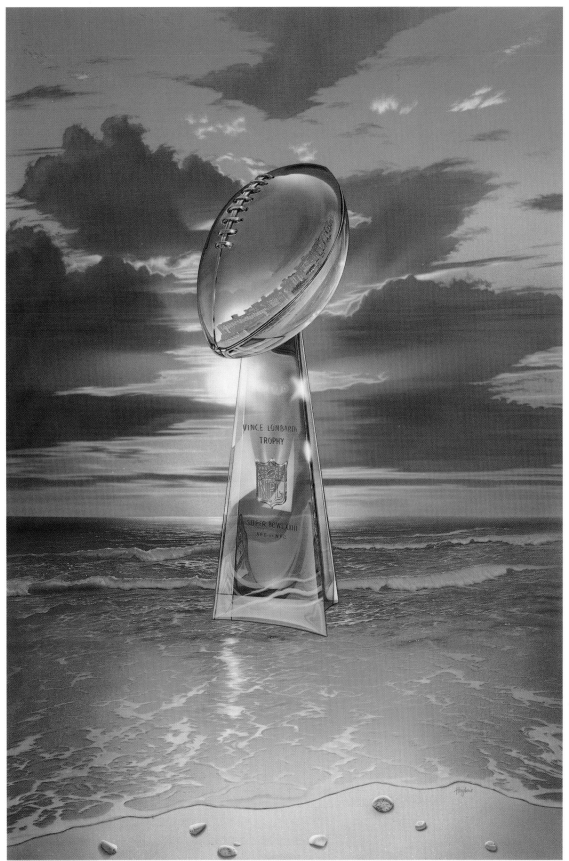

**Artist:** Chris Hopkins
Edmonds, Washington, USA

**Client:** NFL Properties
Los Angeles, California, USA
Theme art for Super Bowl XXIII
advertisement

*"**Super Bowl XXIII,**"* 24 x
36 in. (609mm x 914mm),
Liquitex acrylics on Crescent
100 cold-press illustration
board, Iwata HP-C airbrush.

Artwork reproduced by permission of NFL Properties, David Boss, art director.

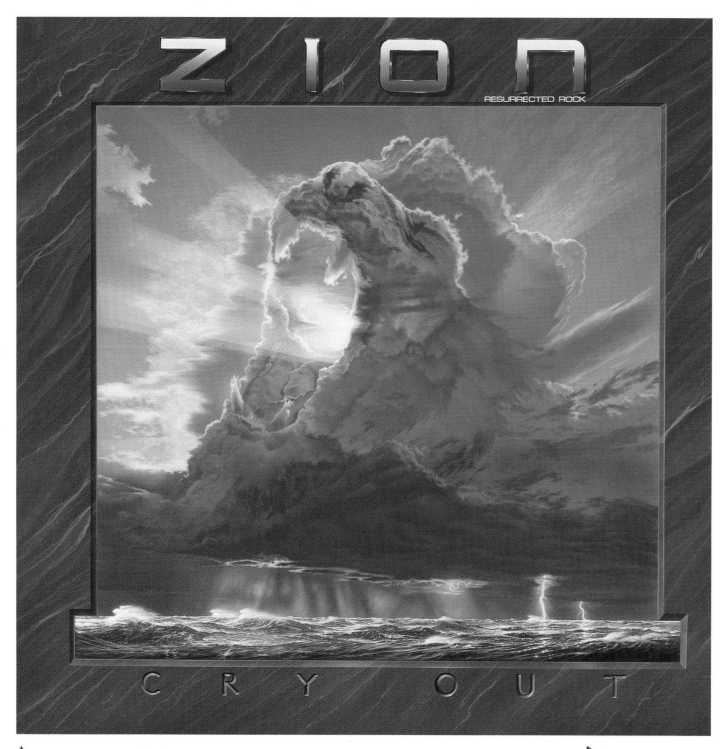

▲
**Artist:** Chris Hopkins
Edmonds, Washington, USA

**Client:** Zion
Jacksonville, Oregon, USA
Album cover, compact disc
jacket and commercial poster for
musical group Zion

**"Zion: Cry Out,"** 20 x 20 in.
(508mm x 508mm), Liquitex
acrylics on Crescent 100 cold-
press illustration board, Iwata
HP-C airbrush.

▶
**Artist:** Todd Schorr
Roxbury, Connecticut, USA

**Client:** Polygram Records
Los Angeles, California, USA
Album Cover

**"Breakfast Club,"** 24 x 24 in.
(609mm x 609mm), Winsor &
Newton gouache on Crescent
illustration board, Iwata HP-SP
airbrush. Combined with dry
brush.

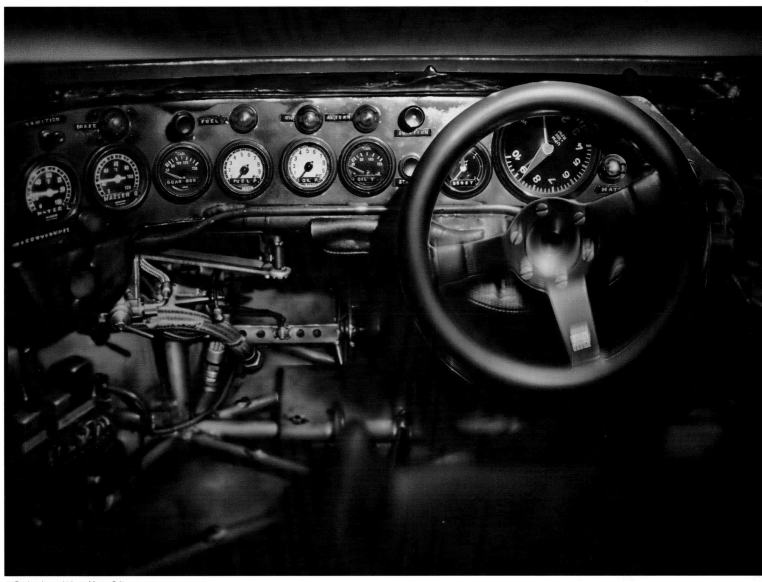

© Dunlop Japan, Ltd. © Masao Saito.

▲
**Artist:** *Masao Saito*
*Kawasaki-shi, JPN*

**Client:** *Dunlop Japan, Ltd.*
*Tokyo, JPN*
*Magazine advertisement and poster*

**"Porsche Cockpit,"** *23 1/2 x 33 in. (594mm x 841mm), Liquitex acrylics and gouache on fine grain canvas, Yaezaki airbrush. Combined with handbrush work.*

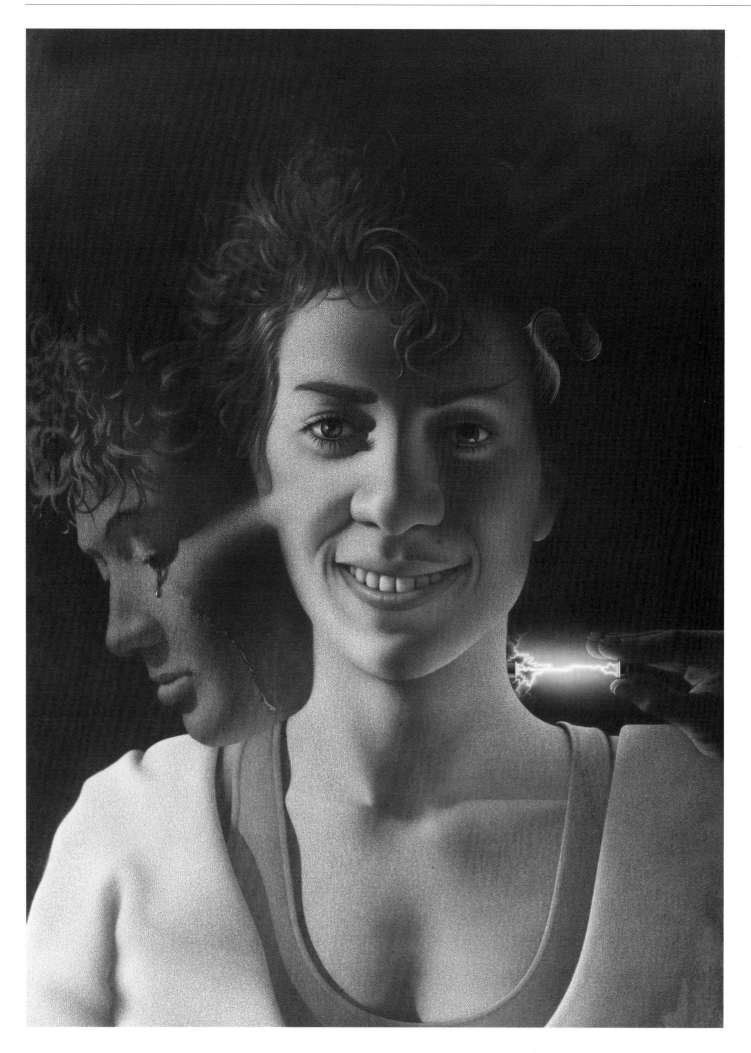

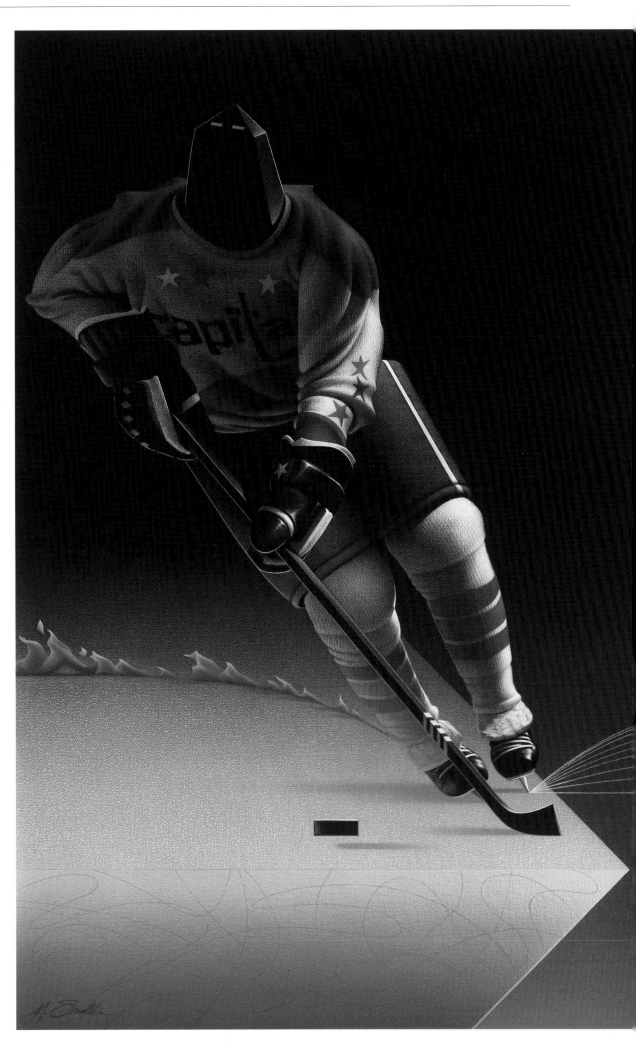

**Artist:** Mark Smollin
Los Angeles, California, USA

**Client:** Victims for Victims
Los Angeles, California, USA
Entry for poster competition
sponsored by Victims for
Victims, a self-help group

**"Victims,"** 24 x 36 in. (609mm
x 914mm), Liquitex acrylics on
canvas, Paasche VL airbrush.
Combined with handbrush work,
colored pencil, and graphite.

**Artist:** Mark Smollin
Los Angeles, California, USA

**Client:** South Paw Studios
Washington D.C., USA
Sports poster for hockey team

**"On the Edge,"** 24 x 36 in.
(609mm x 914mm), Liquitex
acrylics on canvas, Paasche VL
airbrush. Combined with colored
pencil and graphite.

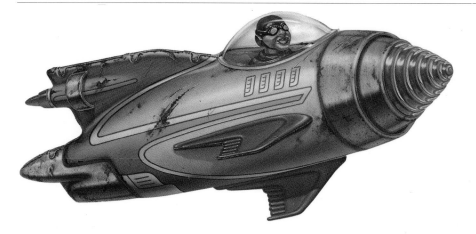

▲
**Artist:** *Cam DeLeon*
*West Los Angeles, California,*
*USA*

**Client:** *Management Science*
*America Computer Software*
*Toronto, Ontario, CAN*
*Magazine and newspaper*
*advertisement for computer*
*software*

**"Toy Rocket,"** *13 in. (330mm)*
*from nose to tail, Liquitex*
*acrylics on Frisk cold-press*
*illustration board, Iwata HP-C*
*and Paasche AB airbrushes.*

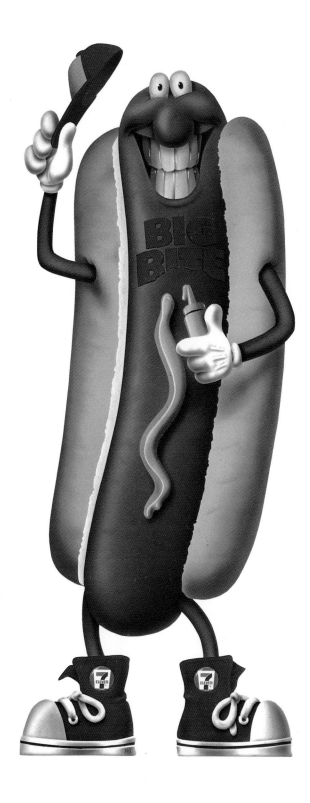

◄
**Artist:** *Ken Westphal*
*Prairie Village, Kansas, USA*

**Client:** *Southland Corporation*
*Dallas, Texas, USA*
*Five-foot high, die cut, point-of-*
*purchase display for 7-Eleven*
*Stores*

**"Mr. Big Bite,"** *8 x 18 in.*
*(203mm x 457mm), Dr. Martin's*
*Spectralite acrylics and Badger*
*Air Opaque Airbrush Colors on*
*Frisk CS10 illustration board,*
*Iwata HP-B and Paasche AB*
*airbrushes.*

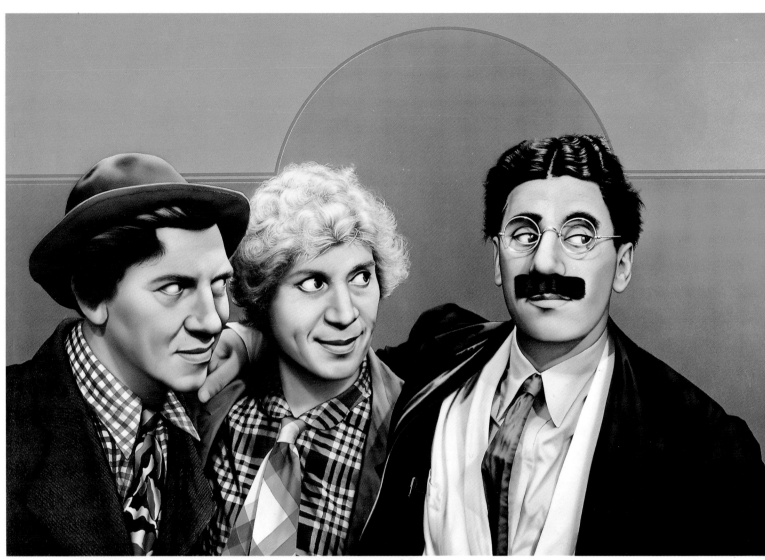

© 1988 Art Studio, Ri Kaiser.

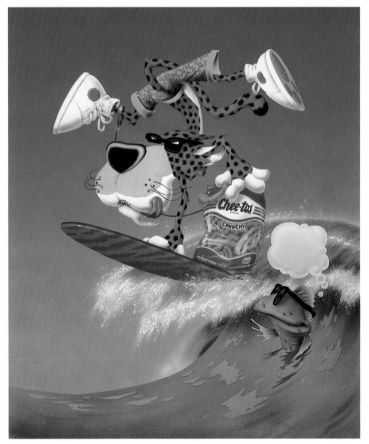

© 1989 DDB Needham/Frito Lay. Used by permission. Art director Brad Morgan.

▲

**Artist:** Ri Kaiser
Hamburg, W. GER

**Client:** R. J. Reynolds
Madrid, SPN
Billboard for cigarette
advertisement

**"Marx Brothers,"** 35 1/2 x
23 1/2 in. (900mm x 600mm),
retouching colors on illustration
board, Grafo airbrush (0.15mm
and 0.3mm nozzles).

◄

**Artist:** Ken Westphal
Prairie Village, Kansas, USA

**Client:** DDB Needham
Chicago, Illinois, USA
Advertisement in children's
magazines for Frito Lay's
Chee-tos Snacks

**"Surfin' Chester,"** 18 x 28 in.
(457mm x 711mm), Dr. Martin's
Spectralite acrylics and Badger
Air Opaque Airbrush Colors on
Frisk CS10 illustration board,
Iwata HP-B and Paasche AB
airbrushes.

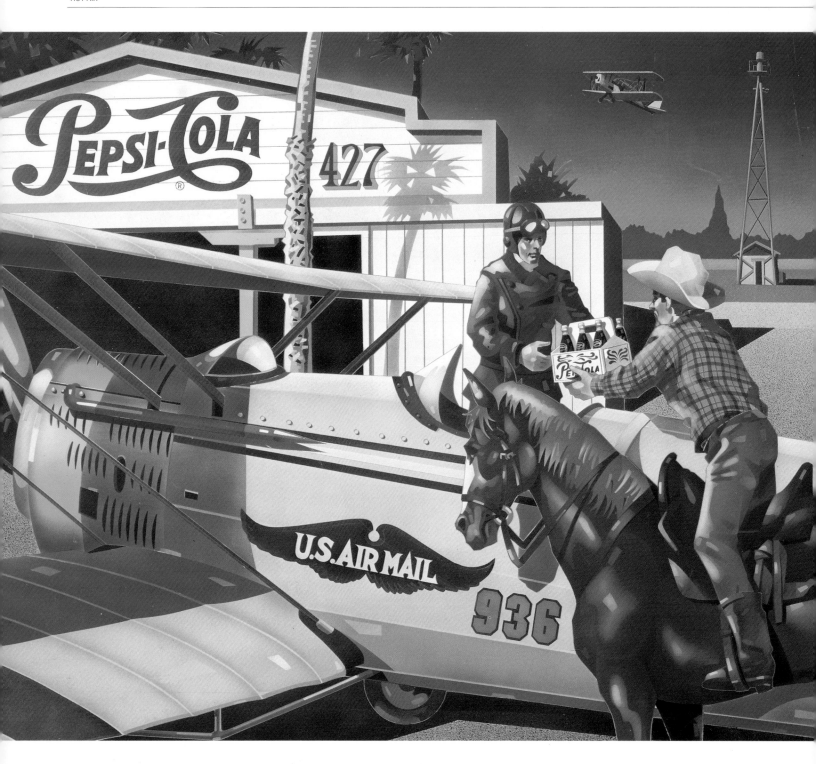

▲

**Artist:** *Katsushi Sei*
*Minato-ku, Tokyo, JPN*

***"Good Old Days,"*** *27 1/2 x
23 1/2 in. (700mm x 595mm),
Holbein ink on Crescent
illustration board, Hohmi
airbrush. Combined with
handbrush work.*

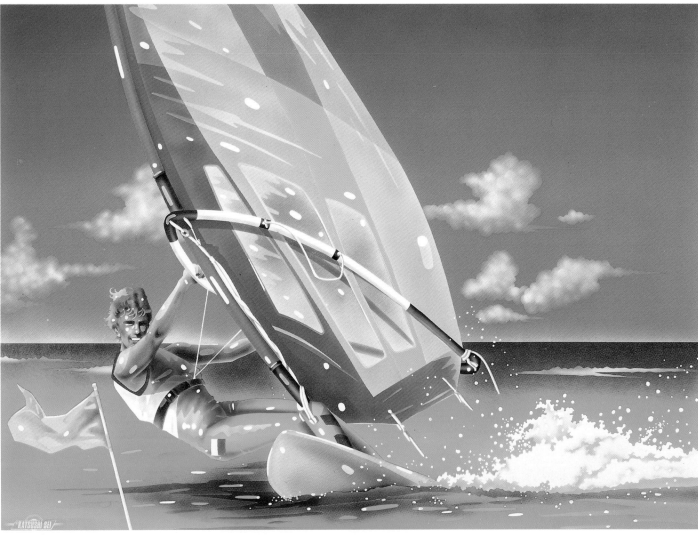

© Katsushi Sei.

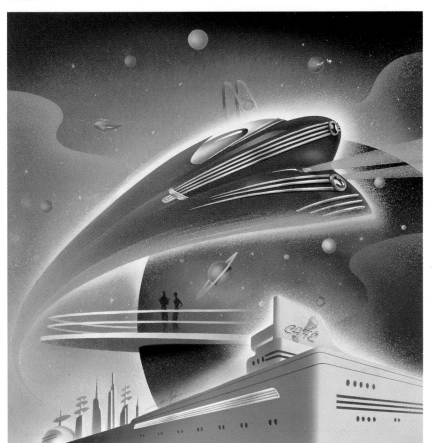

▲
**Artist:** *Katsushi Sei*
*Minato-ku, Tokyo, JPN*

*"Summer Breeze,"* *26 x 19 in.
(660mm x 480mm), Holbein ink
on Crescent illustration board,
Hohmi airbrush. Combined with
handbrush work.*

◀
**Artist:** *Katsushi Sei*
*Minato-ku, Tokyo, JPN*

*"Modern Age,"* *201/4 x 201/4
in. (515mm x 515mm), Holbein
ink on Crescent illustration
board, Hohmi airbrush.
Combined with handbrush work.
Texture created with sandbrush
adapter.*

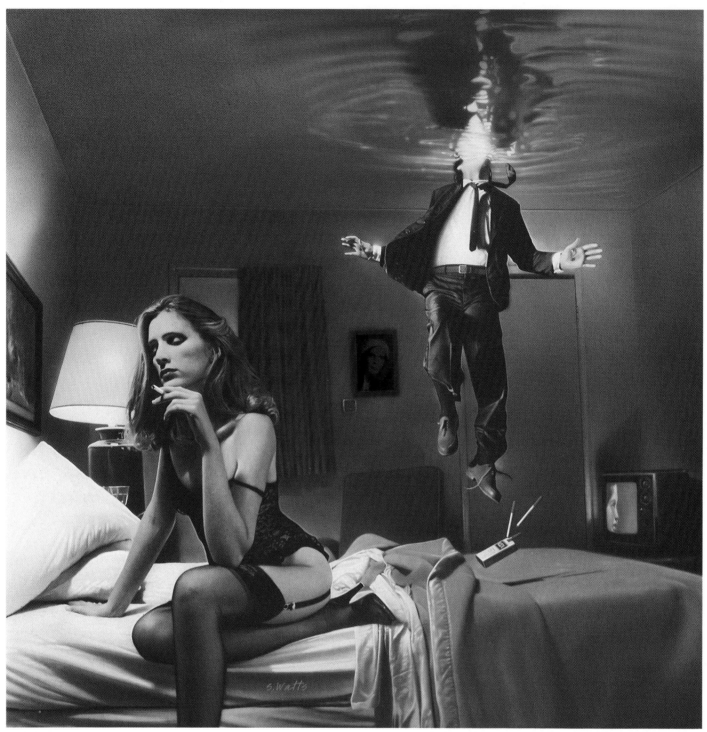

▲
**Artist:** *Stan Watts*
*Agoura Hills, California, USA*

**Client:** *Martin Briley/*
*Polygram Records*
*New York, New York, USA*
*Album cover*

**"One Night With a
Stranger,"** *12 x 12 in. (305mm
x 305mm), Liquitex acrylics and
Dr. Martin's dyes on Crescent
hot-press illustration board,
Iwata HP-B and Iwata HP-C
airbrushes. Combined with dry
brush and Prismacolor colored
pencils.*

▶
**Artist:** *Guerrino Boatto*
*Mestre, Venice, ITA*

**Client:** *Multigraf*
*Venice, ITA*
*Advertisement, unpublished*

**Untitled,** *15 3/4 x 23 1/2 in.
(400mm x 600mm), Liquitex
acrylics on Schoellershammer
illustration board, Paasche V#1
airbrush. Combined with
handbrush work.*

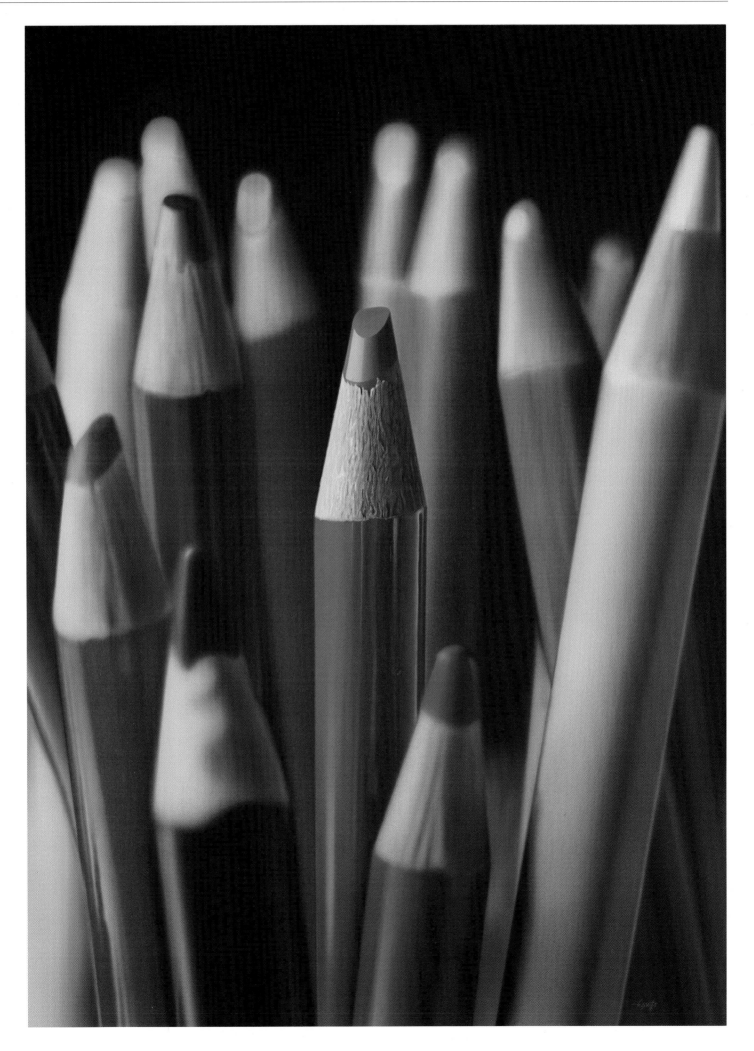

▶
**Artist:** Jeff Wack
Studio City, California, USA

**Client:** Jeffrey Spear Design
Santa Monica, California, USA
Ad agency promotion

**"Let Us Get Fresh,"** 12 x
28 in. (305mm x 711mm),
Liquitex acrylics and Cel-Vinyl
water-based animator's paints
on hot-press illustration board,
Iwata HP-SB airbrush.
Combined with Prismacolor
colored pencil.

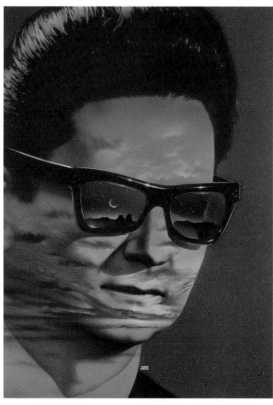

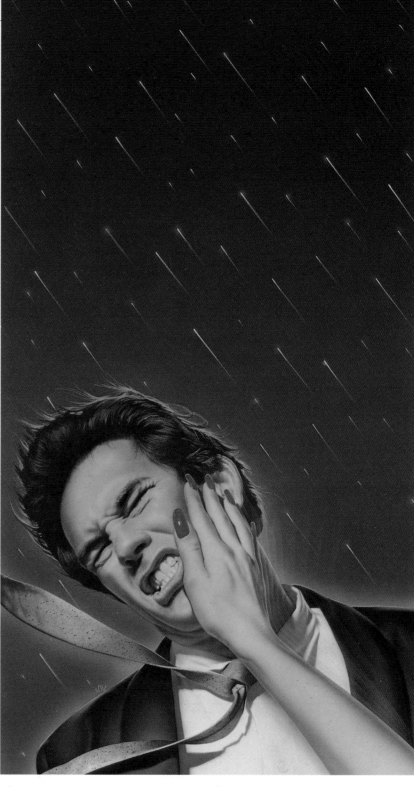

▲
**Artist:** Jeff Wack
Studio City, California, USA

**Client:** Time-Life Music
Alexandria, Virginia, USA
Album and compact disc covers

**"Roy Orbison,"** 30 x 40 in.
(762mm x 1016mm), Cel-Vinyl
water-based animator's paint on
hot-press illustration board,
Iwata HP-SB airbrush.
Combined with handbrush work.

▶
**Artist:** Jeff Wack
Studio City, California, USA

**Client:** MGM
Hollywood, California, USA
Poster and video cover

**"Wizard of Oz,"** 20 x 30 in.
(508mm x 762mm), Liquitex
acrylics and Cel-Vinyl water-
based animator's paints on hot-
press illustration board, Iwata
HP-SB airbrush. Combined with
handbrush work and Prisma-
color colored pencils.

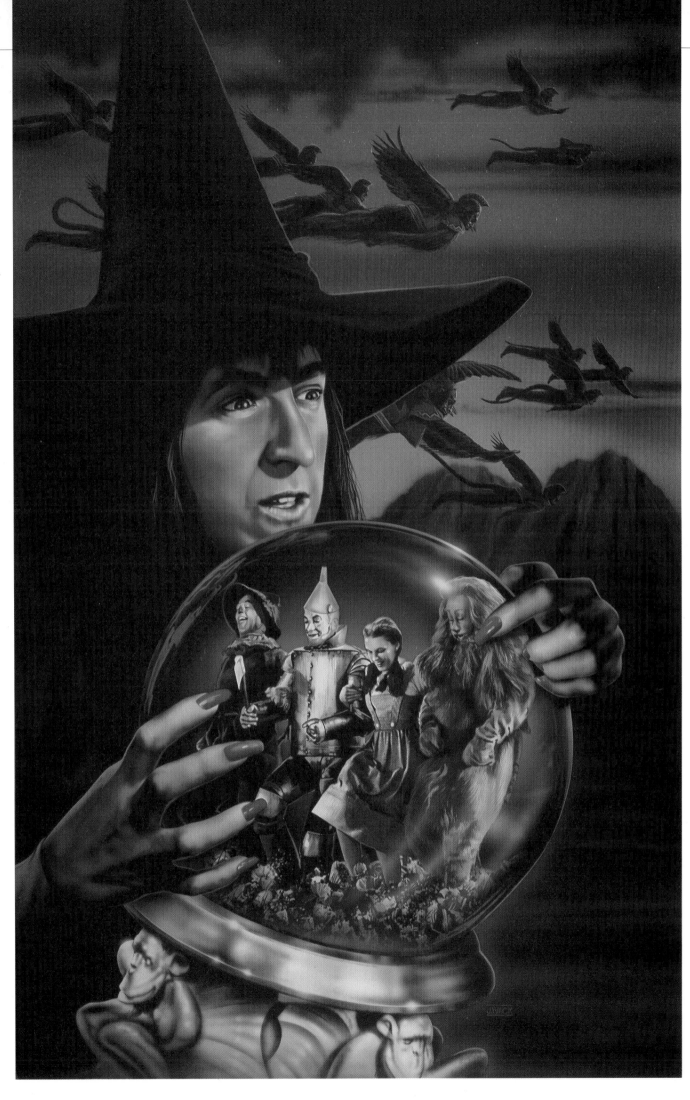

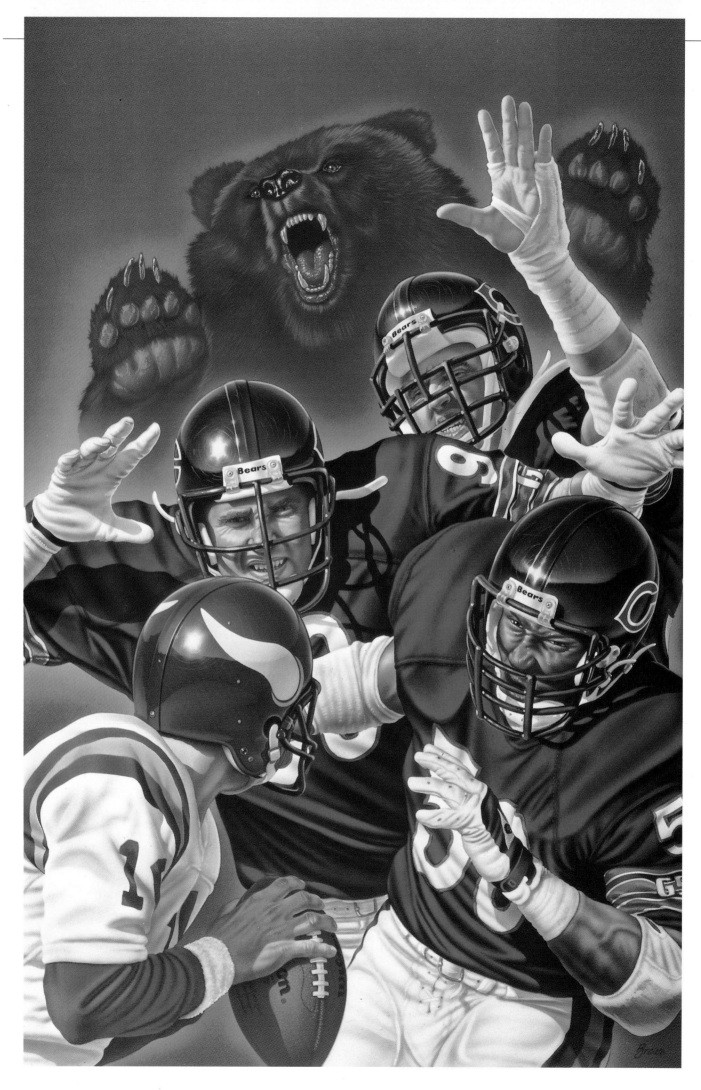

▶
**Artist:** *Rick Brown*
*Burbank, California, USA*

**Client:** *NFL Properties, Inc.*
*Los Angeles, California, USA*
*City series poster for the New*
*York Giants*

**"Giants of The NFL,"** *20 x*
*30 in. (508mm x 762mm),*
*Liquitex acrylics on Crescent*
*100 illustration board, Iwata*
*HP-C airbrush.*

◀
**Artist:** *Rick Brown*
*Burbank, California, USA*

**Client:** *NFL Properties, Inc.*
*Los Angeles, California, USA*
*City series poster for the*
*Chicago Bears*

**"Here Come The Bears,"**
*20 x 30 in. (508mm x 762mm),*
*Liquitex acrylics on Crescent*
*100 illustration board, Iwata*
*HP-C airbrush.*

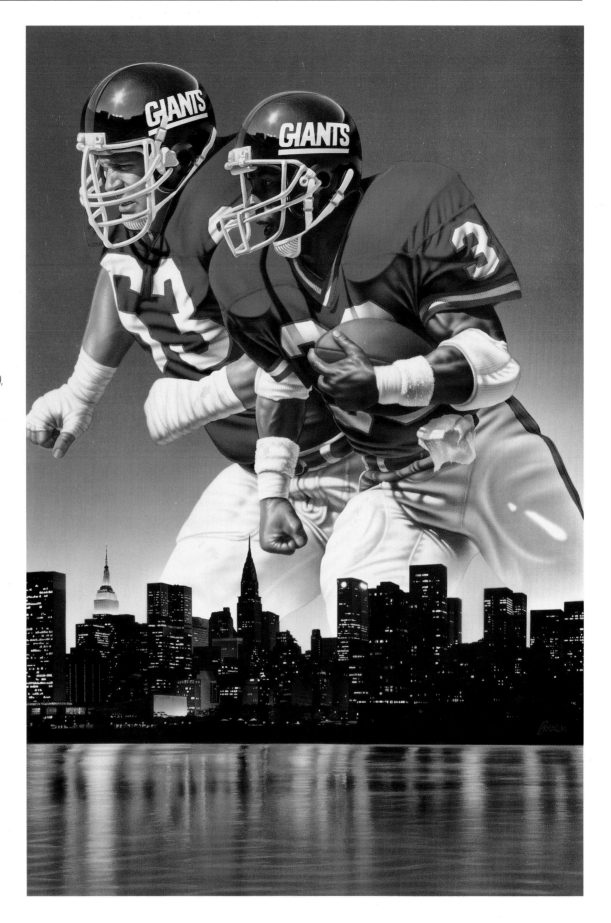

▶
**Artist:** *Bryan Robley*
*Gardnerville, Nevada, USA*

**Client:** *Reebok*
*Stoughton, Massachusetts, USA*
*In-store poster to promote*
*Reebok's involvement in cycling*
*gear*

**"Reebok Cycling,"** *40 x*
*24 in. (1016mm x 610mm),*
*Liquitex acrylics and Winsor &*
*Newton acrylics on Crescent 100*
*illustration board, Paasche AB*
*and VL airbrushes.*

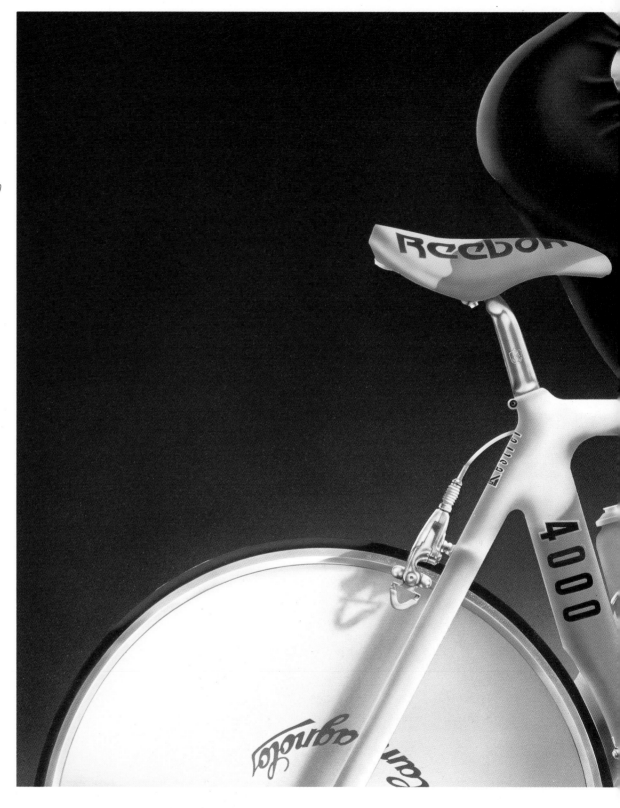

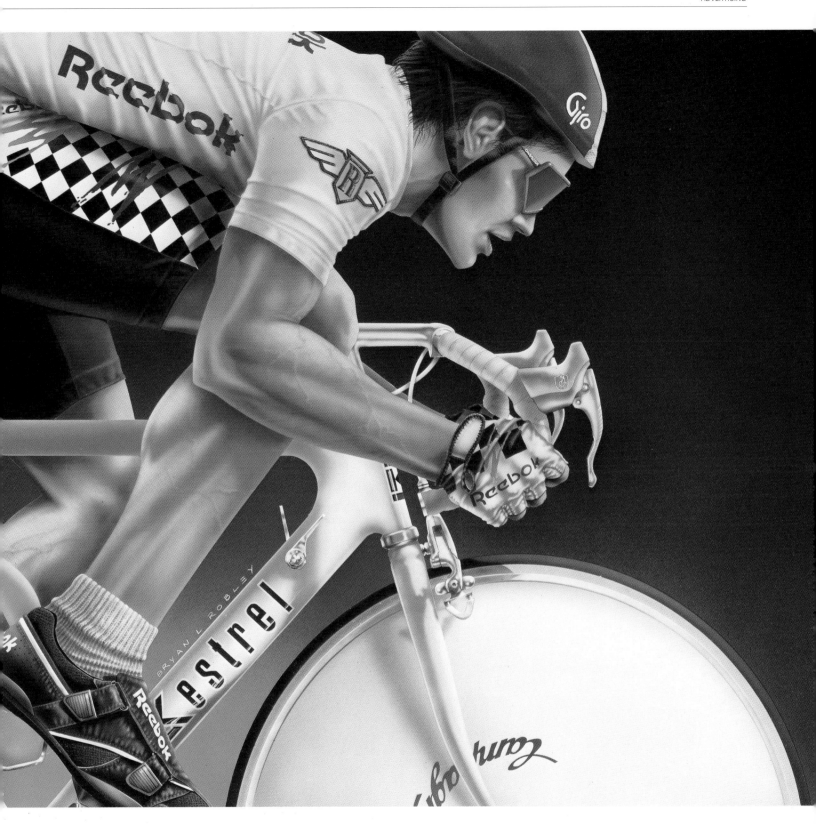

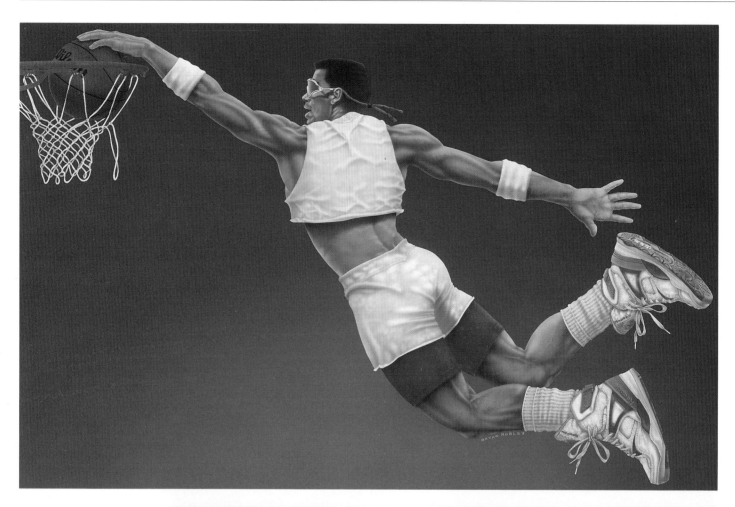

▲
**Artist:** Bryan Robley
Gardnerville, Nevada, USA

**Client:** Reebok International
Stoughton, Massachusetts, USA
Wall mural and poster depicting
the ultimate basketball shoe on
the ultimate playground athlete

**"The Asphalt Jungle,"** 40 x
24 in. (1016mm x 610mm),
Winsor & Newton acrylics on
Crescent 100 illustration board,
Paasche AB.

▶
**Artist:** Bryan Robley
Gardnerville, Nevada, USA

**Client:** Reebok
Stoughton, Massachusetts, USA
Commercial poster

**"Legs,"** 40 x 24 in. (1016mm x
610mm), Liquitex acrylics and
Winsor & Newton acrylics on
Crescent 100 illustration board,
Paasche AB and VL airbrushes.

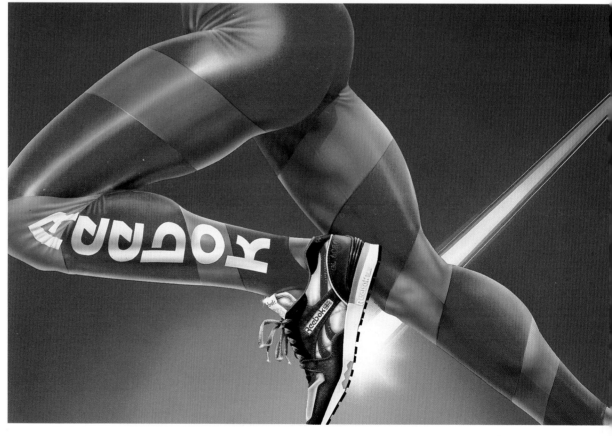

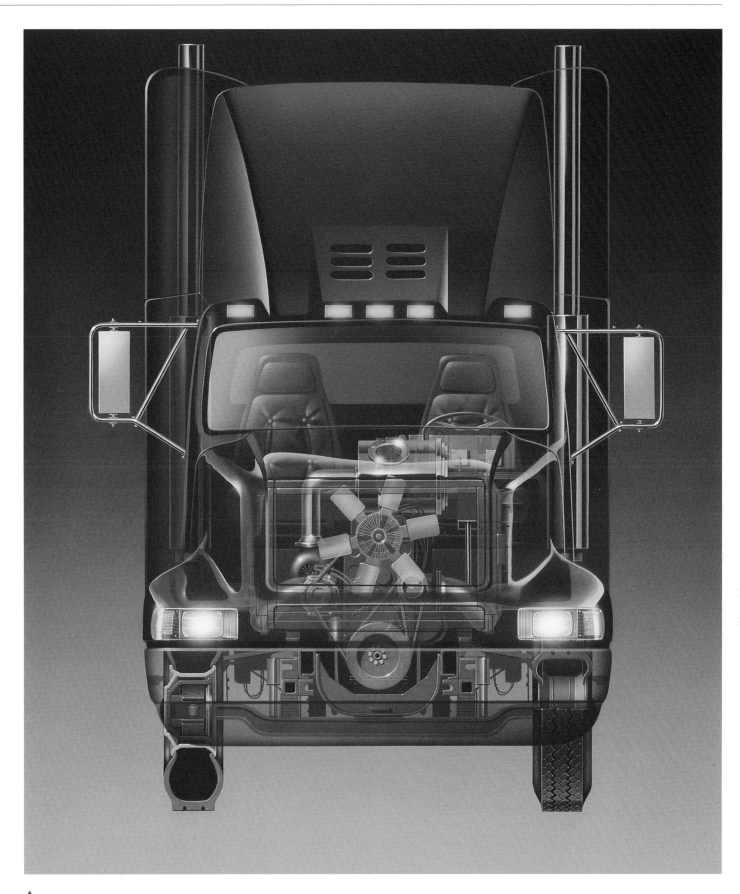

▲

**Artist:** *Dick Truxaw*
*Overland Park, Kansas, USA*

**Client:** *International Truck*
*Kenworth*
*Kansas City, Missouri, USA*
*Used for calendar and truck parts*
*catalog cover*

**Untitled,** *18 x 22 in. (457mm x*
*559mm), Liquitex acrylics on*
*Frisk CS10 illustration board,*
*Paasche AB and Iwata HP-B*
*airbrushes.*

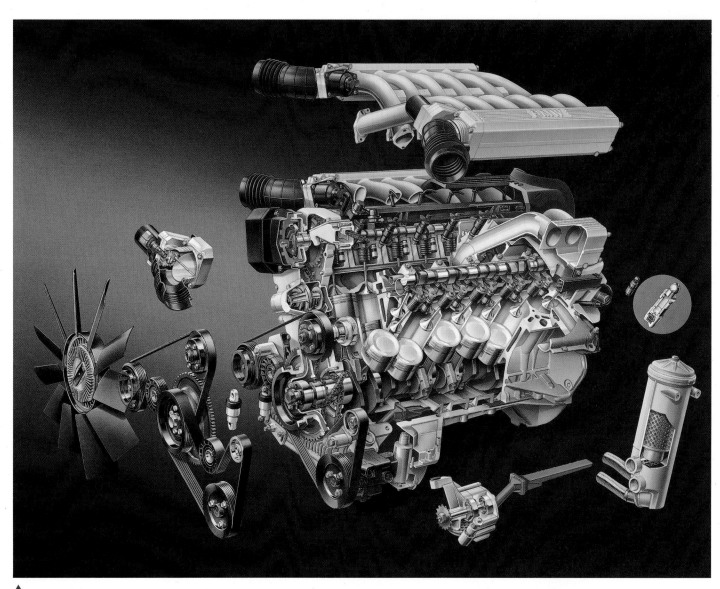

▲
**Artists:** Norbert Schaefer and
Ludwig Eberl
Technical Art
Dietzenbach, W. GER

**Client:** BMW AG
Munich, W. GER
Poster and brochure

**"BMW 12-Cylinder Engine,"**
39 1/2 x 27 1/2 in. (1000mm x
700mm), Liquitex acrylics on
Zanders Parole illustration
board, Holbein airbrush.
Combined with handbrush work.

▶
**Artist:** Klaus Wagger
Bad Haering, AUS

**Client:** Koenig
Munich, W. GER
Brochure featuring Koenig's
turbo compressor

**"Koenig Kompressor
Turbo,"** 27 1/2 x 39 1/2 in.
(700mm x 1000mm), Schmincke
Aerocolor on Zanders Parole
illustration board, Iwata HP-B
airbrush.

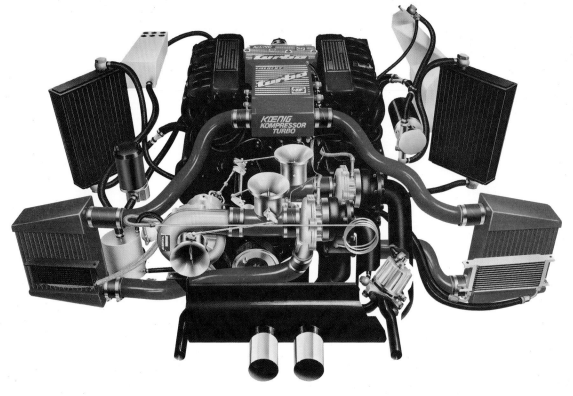

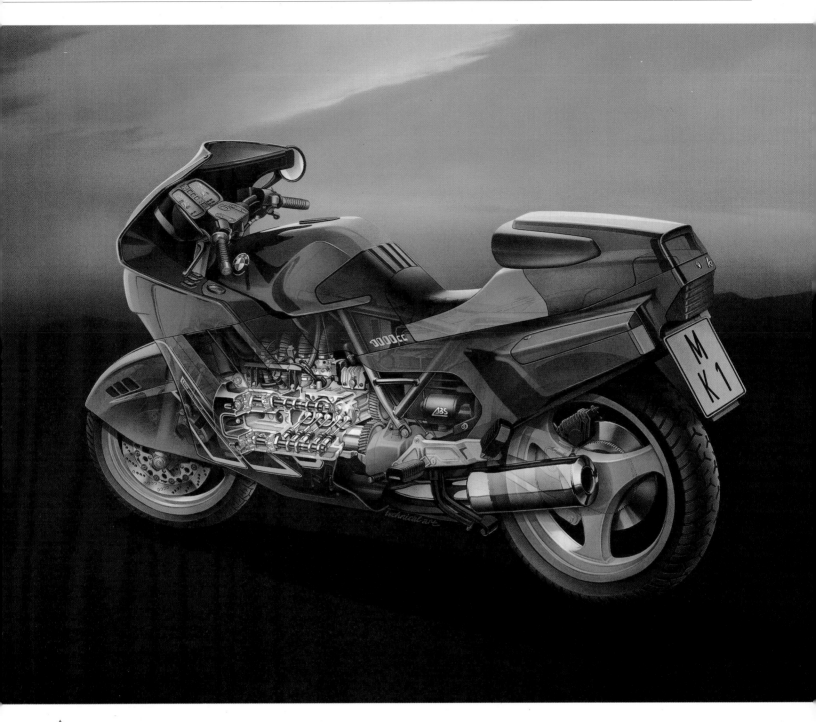

▲
**Artists:** *Norbert Shaefer and*
*Ludwig Eberl*
*Technical Art*
*Dietzenbach, W. GER*

**Client:** *BMW Motorrad GmbH*
*Munich, W. GER*
*Poster for BMW motorcycles*

**"BMW K1,"** *31 1/2 x 27 1/2 in.*
*(800mm x 700mm), Liquitex*
*acrylics on Zanders Parole*
*illustration board, Holbein*
*airbrush. Combined with*
*colored pencil.*

◄

**Artist:** Helmut Steiner
Mainz, W. GER

**Client:** Luerzer & Conrads
ad agency
Frankfurt am Main, W. GER
Advertisement for car stereo
manufacturer, Blaupunkt

**"U-Boot,"** (Submarine), 19 3/4 x
27 in. (500mm x 700mm),
Liquitex acrylics on Zanders
Parole 4R-thick illustration
board, Grafo (0.3mm/0.5mm
nozzles) airbrushes. Combined
with colored pencil.

◄

**Artist:** Sandra Marziali
Rome, ITA

**Client:** Fiamma
Piacenza, ITA
Advertisement for children's wear
fashion show

**"Royal Garden,"** 27 1/2 x
39 1/2 in. (700mm x 1000mm),
Liquitex acrylics and Magic
Color on Zanders Parole
illustration board, Iwata HP-C
airbrush. Combined with
handbrush work.

▶
**Artist:** *Laura Smith*
*New York, New York, USA*

**Client:** *Manhattan Design*
*New York, New York, USA*
*Poster promoting Max Weinberg*
*of the E Street Band*

**"The Big Beat,"** *23 1/2 x 34 in.*
*(597mm x 863mm), Winsor &*
*Newton gouache on Strathmore*
*illustration board, Paasche VL-5*
*airbrush. Combined with some*
*drybrush. Type lettered on*
*overlay by designer*
*Michael Doret.*

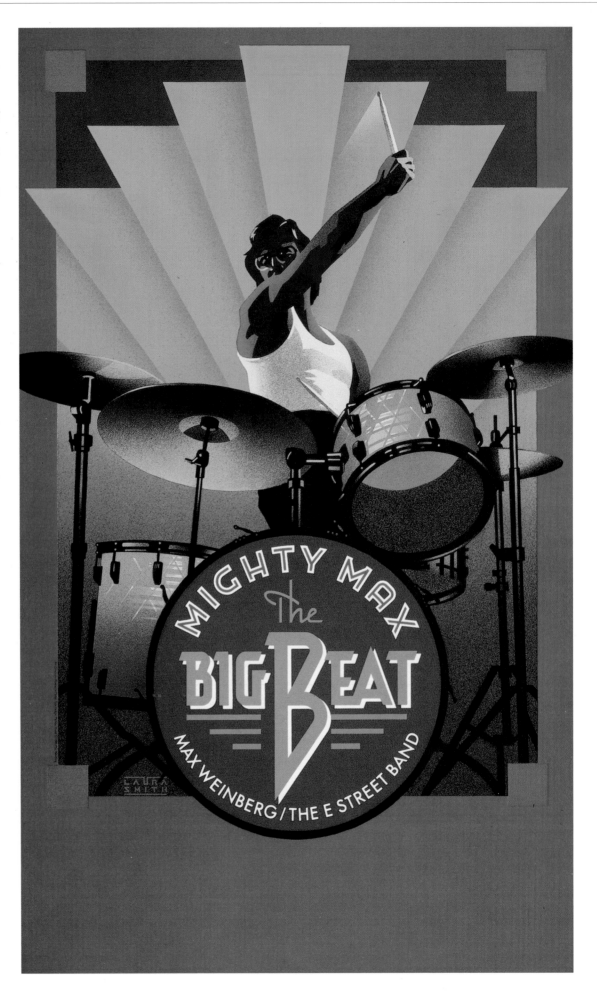

◄
**Artist:** Fred Preston
Allerod, DEN

**Client:** Grey Advertising
Paris, FRC
Advertisement and outdoor
poster for a contest sponsored
by a shoe manufacturer.  First
prize was a cruise.

**"Liner,"** 23 1/2 x 19 3/4 in.
(600mm x 500mm), Rowney
acrylics and Winsor & Newton
ink on canvas, DeVilbiss Super
63 airbrush.  Combined with
handbrush work.

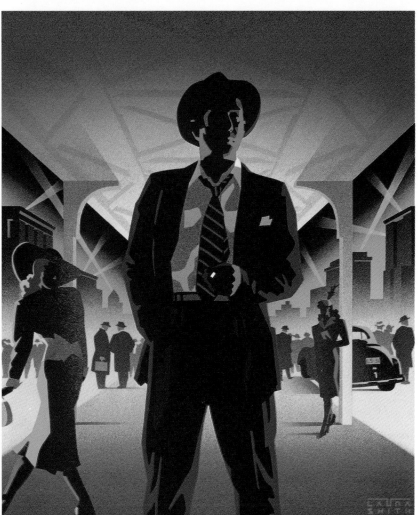

◄
**Artist:** Laura Smith
New York, New York, USA

**Client:** Goodman Theatre
Chicago, Illinois, USA
Theatre poster for "Pal Joey"

**"Pal Joey,"** 28 x 22 in.
(711mm x 559mm), Winsor &
Newton on Strathmore
illustration board, Paasche VL-5
airbrush.

▶

**Artist:** *Kevin Hulsey*
*Los Angeles, California, USA*

**Client:** *Continental Tires*
*Los Angeles, California, USA*
*Advertisement for tires*

*"Continental Tires," 25 x*
*30 in. (635mm x 762mm),*
*Badger Air Opaque Airbrush*
*Colors on Crescent hot-press*
*illustration board, Iwata HP-C*
*airbrush. Combined with*
*Prismacolor colored pencil*
*and ink.*

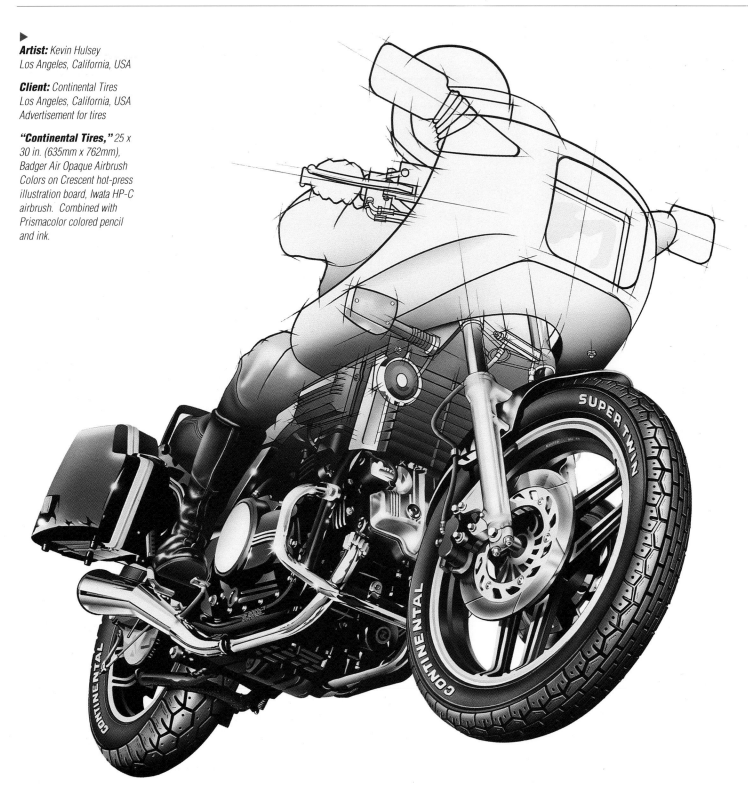

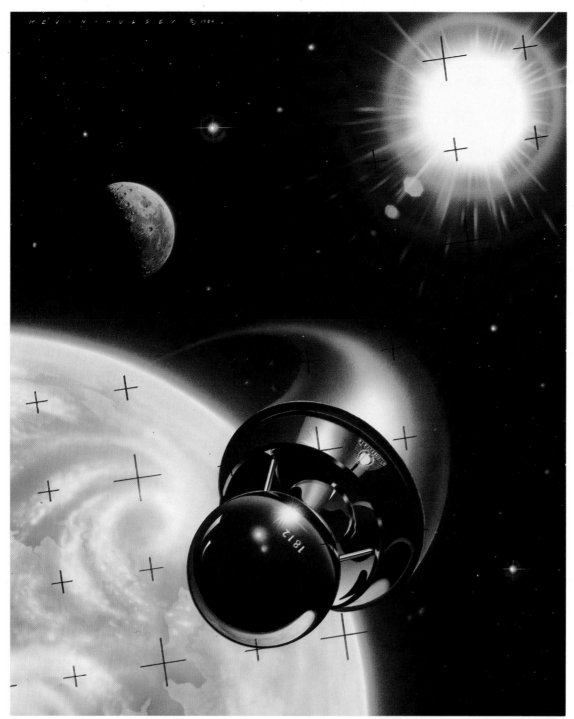

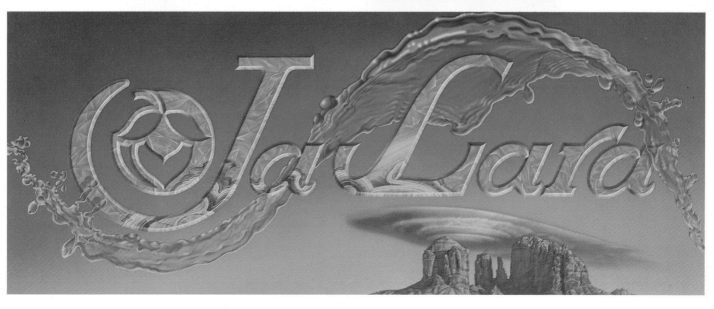

**Artist:** Kevin Hulsey
Los Angeles, California, USA

**Client:** Omnisphere
Los Angeles, California, USA
Advertisement in a consumer
brochure for speakers

**"Omnisphere,"** 20 x 25 in.
(508mm x 635mm), Badger Air
Opaque Airbrush Colors on
Crescent hot-press illustration
board, Iwata HP-C airbrush.
Combined with Prismacolor
colored pencils and ink.

© Kevin Hulsey 1984.

**Artist:** Cam DeLeon
West Los Angeles, California,
USA

**Client:** Ja Lara Products
Santa Barbara, California, USA
Corporate wall decoration for
skin and hair care company

**"Ja Lara,"** 16 x 40 in. (406mm
x 1016mm), Liquitex acrylics on
gessoed Masonite, Paasche
VL-3 airbrush.

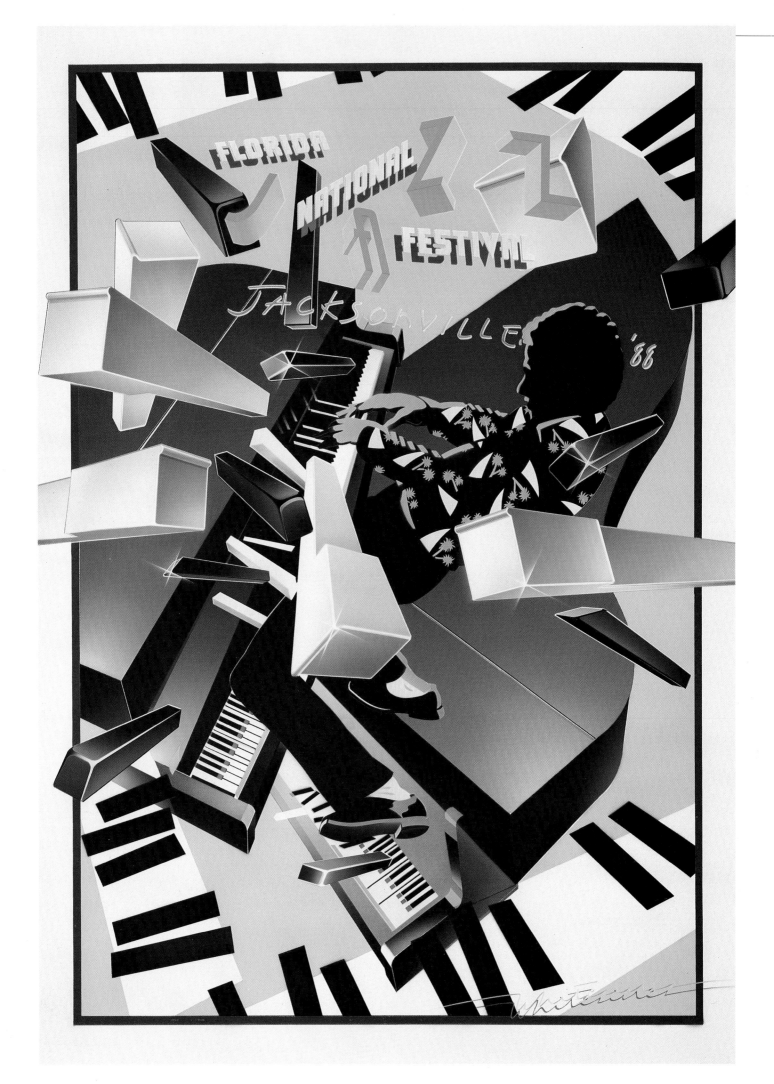

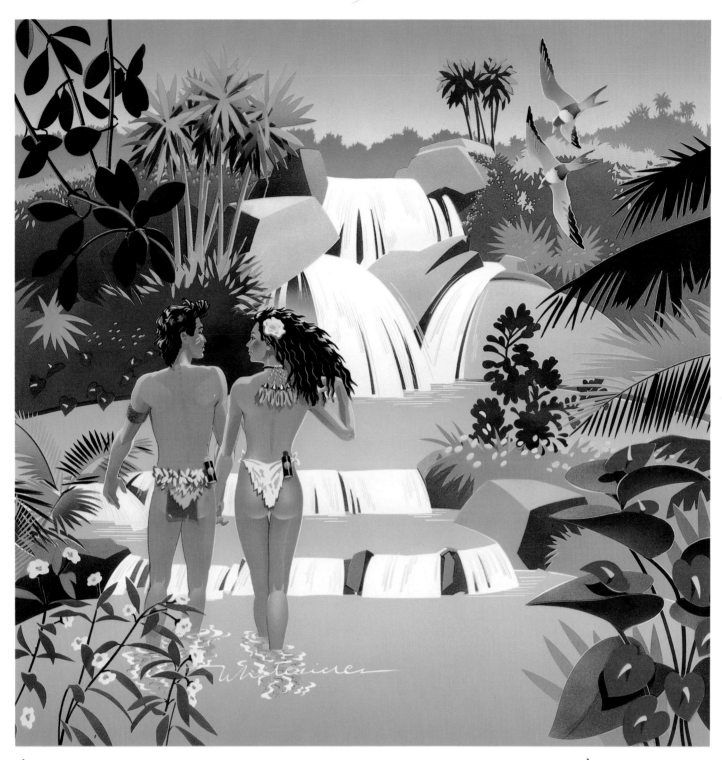

◄
**Artist:** Kim Whitesides
Park City, Utah, USA

**Client:** WJCT TV
Jacksonville, Florida, USA
Poster promoting jazz festival,
also available for purchase

**"Jazz/Jacksonville '88,"**
24 x 34 in. (609mm x 863mm),
Liquitex acrylics on Strathmore
heavyweight high surface
illustration board, Iwata HP-A,
Iwata HP-B and Iwata HP-C
airbrushes.

▲
**Artist:** Kim Whitesides
Park City, Utah, USA

**Client:** Braza Bra
Miami, Florida, USA
Advertisement in trade magazine
for Braza Bronze suntan oil

**"Jungle Love,"** 32 x 32 in.
(813mm x 813mm), Liquitex
acrylics on Strathmore
heavyweight high surface
illustration board, Iwata HP-A,
Iwata HP-B and Iwata HP-C
airbrushes.

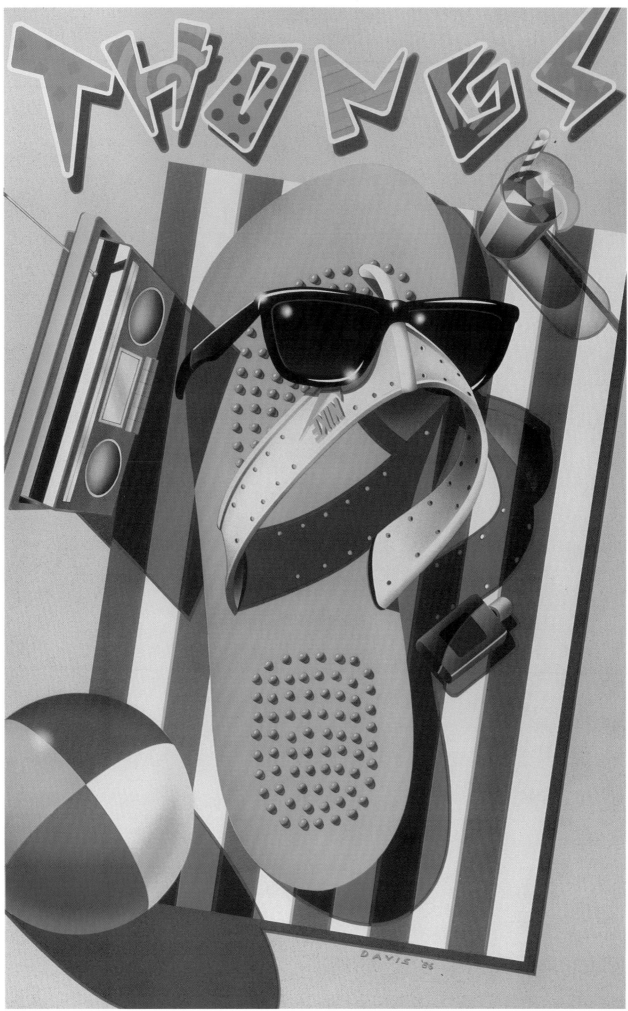

◄

**Artist:** David M. Davis
Portland, Oregon, USA

**Client:** Nike
Beaverton, Oregon, USA
In-store poster

**"Thongs,"** 16 x 25 in. (406mm
x 635mm), Winsor & Newton
and Maimeri gouache on
Strathmore 2-ply 100% rag
medium surface, Iwata HP-B
airbrush.

▶

**Artist:** David M. Davis
Portland, Oregon, USA

**Client:** Oregon Special
Olympics
Portland, Oregon, USA
Poster for a food fair

**"The Bite,"** 12 x 33 in.
(305mm x 838mm), Winsor &
Newton gouache on Strathmore
6-ply 100% rag illustration
board, Iwata HP-B and Iwata
HP-C airbrushes.
Design: Nancy Davis.
Illustration: David M. Davis.

© 1989 Errolgraphics.

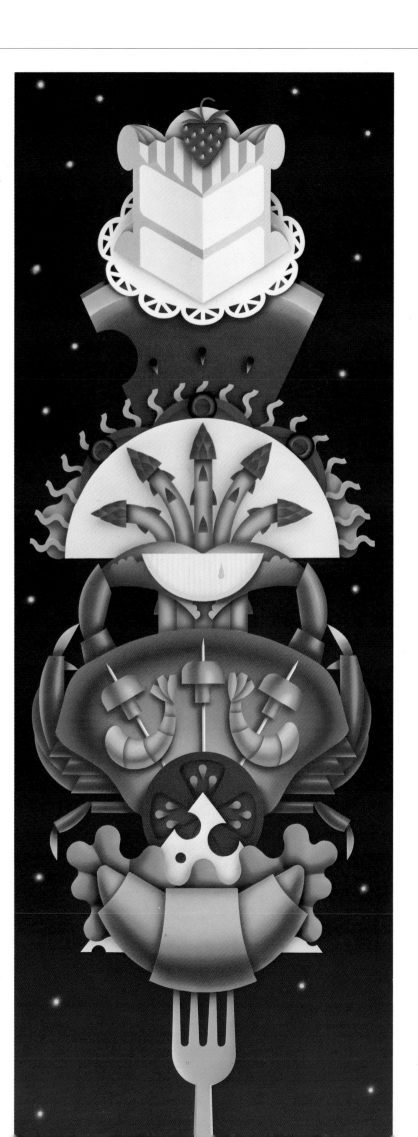

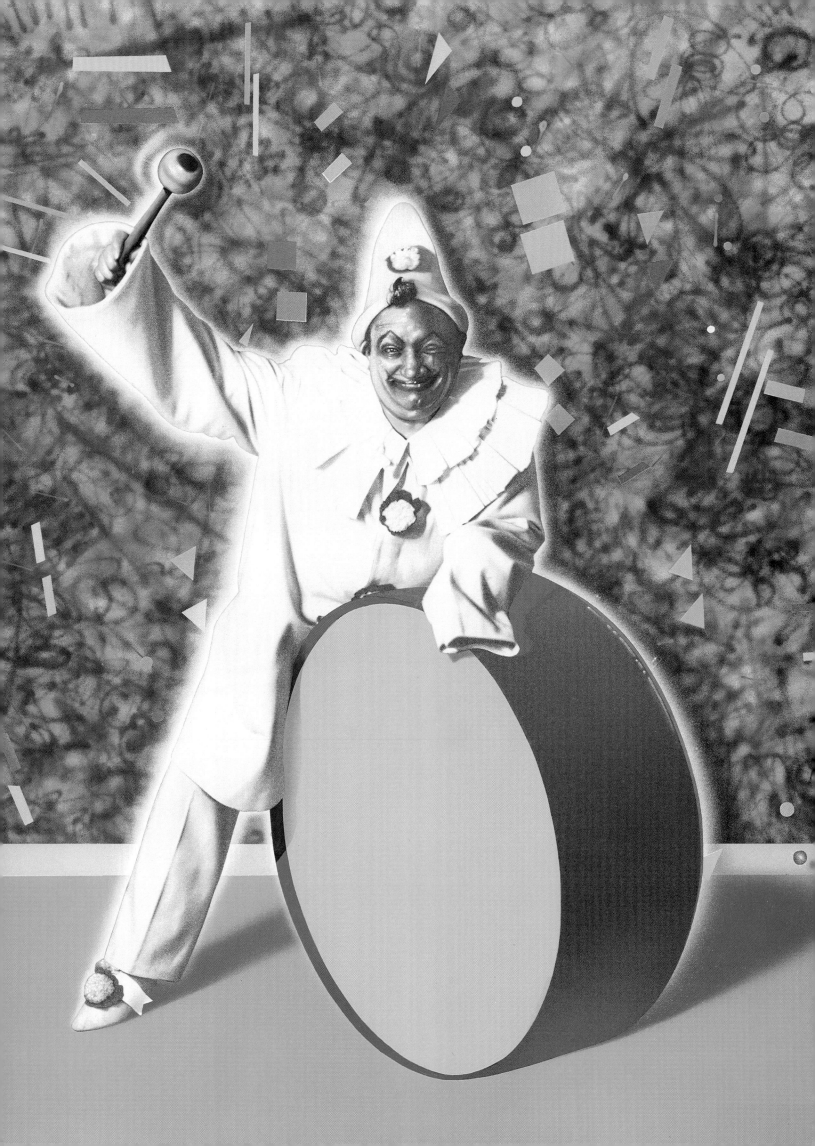

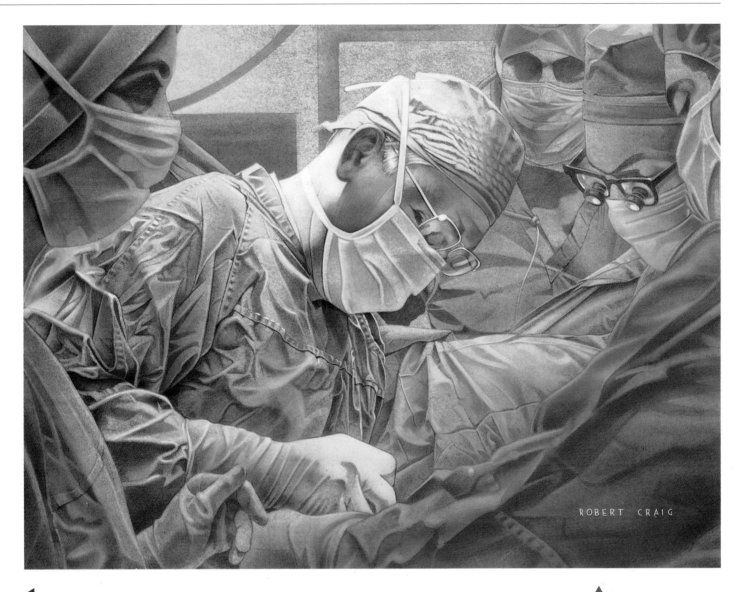

ROBERT CRAIG

◄

**Artist:** Guy Fery
New York, New York, USA

**Client:** Maxell
New York, New York, USA
Advertisement for audio tapes

**"No More Airbrush,"** 14 x
17 in. (355mm x 431mm),
Liquitex acrylic, Schmincke
gouache on photographic paper,
Thayer & Chandler model 4
airbrush. Combined with oil and
colored pencil.

▲

**Artist:** Robert Craig
Greensboro, North Carolina,
USA

**Client:** Ciba-Giegy
Greensboro, North Carolina,
USA
Magazine advertisement

**"The Best of Care,"** 16 3/4 x
21 1/2 in. (425mm x 546mm),
Dr. Martin's acrylics on blueprint
paper, Iwata HP-B airbrush.
Combined with Prismacolor
colored pencil.

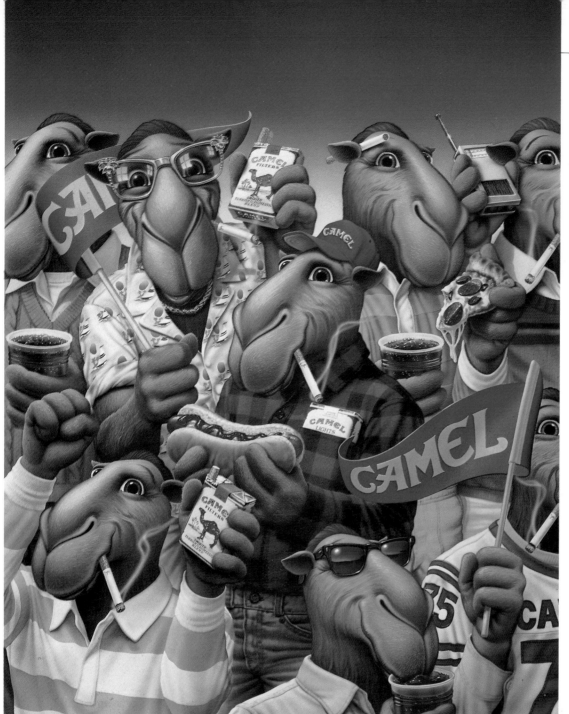

◄

**Artist:** Mick McGinty
Shadow Hills, California, USA

**Client:** Trone Advertising
High Point, North Carolina, USA
Magazine advertisement for the
75th anniversary of Camel
cigarettes

**"Camel Spectators,"** 20 x
26 in. (508mm x 660mm),
Liquitex acrylics on Crescent
cold-press illustration board,
Iwata HP-B airbrush. Combined
with handbrush work for texture.

© 1988 R.J. Reynolds.
Artist represented by Randy Pate &
Assoc., Inc., Los Angeles, California.

▶

**Artist:** Charlie White III
Los Angeles, California, USA

**Client:** Charlie's III Shirt Co.
New York, New York, USA
Shirt design

**"NY Door,"** 18 x 24 in.
(457mm x 609mm), Winsor &
Newton gouache and
Dr. Martin's Spectralite acrylics
on Crescent illustration board,
Iwata HP-C airbrush.

▶

**Artist:** Mick McGinty
Shadow Hills, California, USA

**Client:** Graphics Plus and
Pepsi Cola
Port Chester, New York, USA
P-O-P display

**"Mug Root Beer,"** 20 x 26 in.
(508mm x 660mm), Liquitex
acrylics on Crescent cold-press
illustration board, Iwata HP-B
airbrush. Combined with
handbrush work for texture.

© 1989 Mick McGinty.
Artist represented by Randy Pate &
Assoc., Inc., Los Angeles, California.

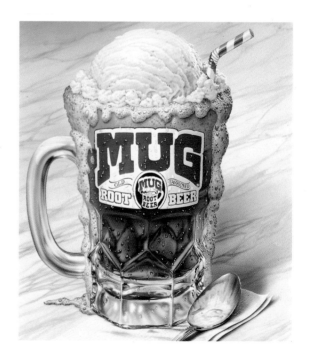

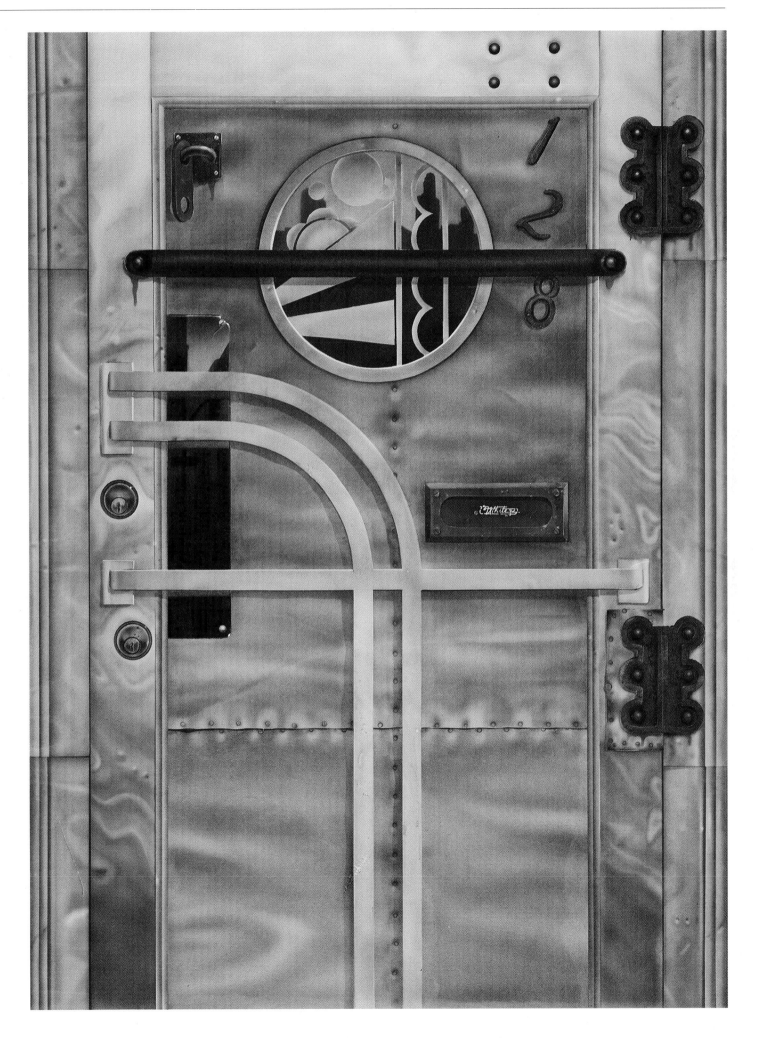

▶
**Artist:** *Dave Miller
Cincinnati, Ohio, USA*

**Client:** *Oscar Robertson
Cincinnati, Ohio, USA
Promotional poster for a tennis
tournament*

**"Oscar Robertson
Tournament,"** *15 x 26 in.
(381mm x 660mm), Winsor &
Newton gouache on 100% rag
mounted onto cold-press
illustration board, Iwata HP-C
airbrush. Acrylics added to
modeling paste, texture created
with a comb. Background is
crumpled paper airbrushed,
ironed flat, and dry mounted.
Art Director: Tom Shaw.*

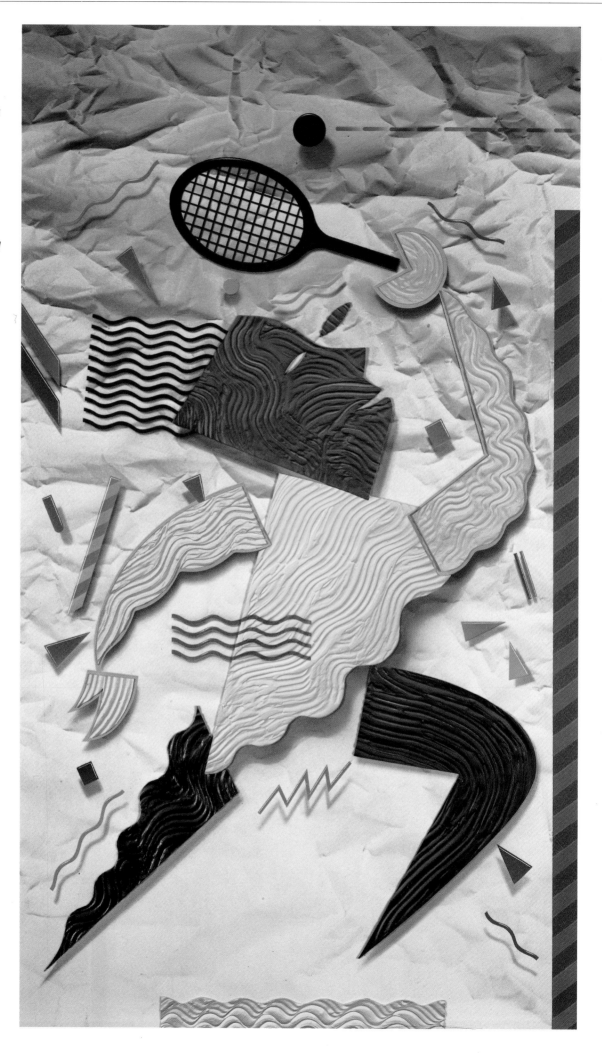

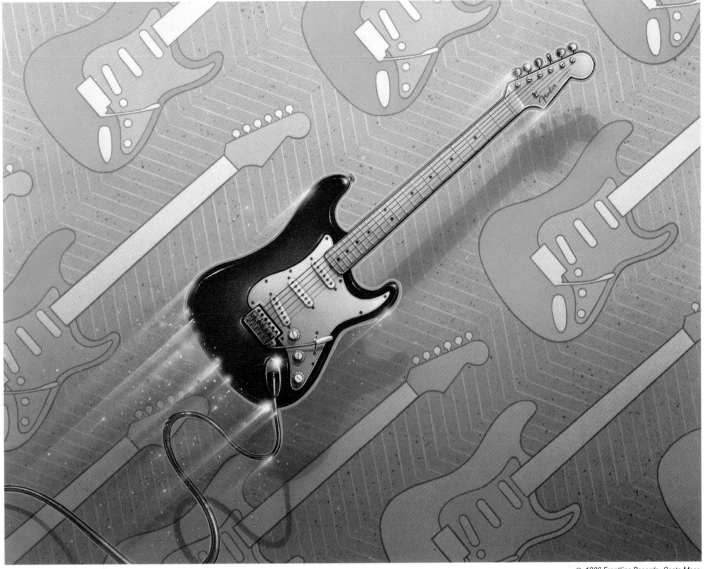

▲

**Artist:** John Dickenson
Anaheim, California, USA

**Client:** Frontline Records
Costa Mesa, California, USA
Album cover art for Paul
Johnson & The Packards

**"Guitar Heaven,"** 18 x 18 in.
(457mm x 457mm), Com-Art
airbrush colors on Crescent 110
illustration board, Iwata HP-A,
Iwata HP-B and Iwata HP-C
airbrushes. Combined with
colored pencil, watercolor,
and oil.

▶

**Artist:** *Takashi Ohno and assistant Yoshiaki Kashiwazki Kita-ku, Tokyo, JPN*

**Client:** *Orientalland Chiba-Ken, JPN Promotional poster for Tokyo Disneyland*

**"Big Thunder Mountain,"** *34 3/4 x 25 1/4 in. (885mm x 640mm), Liquitex acrylics on Crescent illustration board, Olympos HP-100A airbrush.*

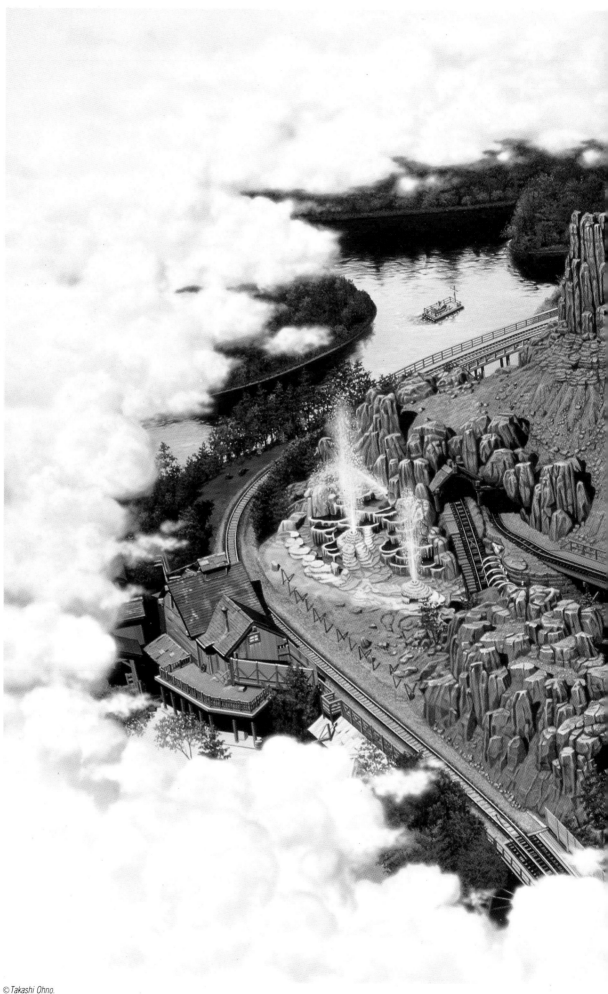

© Takashi Ohno.

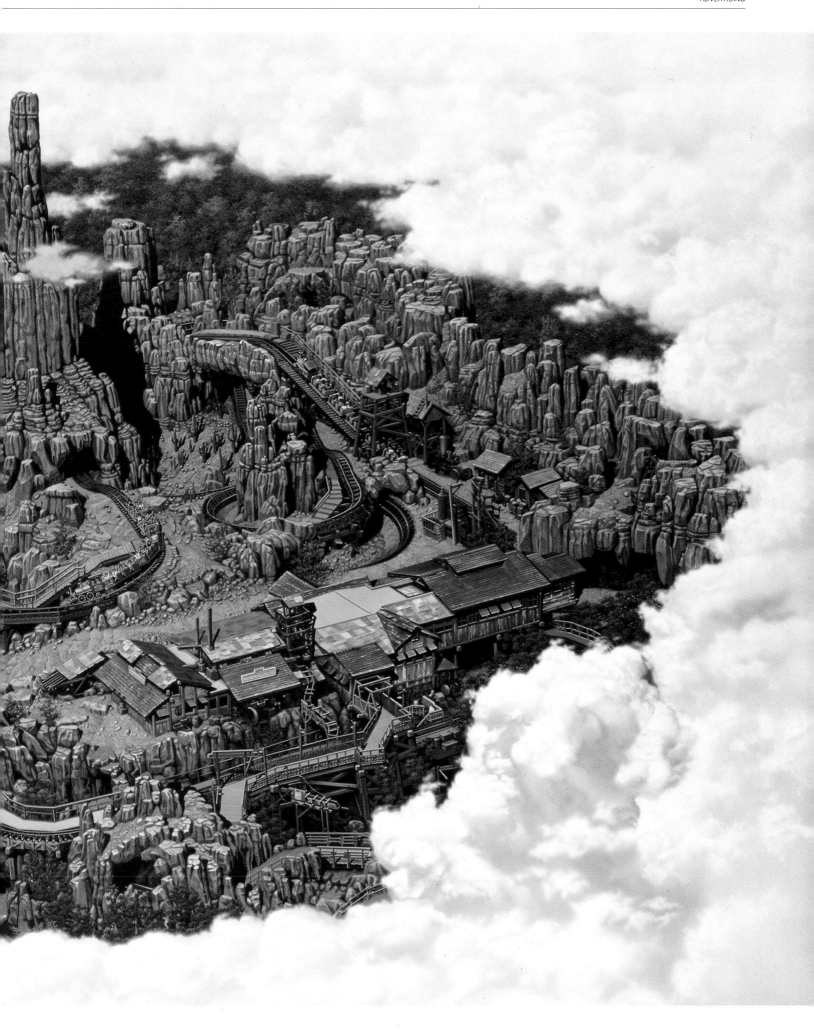

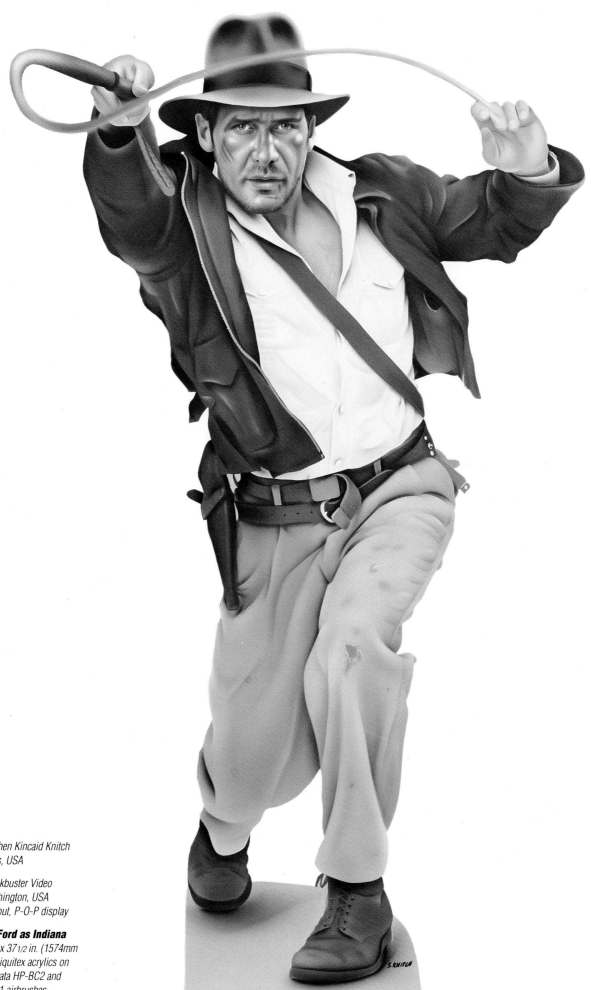

▶
**Artist:** *Stephen Kincaid Knitch*
*Dallas, Texas, USA*

**Client:** *Blockbuster Video*
*Seattle, Washington, USA*
*Life-size cutout, P-O-P display*

**"Harrison Ford as Indiana Jones,"** *62 x 37 1/2 in. (1574mm x 952mm), Liquitex acrylics on Masonite, Iwata HP-BC2 and Paasche VL-1 airbrushes.*

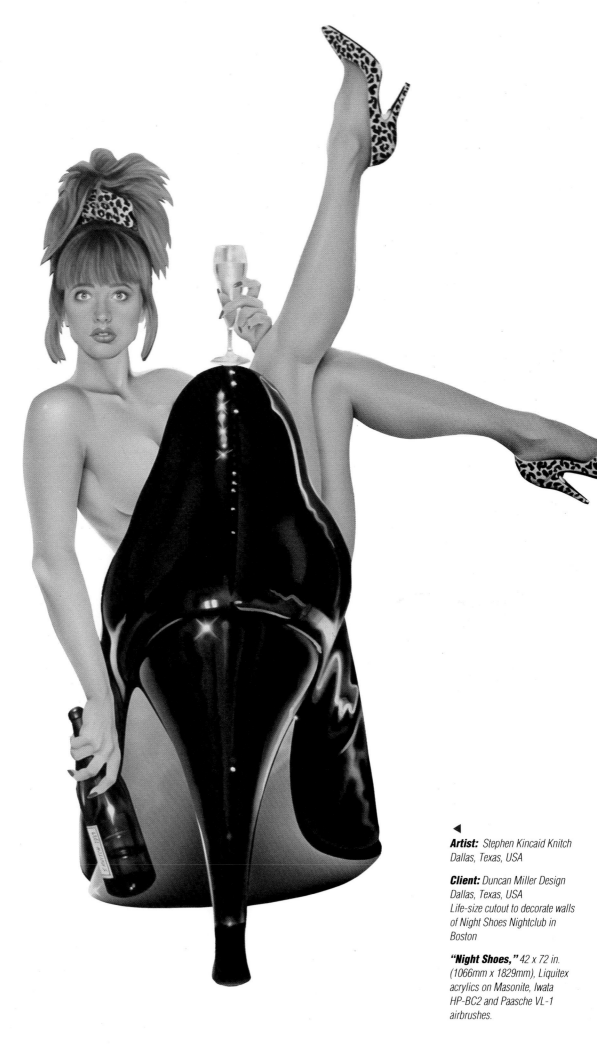

◀

**Artist:** Stephen Kincaid Knitch
Dallas, Texas, USA

**Client:** Duncan Miller Design
Dallas, Texas, USA
Life-size cutout to decorate walls
of Night Shoes Nightclub in
Boston

**"Night Shoes,"** 42 x 72 in.
(1066mm x 1829mm), Liquitex
acrylics on Masonite, Iwata
HP-BC2 and Paasche VL-1
airbrushes.

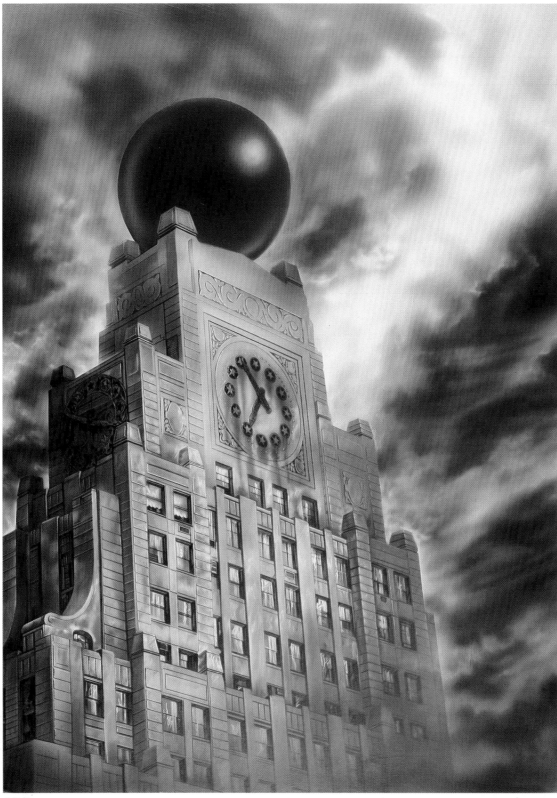

© T. Clauson.

▶
**Artist:** Mike Kammer
Duesseldorf, W. GER

**Client:** Capanina/Tommasini
Krefeld, W. GER
One of a series of eight pieces
used as wall decorations in a
restaurant promotion

**"Lobster,"** 19 3/4 x 27 1/2 in.
(500mm x 700mm), Schmincke
watercolors on Schoeller Parole
illustration board, EFBE A
airbrush. Combined with
handbrush work and colored
pencil.

◀
**Artist:** Thierry Clauson
Geneva, SWI

**Client:** von Laufen Architecte
Geneva, SWI
Architectural rendering

**"Rencontre"** (Meeting), 27 1/2
x 39 1/2 in. (700mm x 1000mm),
Winsor & Newton acrylics on
Contrecolle illustration board,
Paasche V#1 airbrush.

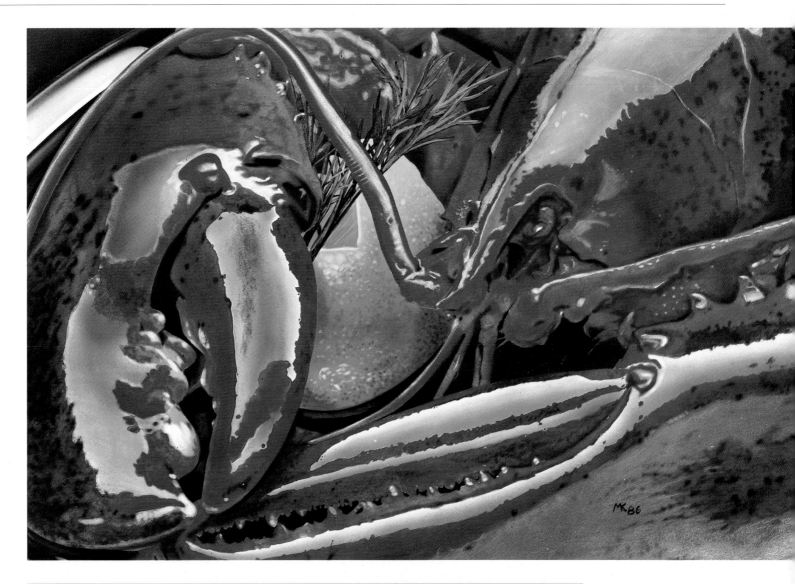

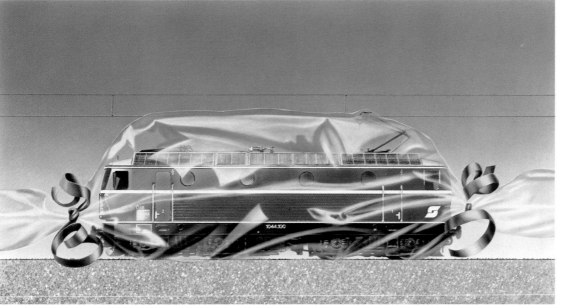

**Artist:** Mike Kammer
Duesseldorf, W. GER

**Client:** Oesterreichische
Bundesbahn
Vienna, AUS
Billboard and advertisement for
railway

**"Oesterreichische Bundesbahn"** (Federal
Austrian Railway), 19 3/4 x
27 1/2 in. (500mm x 700mm),
Schmincke DiaPhoto retouching
colors on Schoeller Parole
illustration board, EFBE A
airbrush.  Combined with
handbrush work and colored
pencils.

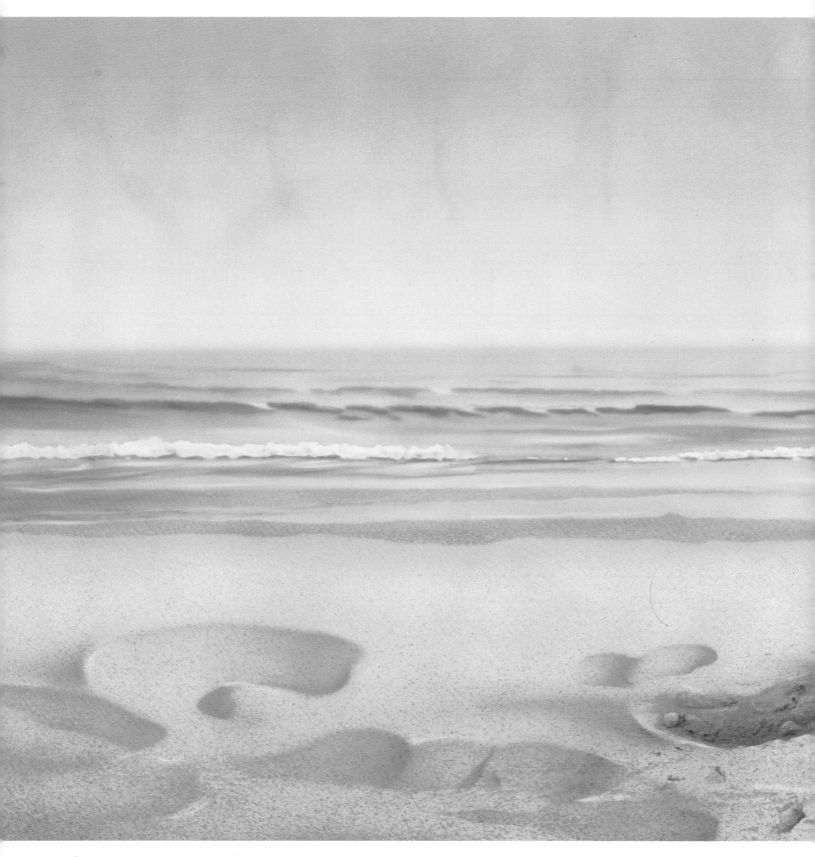

▲
**Artist:** *Kurt Jean Lohrum*
*Helsinki, FIN*

**Client:** *Helsingin Sanomat*
*Helsinki, FIN*
*Billboard promoting a*
*newspaper*

**"Newspaper at Summer,"**
*31 1/2 x 15 3/4 in. (800mm x*
*400mm), Schmincke DiaPhoto*
*retouching colors on*
*Schoellershammer 4G*
*illustration board, Grafo*
*(0.15mm nozzle) airbrush.*

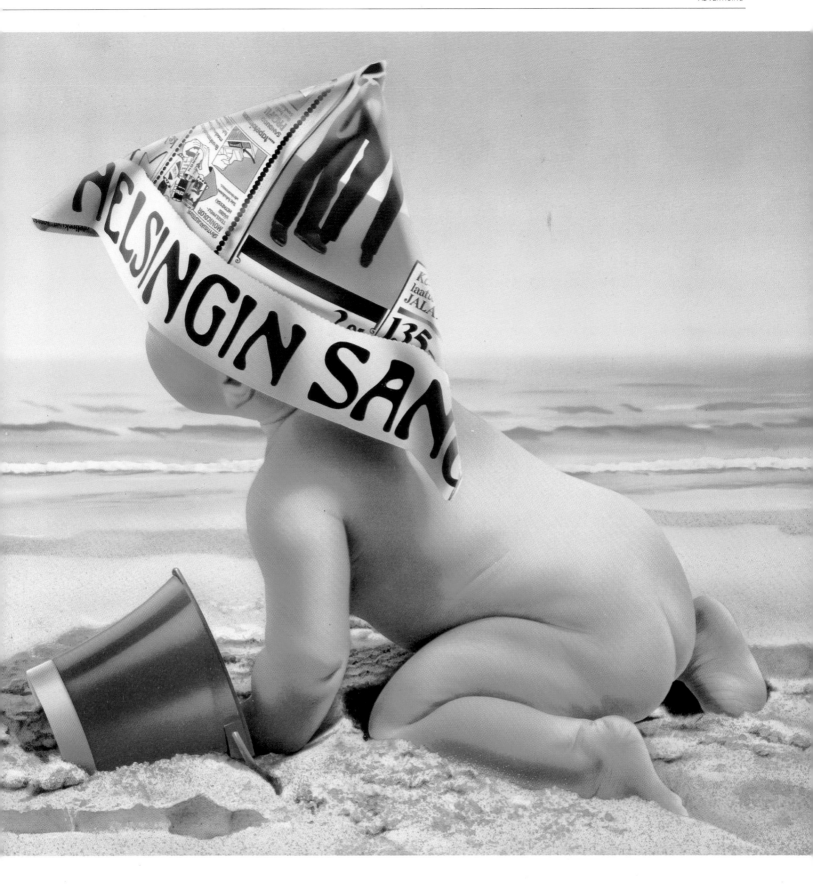

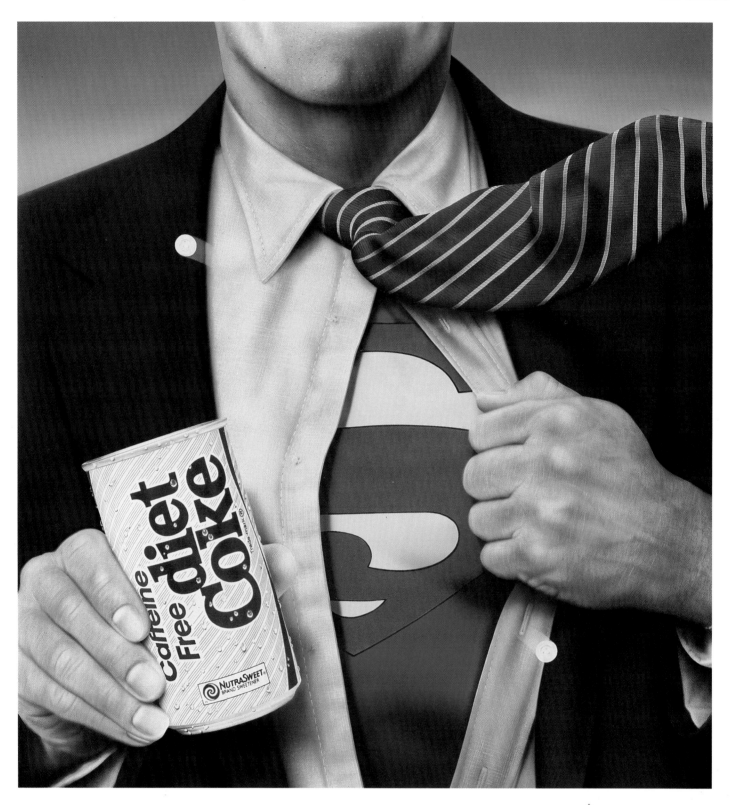

▲
**Artist:** *Peter R. Stallard*
*Drake, Colorado, USA*

**Client:** *Diet Coke*
*New York, New York, USA*
*Advertisement*

**"Superman,"** *30 x 40 in.*
*(762mm x 1016mm), Winsor &*
*Newton gouache on Frisk CS10*
*illustration board, Badger 100-*
*GXF and Paasche AB airbrushes.*

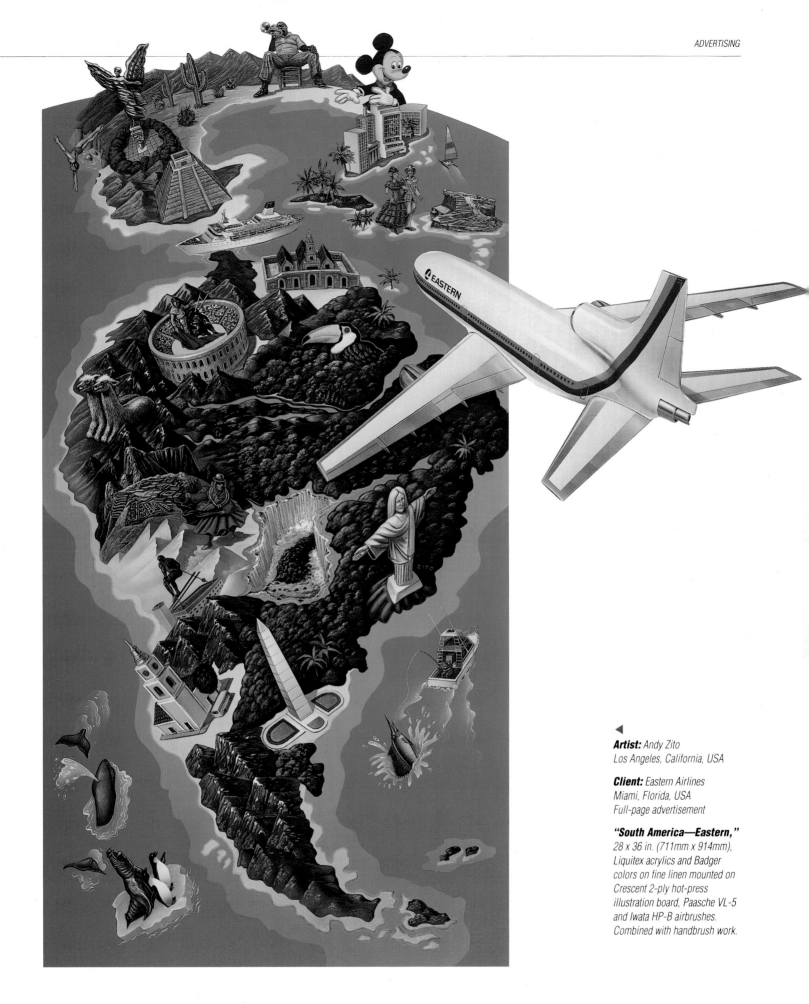

◄

**Artist:** *Andy Zito*
*Los Angeles, California, USA*

**Client:** *Eastern Airlines*
*Miami, Florida, USA*
*Full-page advertisement*

**"South America—Eastern,"**
*28 x 36 in. (711mm x 914mm),*
*Liquitex acrylics and Badger*
*colors on fine linen mounted on*
*Crescent 2-ply hot-press*
*illustration board, Paasche VL-5*
*and Iwata HP-B airbrushes.*
*Combined with handbrush work.*

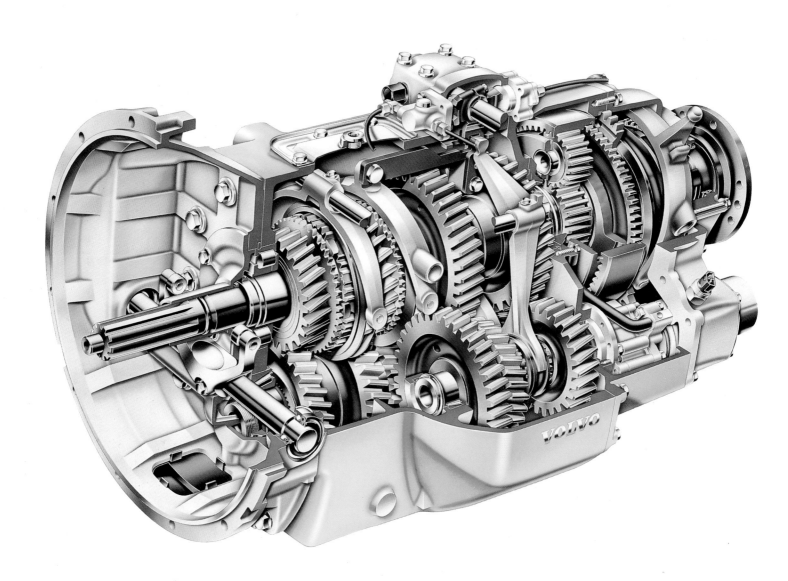

▲
**Artist:** *Roger Full*
*St. Ives, GBR*

**Client:** *Volvo Truck Corporation*
*Goteborg, SWE*
*Published on posters,*
*brochures, in magazines and*
*for exhibitions*

**"Volvo Gear Box,"** *25 1/2 x*
*17 in. (650mm x 430mm),*
*Badger Air Opaque Airbrush*
*Colors on Frisk CS10 illustration*
*board, DeVilbiss Aerograph*
*Super 63 airbrush.*

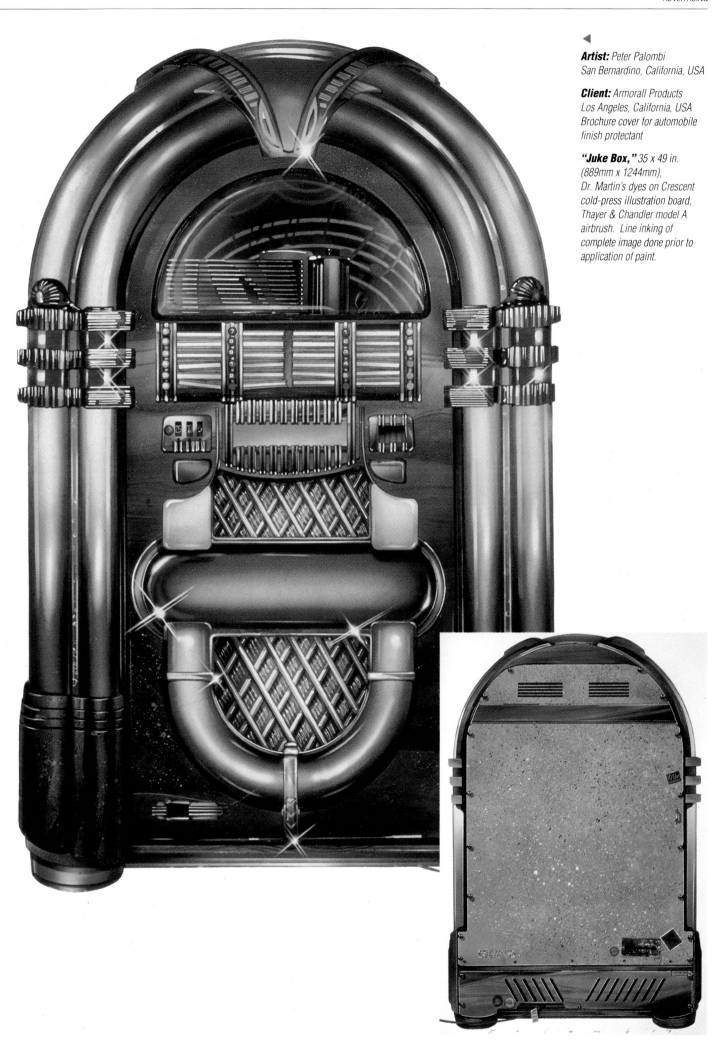

**Artist:** Peter Palombi
San Bernardino, California, USA

**Client:** Armorall Products
Los Angeles, California, USA
Brochure cover for automobile
finish protectant

**"Juke Box,"** 35 x 49 in.
(889mm x 1244mm),
Dr. Martin's dyes on Crescent
cold-press illustration board,
Thayer & Chandler model A
airbrush. Line inking of
complete image done prior to
application of paint.

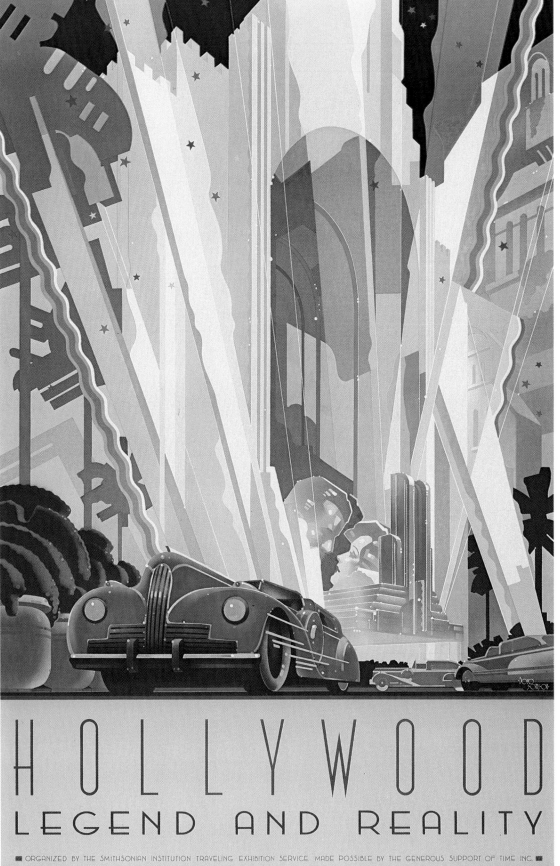

HOLLYWOOD
LEGEND AND REALITY

ORGANIZED BY THE SMITHSONIAN INSTITUTION TRAVELING EXHIBITION SERVICE. MADE POSSIBLE BY THE GENEROUS SUPPORT OF TIME INC.

◄

**Artist:** *Doug Johnson*
*New York, New York, USA*

**Client:** *Smithsonian Institution*
*Washington, District of*
*Columbia, USA*
*Poster promoting an exhibition*
*of Hollywood artifacts*

**"Hollywood, Legend and**
**Reality,"** *26 x 40 in. (660mm x*
*1016mm), Winsor & Newton*
*gouache on Crescent 100*
*illustration board, Thayer &*
*Chandler model A left-handed*
*airbrush. Combined with*
*handbrush work.*

►

**Artist:** *Ed Scarisbrick*
*Julian, California, USA*

**Client:** *Rose Parade*
*"Tournament of Roses"*
*Pasadena, California, USA*
*Program cover for the Rose*
*Parade*

**"Liberty,"** *15 x 17 in. (381mm*
*x 432mm), acrylics on hot-press*
*illustration board, Iwata C*
*airbrush.*

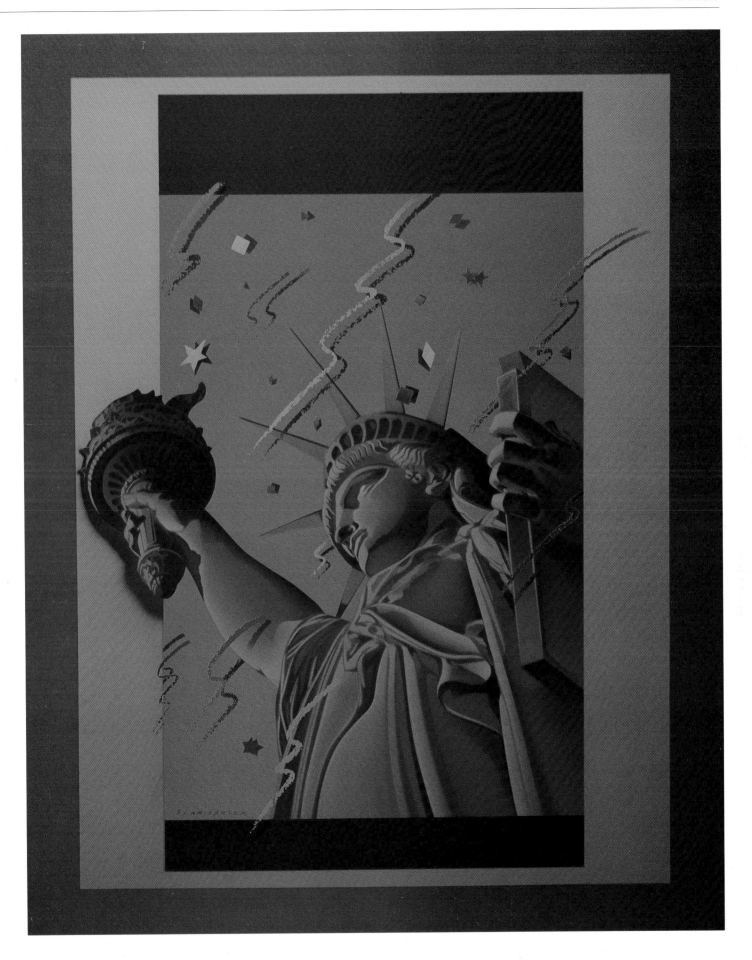

# EDITORIAL

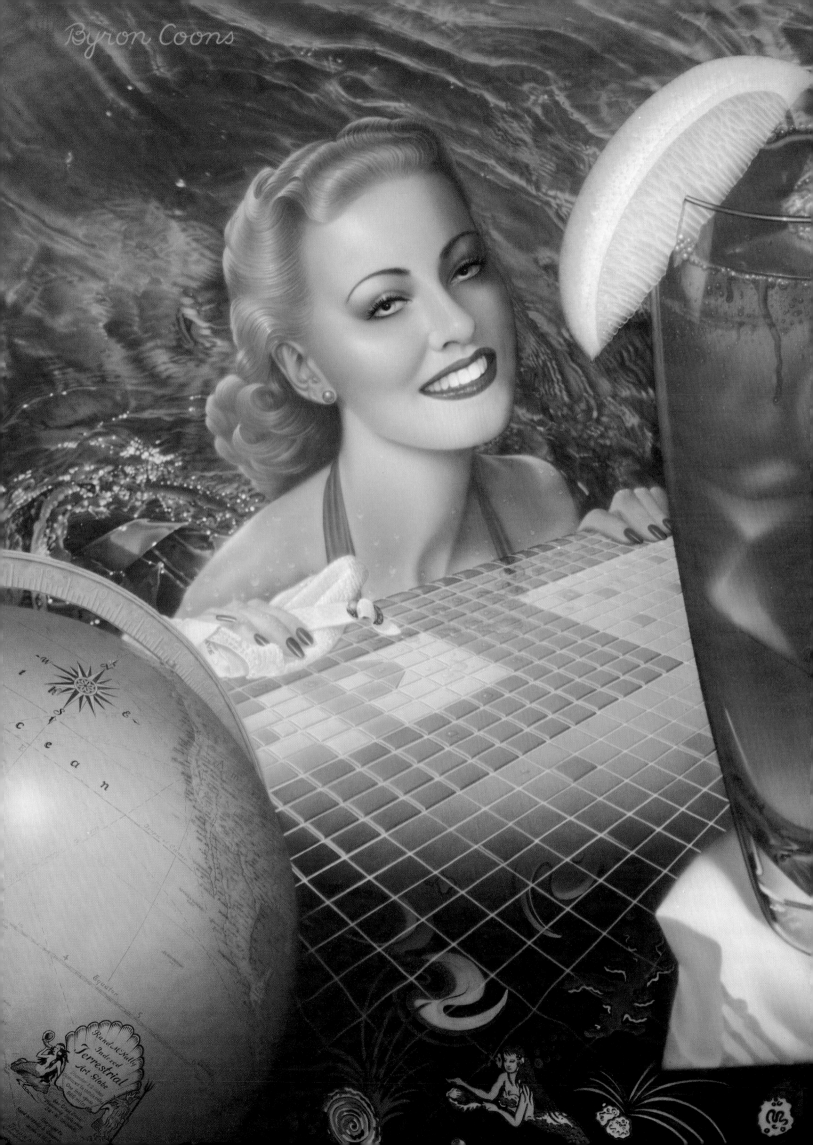

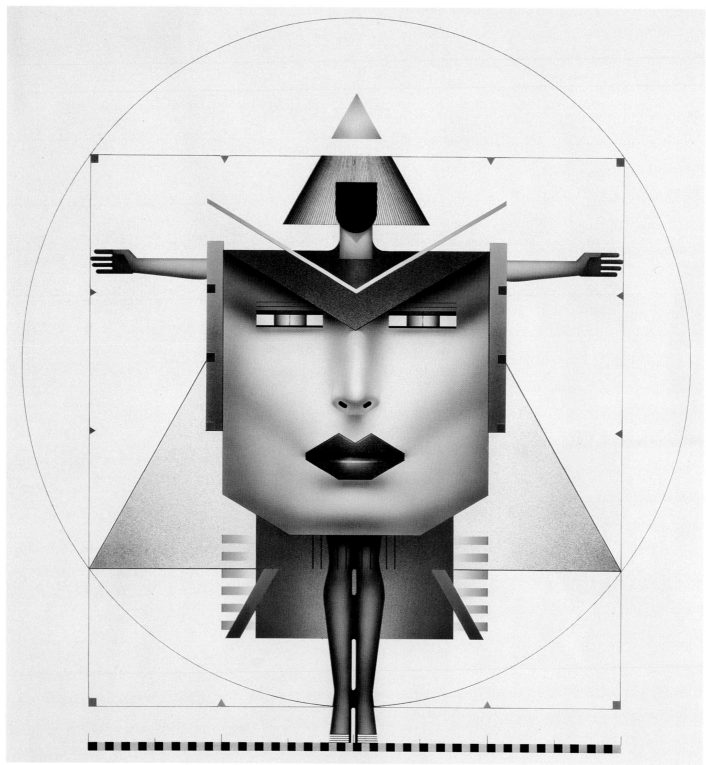

© 1988 Stanislaw Fernandes.

◀

**Artist:** Byron Coons
Palo Alto, California, USA

**Client:** Pomegranate
Publications, Inc.
Petaluma, California, USA
Notecard illustration

**"Pacifica,"** 30 x 40 in.
(762mm x 1016mm), Liquitex
Acrylics on Crescent 200 hot-
press illustration board, Paasche
AB, Paasche VL-5, and Iwata
HP-B airbrushes.

© 1986 Byron Coons.

▲

**Artist:** Stanislaw Fernandes
New York, New York, USA

**Client:** Stanislaw Fernandes
Design
New York, New York, USA

**"L.D.V. One,"** 21x 30 in.
(533mm x 762mm), Rotring
Artist Color on Frisk CS10
illustration board, DeVilbiss
airbrush.

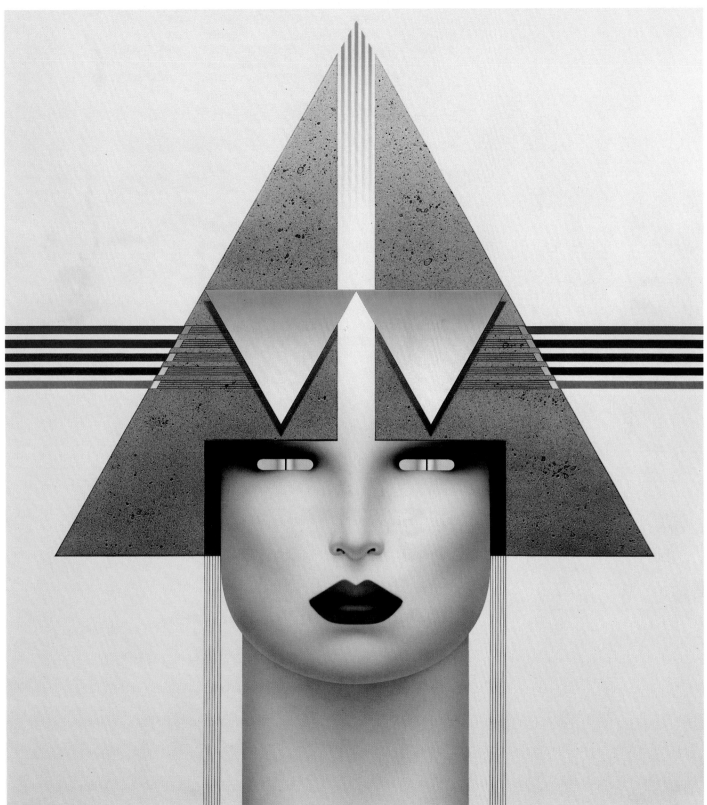

© 1988 Stanislaw Fernandes.

**Artist:** Stanislaw Fernandes
New York, New York, USA

**Client:** Stanislaw Fernandes
Design
New York, New York, USA

**"Pyramidal,"** 21 x 30 in.
(533mm x 762mm), Pelikan inks
and Flashe acrylics on Frisk
CS10 illustration board,
DeVilbiss airbrush.

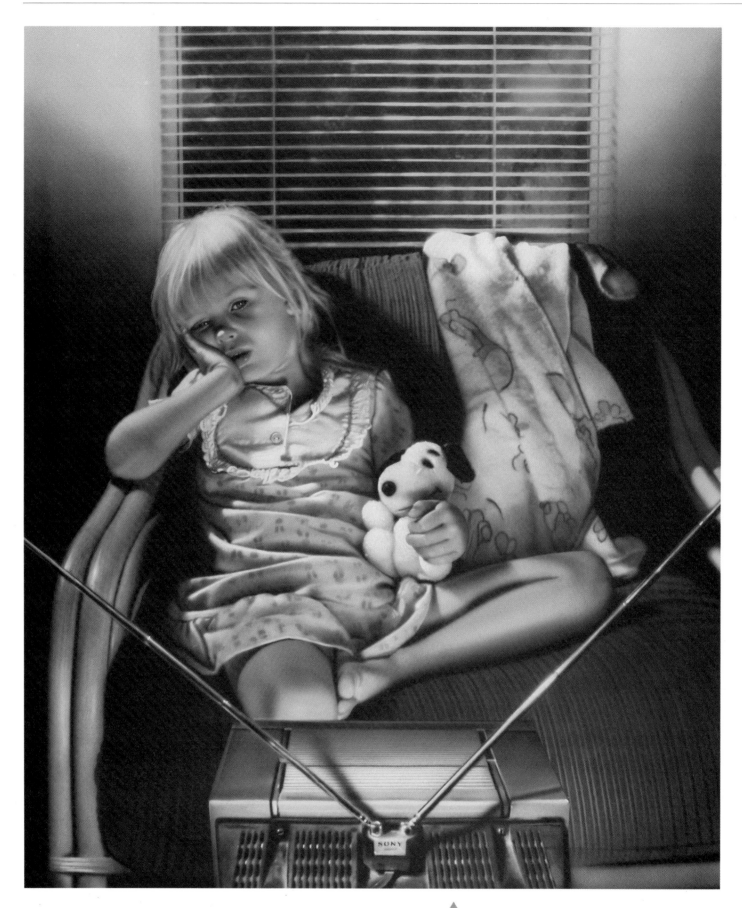

▲

**Artist:** *Stan Watts*
*Agoura Hills, California, USA*

**Client:** *Emmy Magazine*
*Los Angeles, California, USA*
*Cover illustration*

**"Boring TV Programming for Children,"** *16 x 24 in. (406mm x 609mm), Liquitex acrylics and Dr. Martin's dyes on Crescent hot-press illustration board, Iwata HP-B and Iwata HP-C airbrushes. Combined with dry brush and Prismacolor colored pencils.*

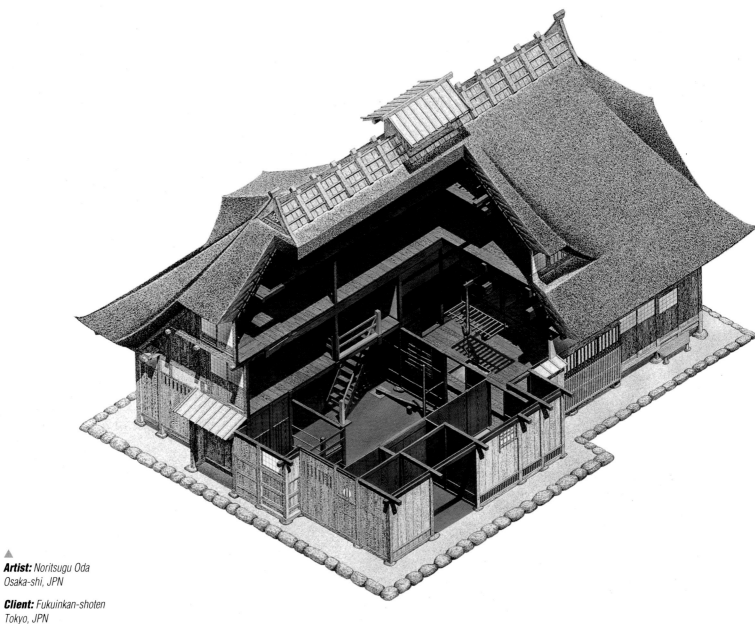

▲
**Artist:** *Noritsugu Oda*
*Osaka-shi, JPN*

**Client:** *Fukuinkan-shoten*
*Tokyo, JPN*
*Picture book illustration*

**"Old House in Japan,"** *40 1/2*
*x 28 3/4 in. (1030mm x 728mm),*
*Liquitex acrylics on Crescent*
*illustration board.*

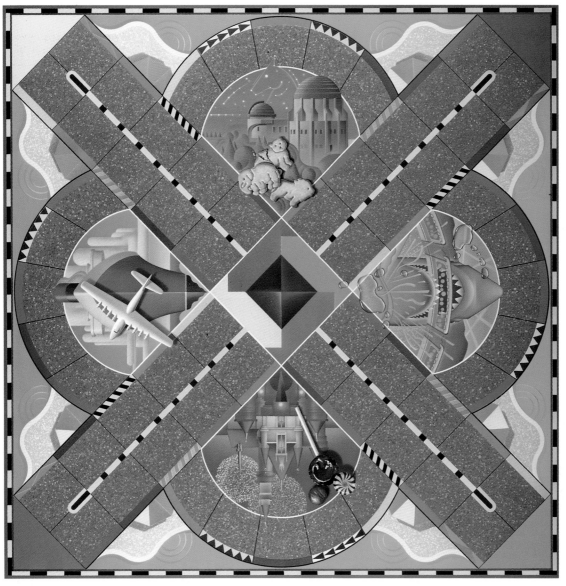

**Artist:** Cam DeLeon
West Los Angeles, California,
USA

**Client:** Mark Peach
California, USA
Game board illustration for pre-
school children's games,
unpublished

**Untitled,** 23 1/2 x 31 in.
(597mm x 787mm), Liquitex
acrylics on Crescent double
weight cold-press illustration
board, Iwata HP-C and Paasche
AB airbrushes.  Metallic ink grid
playing field was added
mechanically.

**Artist:** Cam DeLeon
West Los Angeles, California,
USA

**Client:** Ric and Ana Green
California, USA
Game board component to "Surf
Trip – The Board Game"

**"Surf Trip"** game board, each
image approximately 9 x 13 in.
(228mm x 330mm), assembled
to 19 x 19 in. (482mm x
482mm) square game board,
Liquitex acrylics on Strathmore
3-ply illustration board, Paasche
AB and Iwata HP-C airbrushes.
Combined with handbrush work.

**Artist:** Cam DeLeon
West Los Angeles, California,
USA

**Client:** American Cities Ltd.
Studio City, California, USA
Game board illustration

**"L.A. Game"** Board, 30 x 30 in.
(762mm x 762mm), Liquitex
acrylics on Crescent double
weight cold-press illustration
board, Iwata HP-C and Paasche
AB airbrushes.

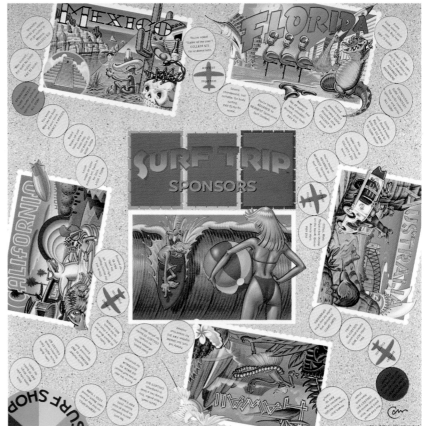

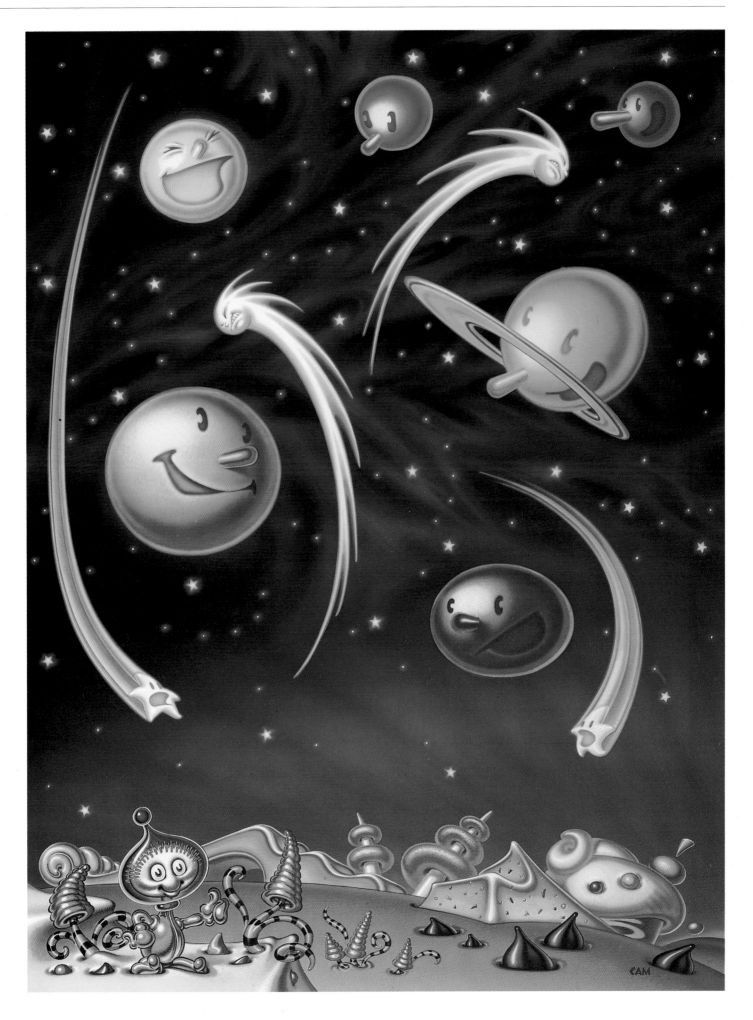

▶
**Artist:** *Guerrino Boatto*
*Mestre, Venice, ITA*

**Client:** *Guerrino Boatto*
*Mestre, Venice, ITA*
*Illustration for self-published*
*calendar*

**"Caramella,"** *13 3/4 x*
*19 3/4 in. (350mm x 500mm),*
*Liquitex acrylics on*
*Schoellershammer illustration*
*board, Paasche V#1 airbrush.*
*Combined with handbrush work.*

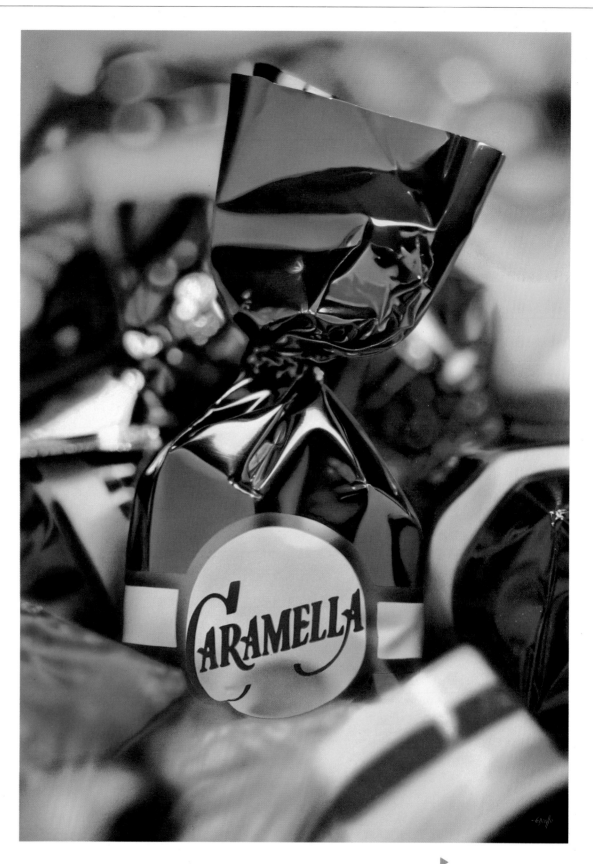

▶
**Artist:** *Guerrino Boatto*
*Mestre, Venice, ITA*

**Client:** *Guerrino Boatto*
*Mestre, Venice, ITA*
*Illustration for self-published*
*calendar*

**Untitled,** *23 1/2 x 35 1/2 in.*
*(600mm x 900mm), Liquitex*
*acrylics on Schoellershammer*
*illustration board, Paasche V#1*
*airbrush. Combined with*
*handbrush work.*

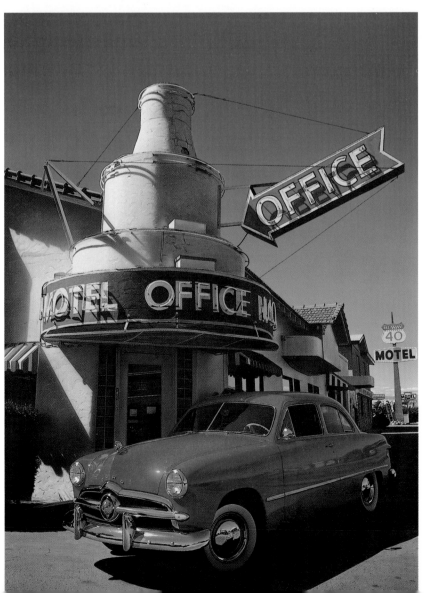

**Artist:** Guerrino Boatto
Mestre, Venice, ITA

**Client:** Guerrino Boatto
Mestre, Venice, ITA
Illustration for self-published
calendar

**Untitled,** 19 3/4 x 27 1/2 in.
(500mm x 700mm), Liquitex
acrylics on Schoellershammer
illustration board, Paasche V#1
airbrush.  Combined with
handbrush work.

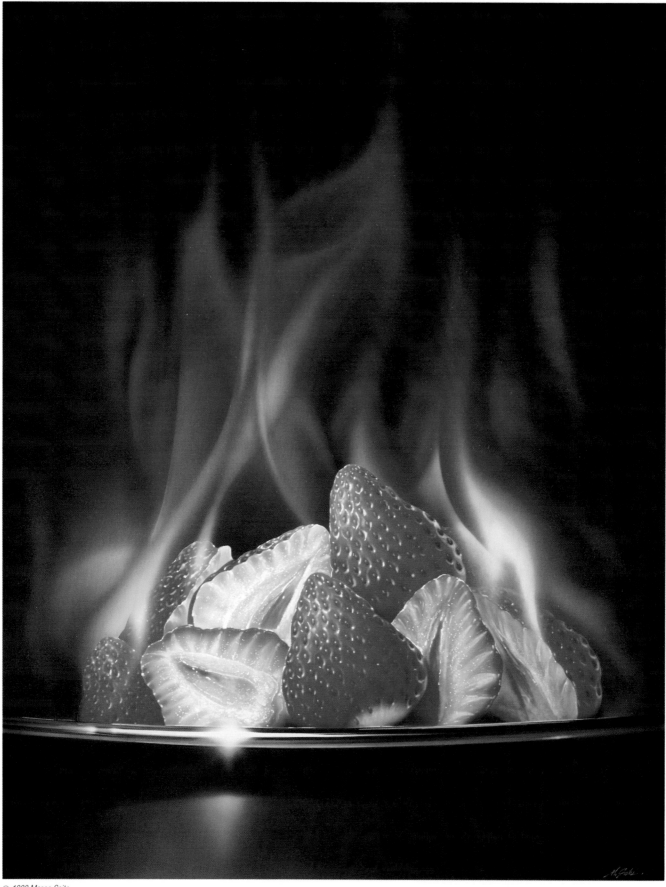

▲

**Artist:** *Masao Saito*
*Kawasaki-shi, JPN*

**Client:** *Bijutsu Shuppan-sha*
*Tokyo, JPN*
*Fine arts book cover*

**"Strawberries for Dessert,"**
*161/4 x 20 in. (410mm x
530mm), Liquitex acrylics and
gouache on illustration board,
Yaezaki airbrush.*

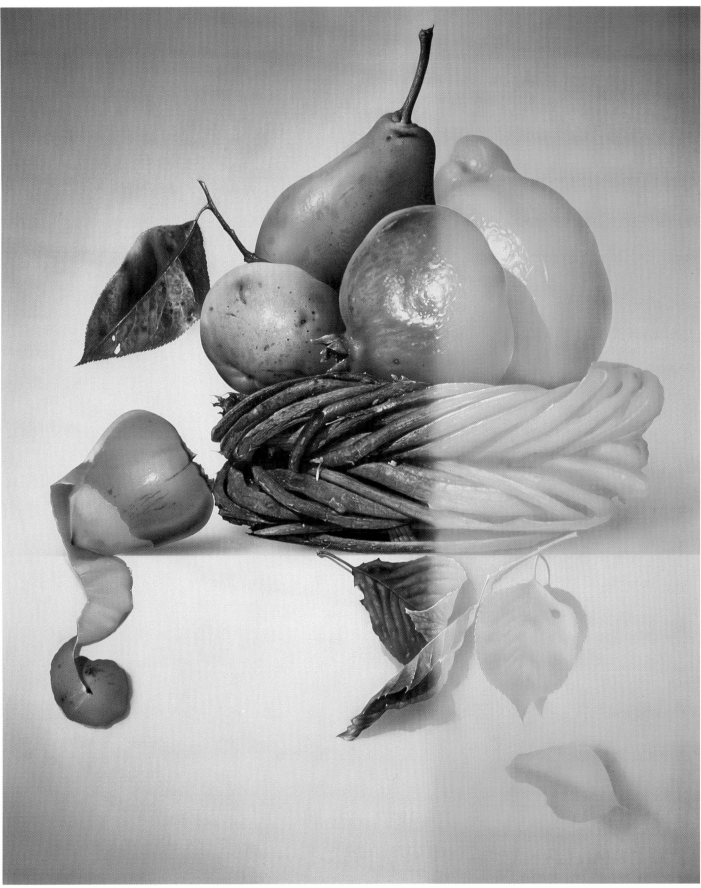

▲

**Artist:** *Masao Saito*
*Kawasaki-shi, JPN*

**Client:** *Bijutsu Shuppan-sha*
*Tokyo, JPN*
*Fine arts magazine article*

**"Autumn Harvest,"** *233/4 x
281/2 in. (606mm x 727mm),
Liquitex acrylics and gouache on
illustration board, Yaezaki
airbrush.*

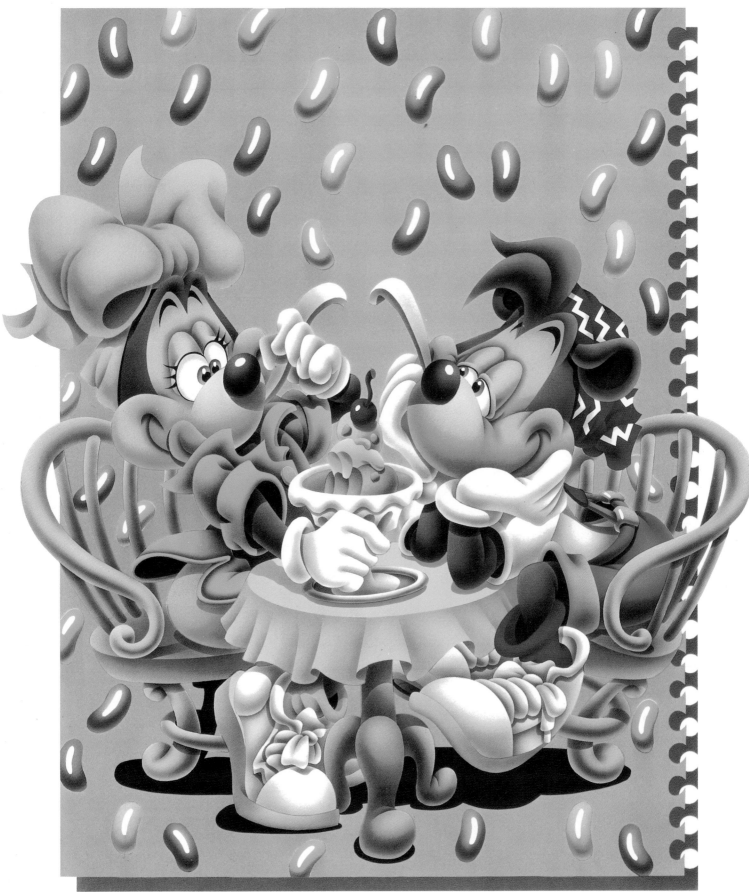

**Artist:** *Susumu Matsushita*
*Tokyo, JPN*

**Client:** *Shueisha*
*Shibuya-ku, Tokyo, JPN*
*Cover for a monthly comics*
*magazine for teens*

**"A Little in Love 'Bears
Club',"** *14 1/4 x 20 1/4 in.
(364mm x 515mm), Winsor &
Newton color ink and Holbein
color ink on Crescent 205
illustration board, Olympos
100B airbrush.*

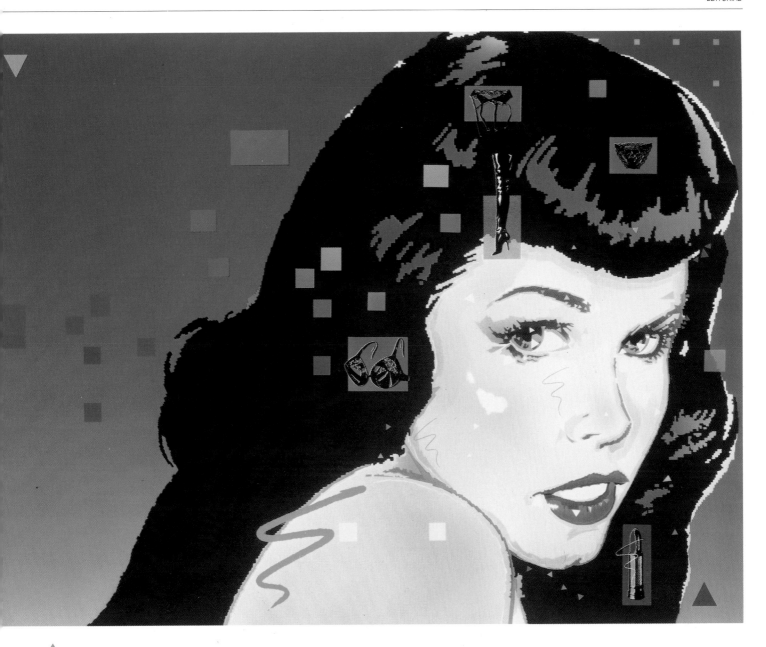

**Artist:** David Willardson
Glendale, California, USA

**Client:** L.A.X. Magazine
Los Angeles, California, USA
Feature story illustration of
former pin-up model in premiere
issue of Language, Art,
Expression magazine

**"Betty Page,"** 20 x 30 in.
(508mm x 762mm), Liquitex
acrylics on Strathmore
illustration board, Iwata HP-C
airbrush. Combined with
Chromatec dry transfer colors.

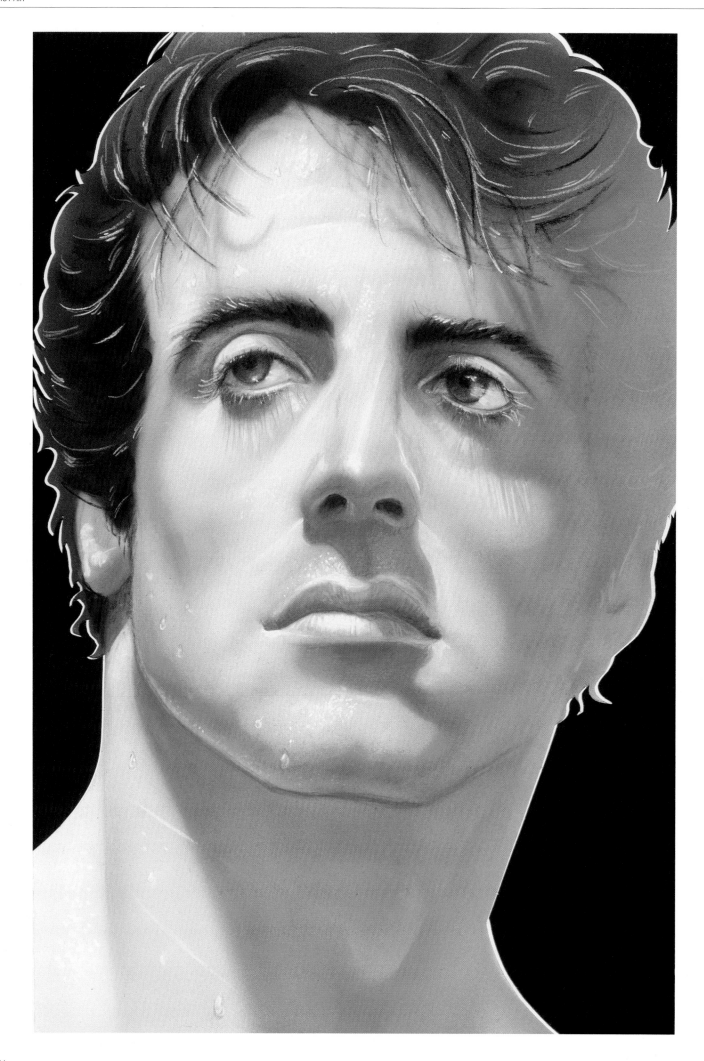

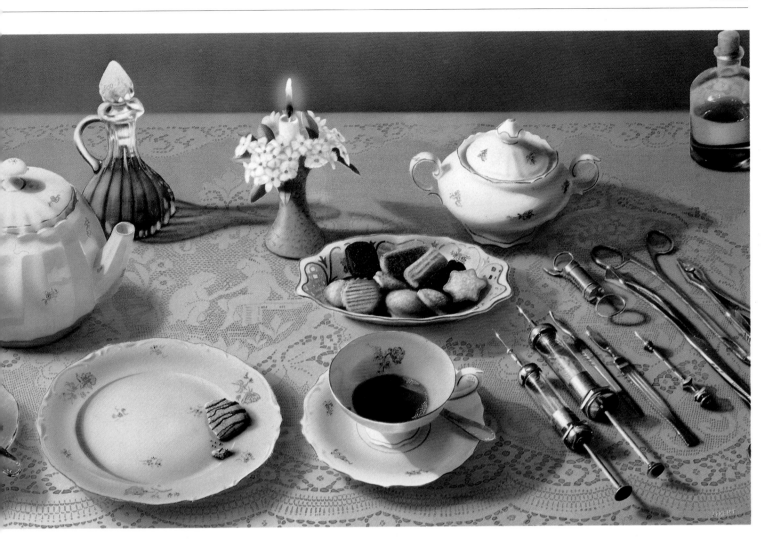

▲
**Artist:** *Rainer Ekkert*
*Essen, W. GER*

**Client:** American Express
*Magazine*
*Frankfurt am Main, W. GER*
*Short story spread*

**"Die Wirtin"** *(The Waitress),*
*19 3/4 x 27 1/2 in. (500mm x*
*700mm), Schmincke Aerocolor*
*on Zanders Parole illustration*
*board, EFBE and Iwata*
*airbrushes.*

◄
**Artist:** *Richard Bernstein*
*New York, New York, USA*

**Client:** Interview
*New York, New York, USA*
*Magazine cover*

**"Stallone,"** *11 x 14 in.*
*(279mm x 356mm), acrylics on*
*illustration board. Airbrush*
*combined with photostat, pastel,*
*and crayon.*

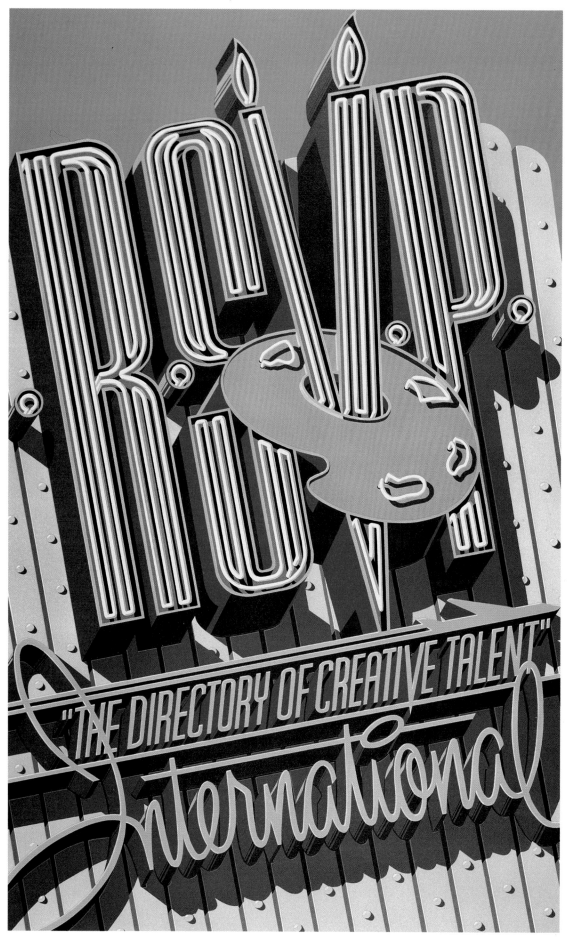

**Artist:** *Tom Nikosey*
*Bell Canyon, California, USA*

**Client:** *RSVP Inc.*
*Brooklyn, New York, USA*
*Book cover*

**"RSVP #8,"** *16 x 20 in.
(406mm x 508mm), Liquitex
acrylics on Crescent cold-press
illustration board,
Thayer & Chandler Model A
airbrush.*

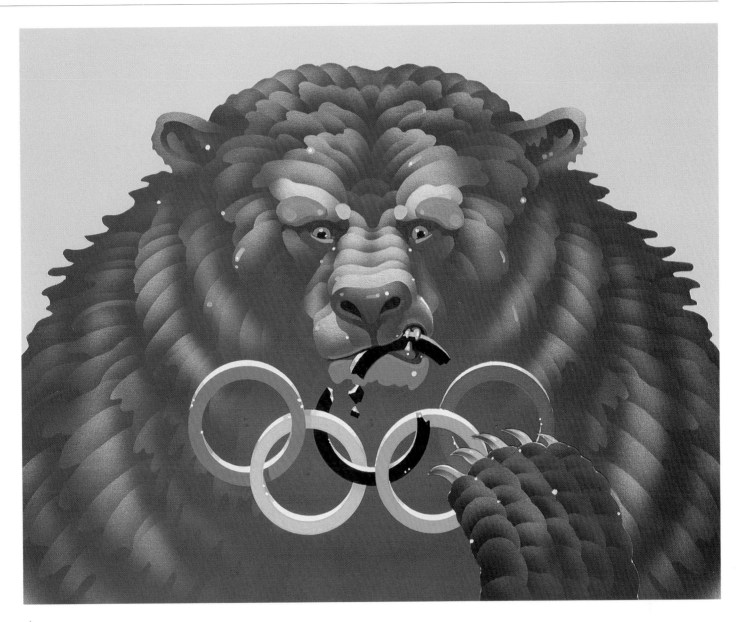

▲
**Artist:** *Doug Johnson*
*New York, New York, USA*

**Client:** *Time Life, Inc.*
*New York, New York, USA*
*Cover illustration for Time magazine*

**"Olympic Bear,"** *11x 18 in. (279mm x 457mm), Winsor & Newton gouache on Crescent 100 illustration board, Thayer & Chandler model A left-handed airbrush. Combined with handbrush work.*

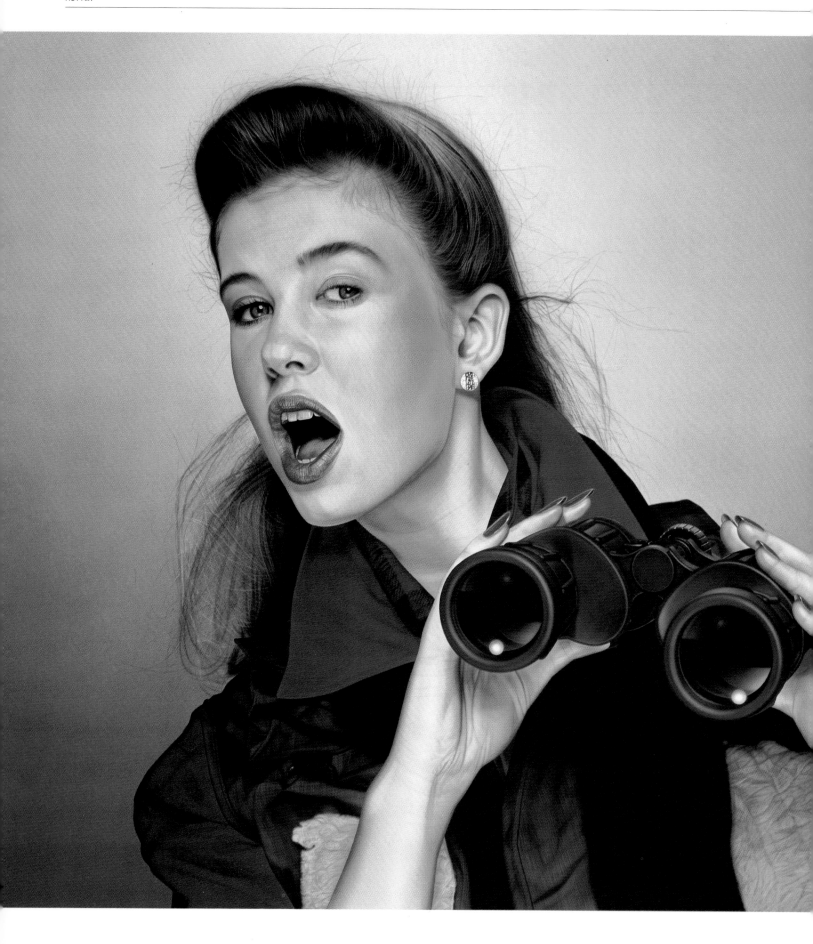

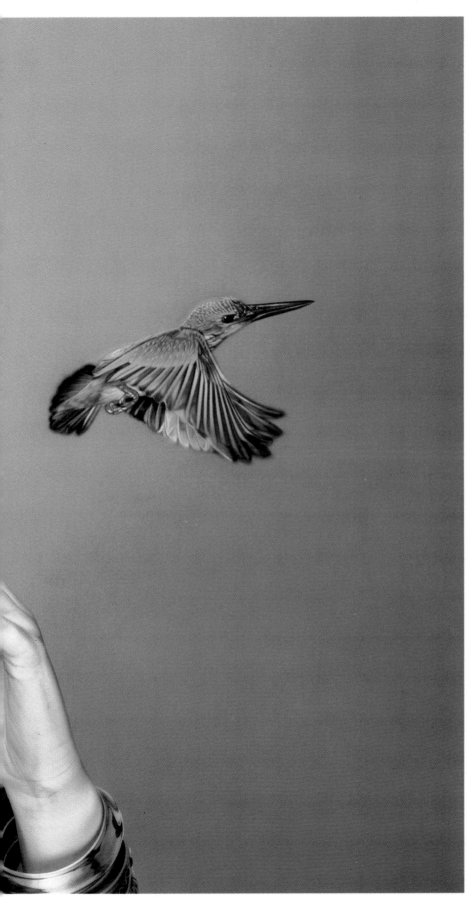

**Artist:** *Toshikunu Okubo*
*Shinjuku-ku, Tokyo, JPN*

**Client:** *Geol Cosmetics*
*Company, Ltd.*
*Osaka-shi, JPN*
*Calendar illustration*

**Untitled,** *20 1/4 x 28 3/4 in.*
*(515mm x 728mm), Holbein*
*watercolors and Bonny acrylics*
*on Crescent 205 illustration*
*board, Hohmi Y-1, Hohmi Y-3,*
*and Hohmi Y-5 airbrushes.*
*Combined with handbrush work*
*and colored pencil.*

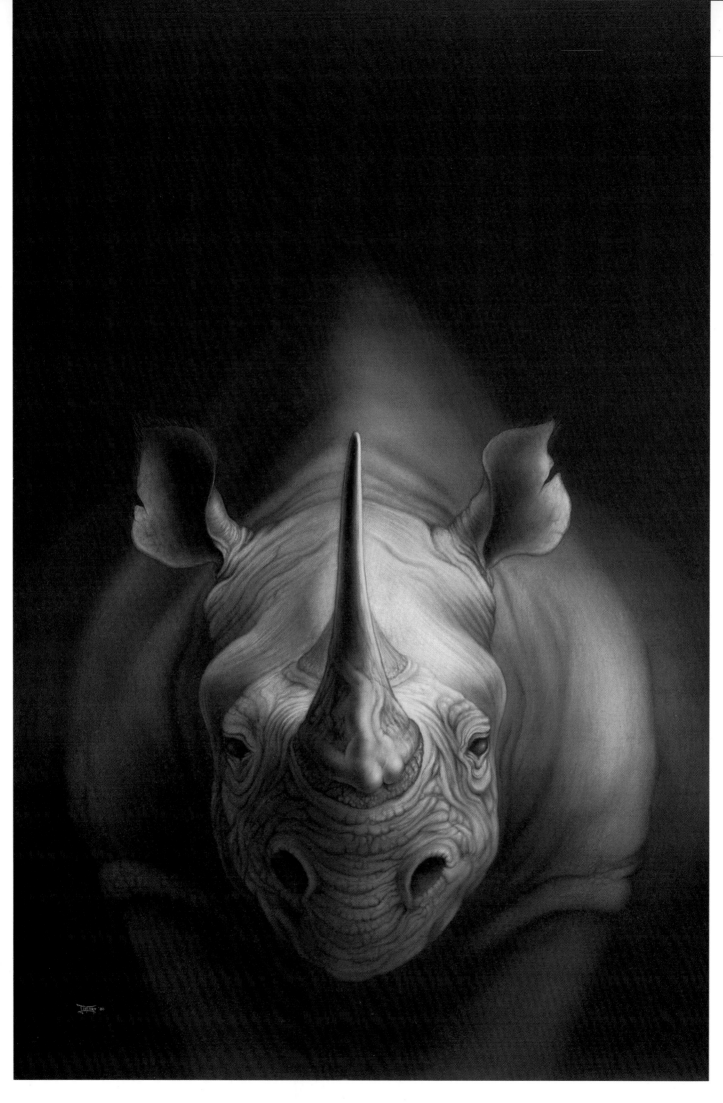

**Artist:** *Jerry LoFaro*
*New York, New York, USA*

**Client:** *Viking Penguin*
*New York, New York, USA*
*Book cover*

**"Appleby and the Ospreys,"**
*12 x 18 in. (305mm x 457mm),*
*Liquitex acrylics on synthetic*
*canvas mounted to Masonite,*
*Paasche AB and Paasche VL*
*airbrushes. Combined with*
*photocopy transferred onto*
*canvas.*

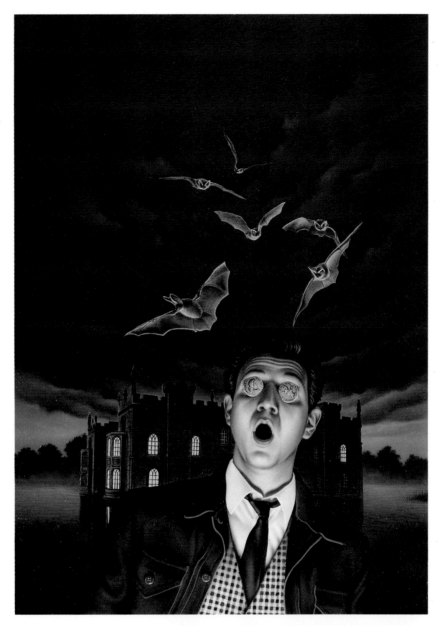

**Artist:** *Jerry LoFaro*
*New York, New York, USA*

**Client:** *Omni magazine*
*New York, New York, USA*
*Magazine illustration for article*
*on rhinoceros hunting*

**"Legend,"** *24 x 36 in. (609mm*
*x 914mm), Liquitex acrylics on*
*stretched canvas, Paasche AB*
*and Paasche VL airbrushes.*
*Image rendered entirely*
*freehand.*

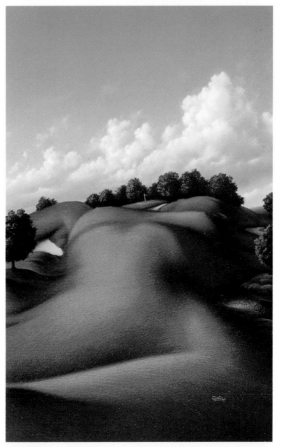

**Artist:** *Jerry LoFaro*
*New York, New York, USA*

**Client:** *Bantam*
*New York, New York, USA*
*Book cover*

**"Rub of The Green,"** *12 x*
*17 in. (304mm x 432mm),*
*Liquitex acrylic on Arches*
*140-lb. watercolor paper*
*mounted on Masonite, Paasche*
*AB and Badger 150 airbrushes.*

▶

**Artist:** *Todd Schorr*
*Roxbury, Connecticut, USA*

**Client:** *Crown Publishers, Inc.*
*New York, New York, USA*
*Book illustration for* The Saga of
Baby Devine

**"Baby Devine in Garden,"**
*15 x 30 in. (381mm x 762mm),*
*Winsor & Newton gouache on*
*Crescent illustration board,*
*Thayer & Chandler model A*
*airbrush. Combined with dry*
*brush.*

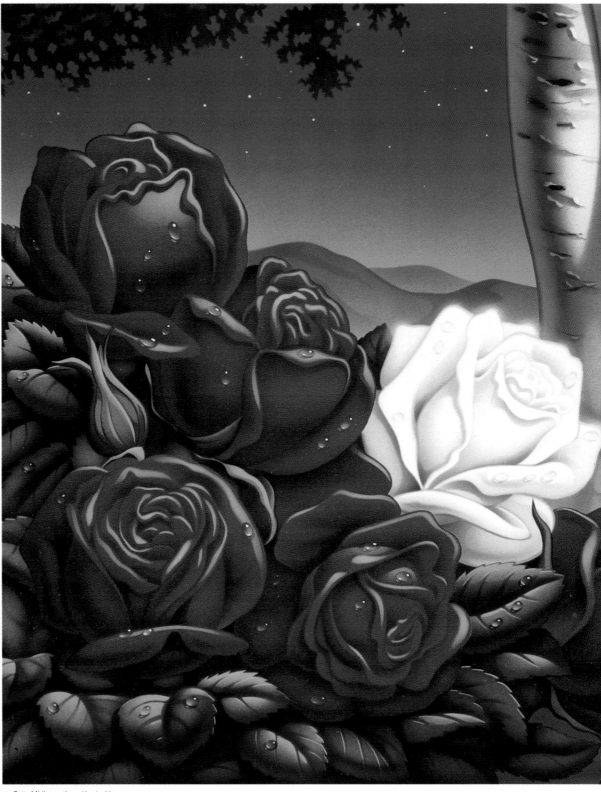

© Bette Midler, author. Used with
permission of Crown Publishers, Inc.

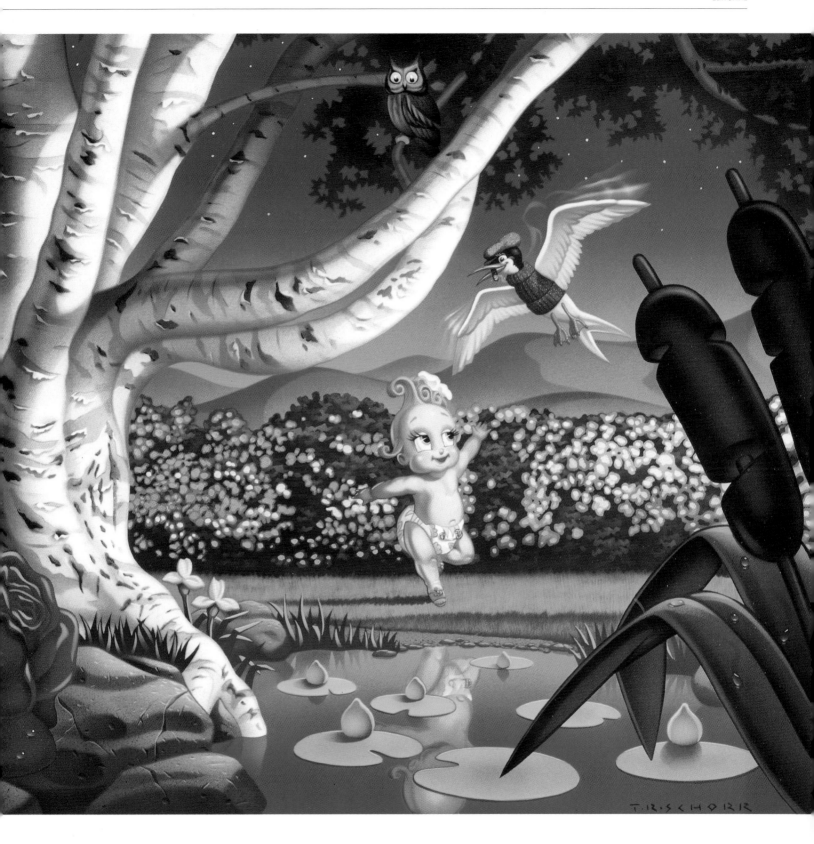

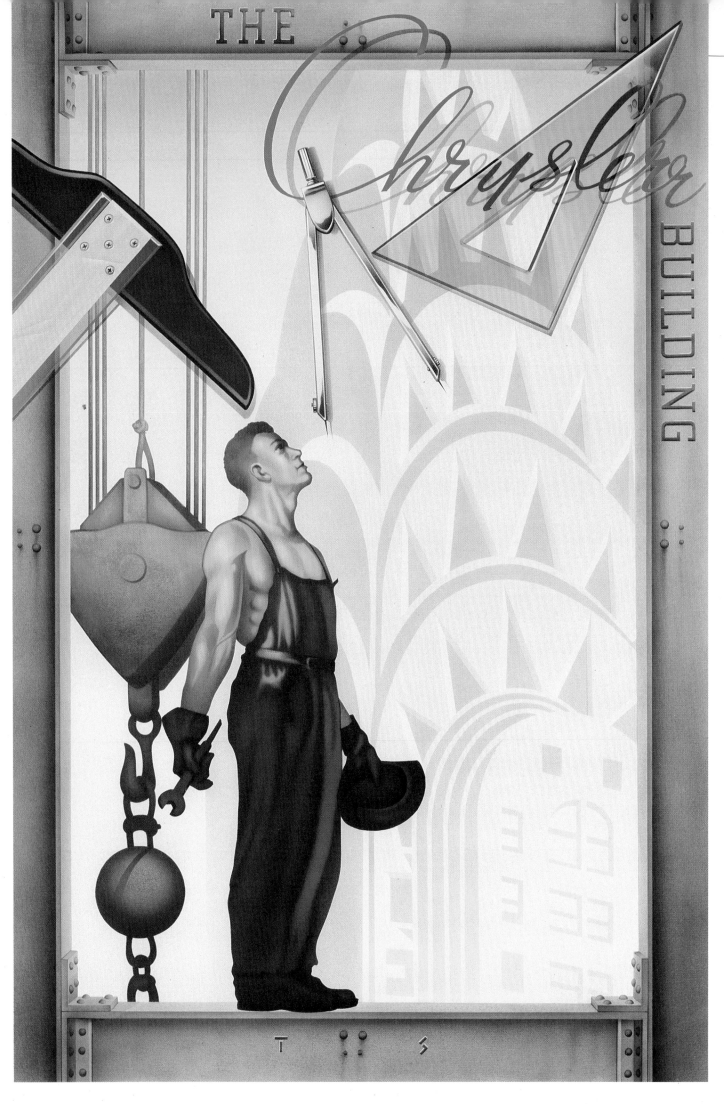

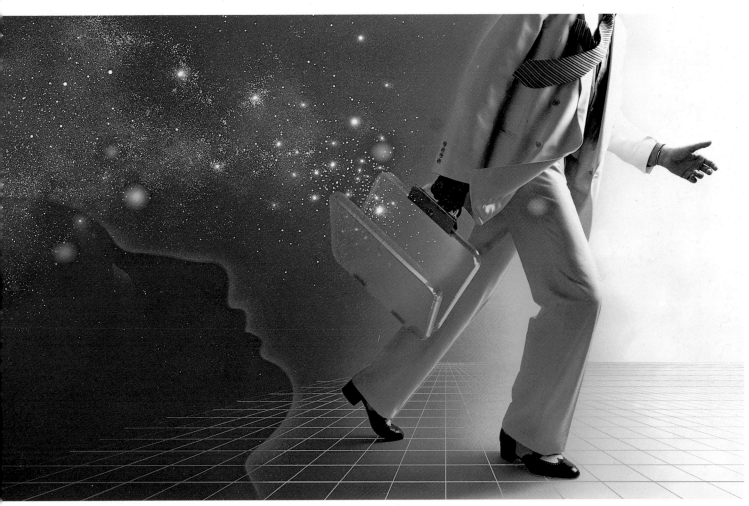

© Art Studio, Ri Kaiser.

**Artist:** Ri Kaiser
Hamburg, W. GER

**Client:** Zeit Magazine
Hamburg, W. GER
Magazine spread on dreaming

**"Blauer Traum 1"** (Blue
Dream 1), 11 3/4 x 15 3/4 in.
(300mm x 400mm), retouching
colors on illustration board,
Grafo airbrushes (0.15mm and
0.30mm nozzles).

**Artist:** Todd Schorr
Roxbury, Connecticut, USA

**Client:** Paper Moon Graphics
Los Angeles, California, USA
Greeting Card

**"Chrysler Building,"** 16 x 24
in. (406mm x 609mm), Dr.
Martin's dyes on Crescent
illustration board, Thayer &
Chandler airbrush. Combined
with handbrush work and
colored pencil.

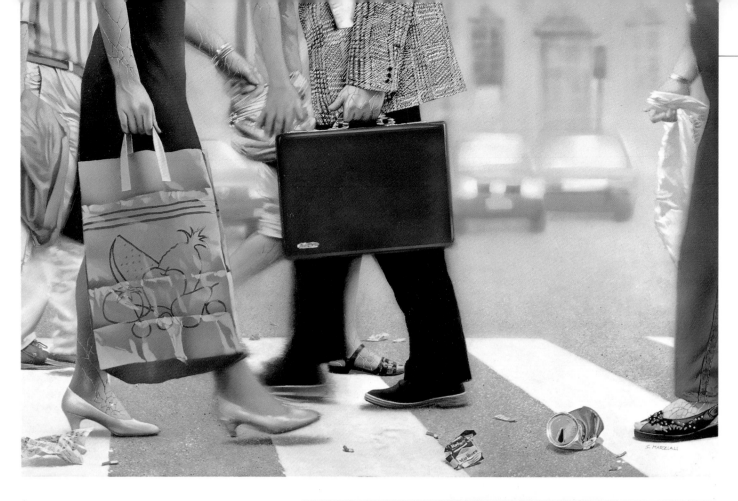

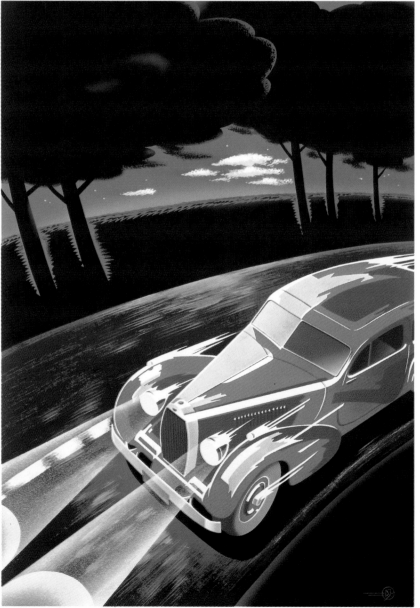

**Artist:** *Sandra Marziali*
*Rome, ITA*

**Client:** *Playboy Magazine*
*Rome, ITA*

**"Stress,"** *28 x 18 1/2 in. (710mm x 470mm), Liquitex acrylics on Zanders Parole illustration board, Iwata HP-C airbrush. Combined with handbrush work.*

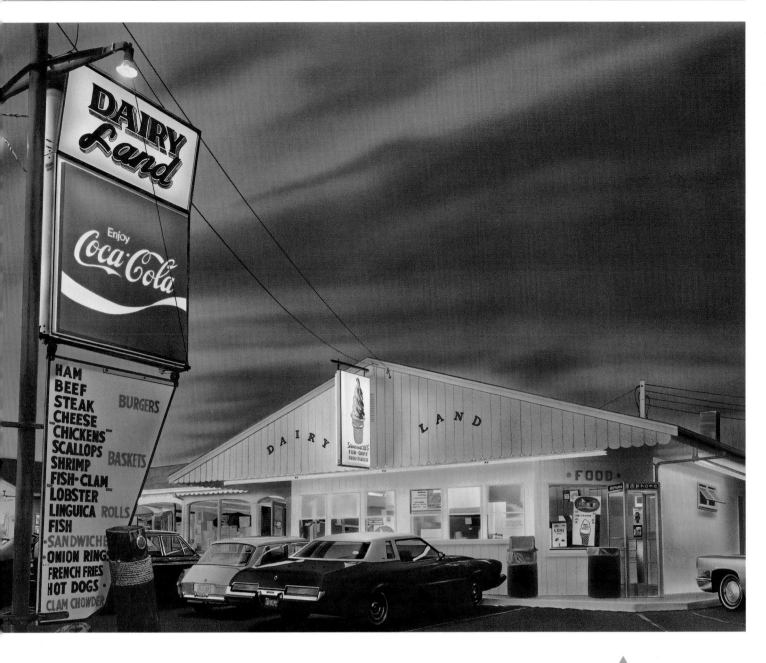

**Artist:** Mike Kammer
Duesseldorf, W. GER

**Client:** Goldman Verlag
Munich, W. GER
Book cover for German version
of American Dad, by Tama
Janowitz

*"Dairy-Land,"* 19 3/4 x
27 1/2 in. (500mm x 700mm),
Schmincke watercolors on
Schoellers Parole illustration
board, EFBE A airbrush.
Combined with handbrush work
and colored pencil.

**Artist:** David Juniper
London, GBR

**Client:** Chatto & Windus
London, GBR
Book cover

*"The Beast Must Die"* 10 x
15 in. (254mm x 381mm),
gouache and acrylics on Frisk
CS10, DeVilbiss Aerograph
Super 63 airbrush. Combined
with handbrush work and
textured materials.

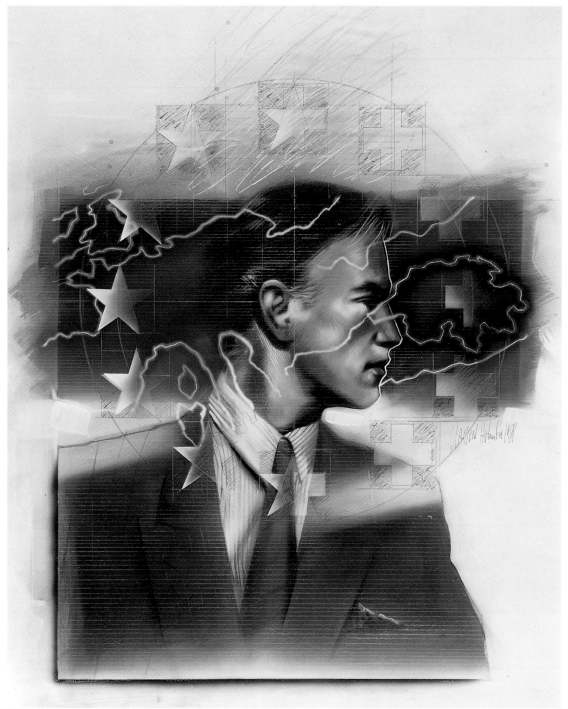

© T. Clauson.

**Artist:** Ken Westphal
Prairie Village, Kansas, USA

**Client:** KANU
Lawrence, Kansas, USA
Magazine cover and limited
edition print for National Public
Radio Station subscribers

**"George Gershwin,"** 12 x
18 in. (305mm x 457mm),
Dr. Martin's Spectralite acrylics
and Winsor & Newton gouache
on Crescent 215 illustration
board, Paasche AB and Thayer &
Chandler A airbrushes.

**Artist:** Thierry Clauson
Geneva, SWI

**Client:** Fides
Geneva, SWI

**"EUROPE & switzerland,"**
14 1/2 x 23 1/2 in. (368mm x
597mm), Winsor & Newton
acrylics on Contrecolle
illustration board, Paasche V#1
airbrush.

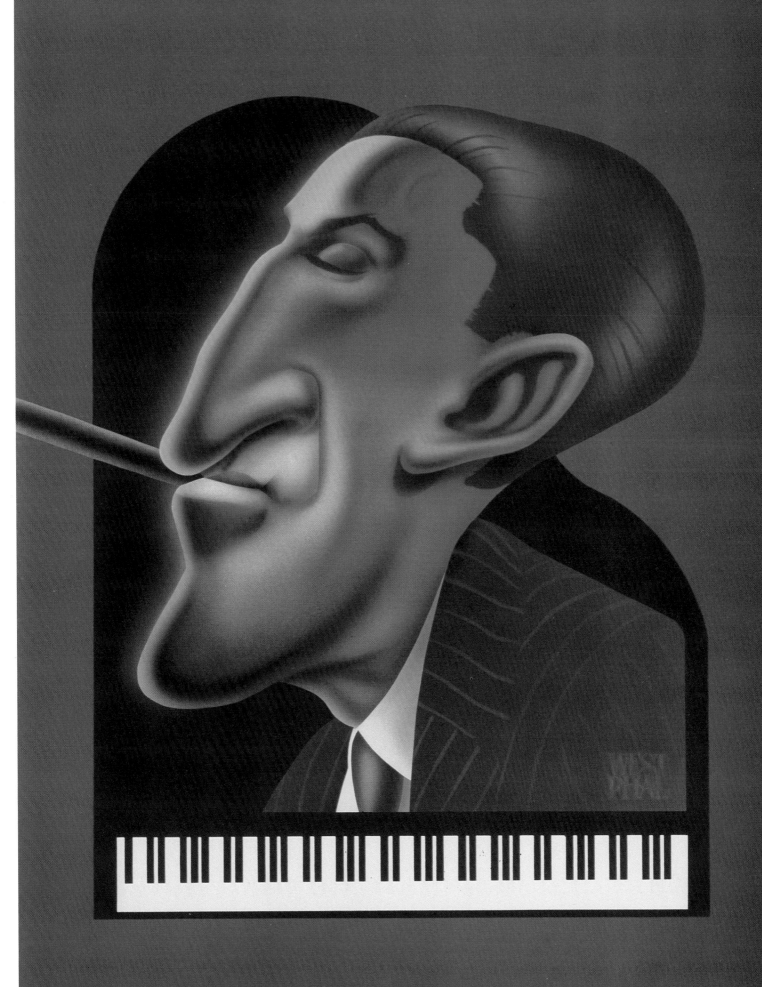

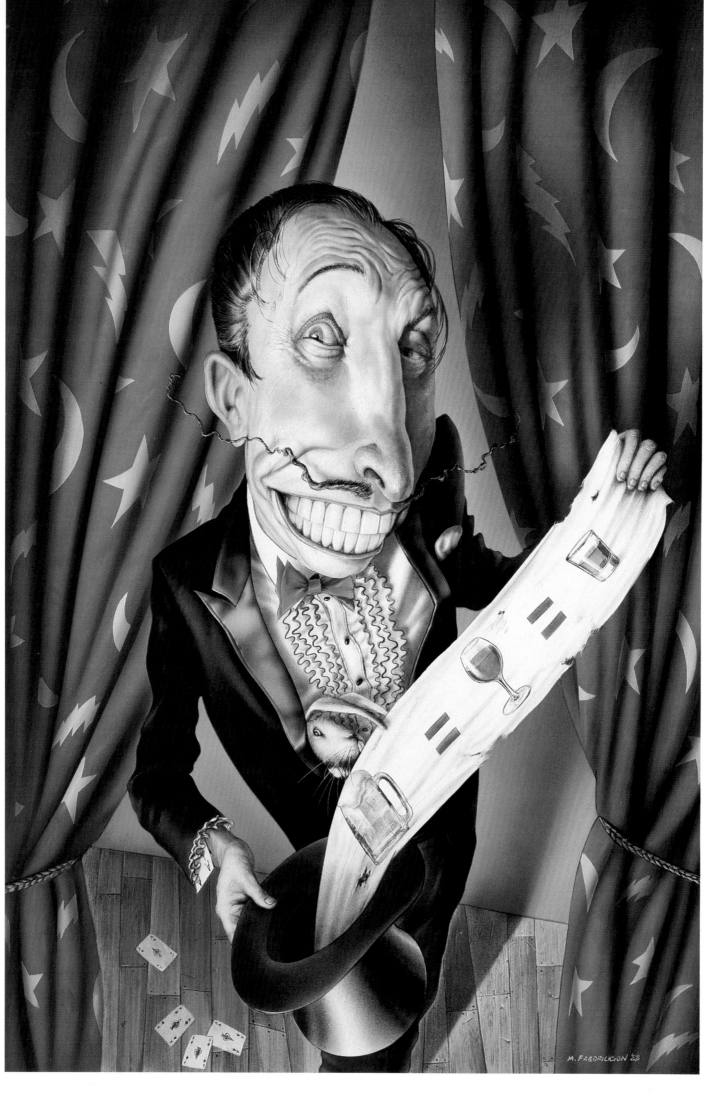

M. FREDRICKSON '98

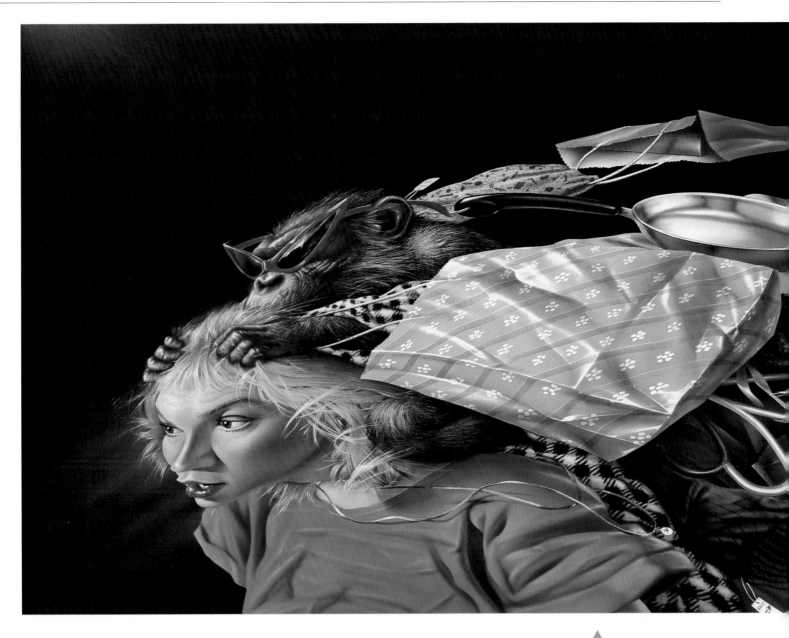

**Artist:** Mark A. Fredrickson
Tucson, Arizona, USA

**Client:** Arizona Daily Star
Tucson, Arizona, USA
Illustration for article on compulsive shopping

**"Shopping Monkey,"** 24 x
18 in. (609mm x 457mm), Com-
Art transparent acrylic on Frisk
CS10 illustration board, Paasche
AB and Iwata HP-C airbrushes.
X-Acto knife used to create
highlights, hair, and textures.

**Artist:** Mark A. Fredrickson
Tucson, Arizona, USA

**Client:** Anheuser Busch
St. Louis, Missouri, USA
Created for story in an in-house
publication, unpublished

**"Sleazy Magician,"** 14 x
20 in. (355mm x 508mm), Com-
Art transparent acrylics on Frisk
CS10 illustration board, Paasche
AB and Iwata HP-C airbrushes.
X-Acto knife used to create
scratched effects.

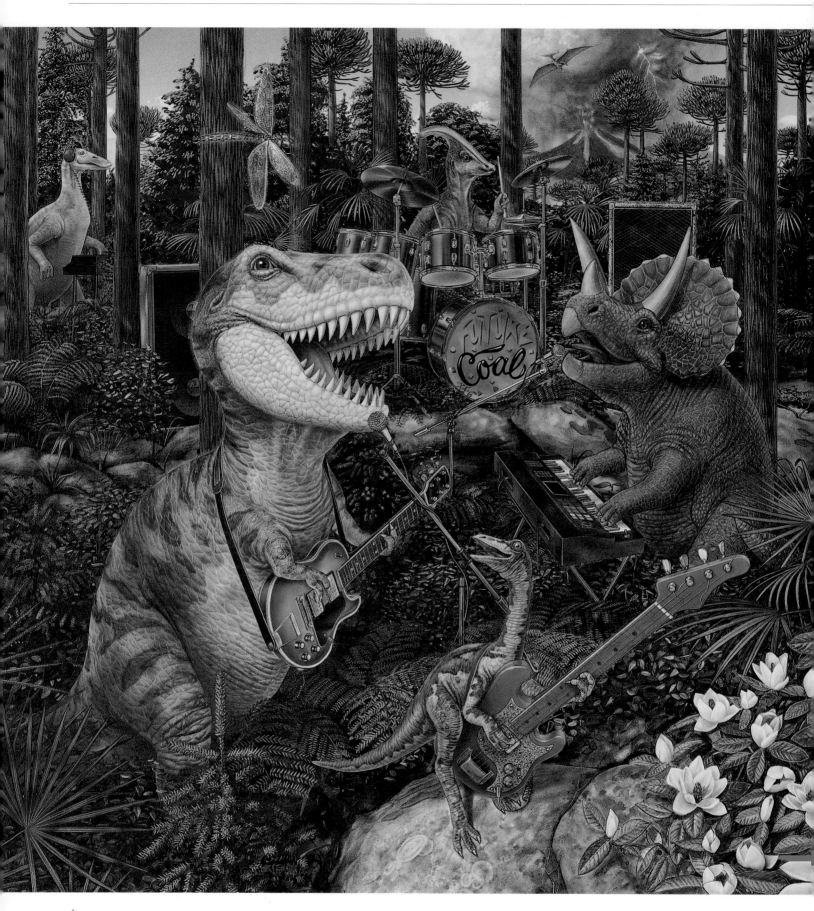

**Artist:** *Thomas A. Gieseke*
*Merriam, Kansas, USA*

**Client:** *Mead Products*
*Dayton, Ohio, USA*
*Notebook cover*

**"Future Coal,"** *20 x 20 in.*
*(508mm x 508mm), watercolor*
*and gouache on Crescent 215*
*hot-press illustration board,*
*Thayer & Chandler A airbrush.*
*Combined with handbrush work.*

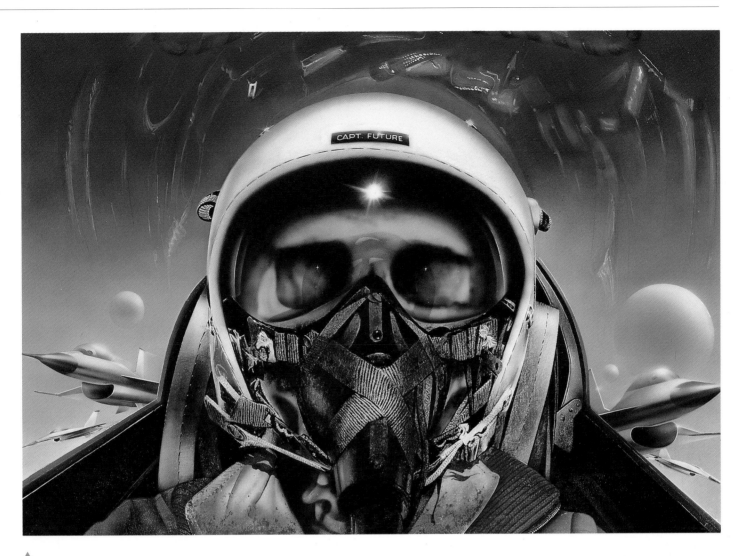

▲
**Artist:** *Peter Roeseler*
*Emsdetten, W. GER*

**Client:** Physis
*Luenen, W. GER*
*Illustration for medical magazine*

**"Captain Future,"** *27 1/2 x*
*19 3/4 in. (700mm x 500mm),*
*Schmincke gouache on*
*Schoellershammer illustration*
*board, Grafo airbrush.*
*Combined with handbrush work*
*and colored pencils.*

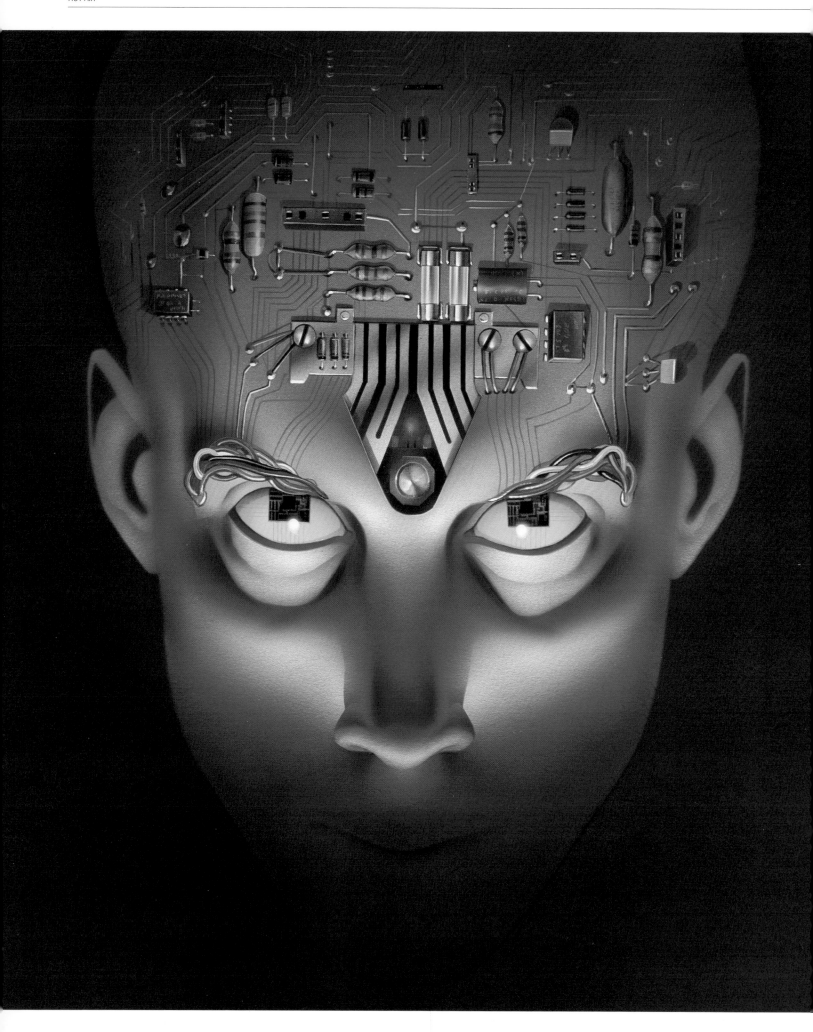

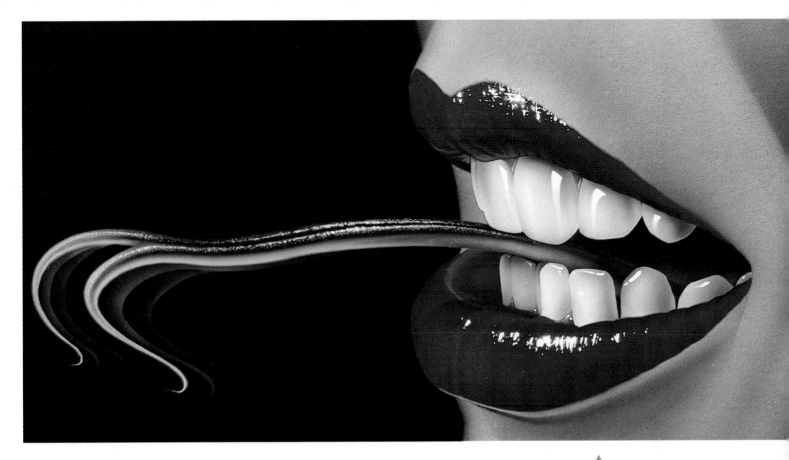

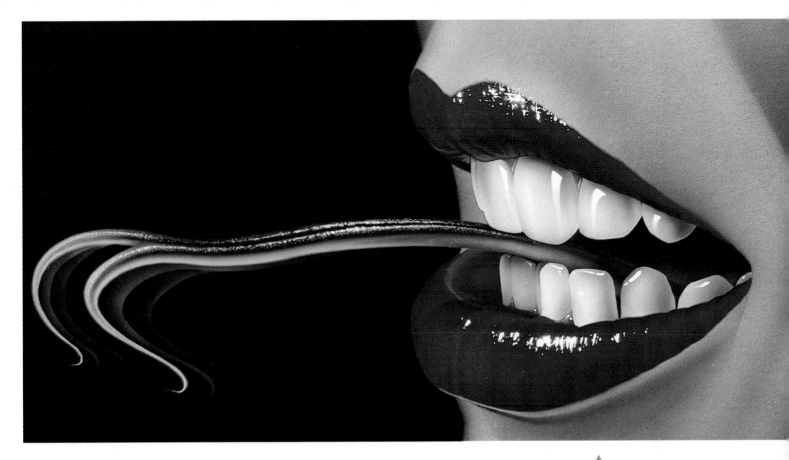

▲
**Artist:** *Wil Cormier*
*Altadena, California, USA*
*Magazine article illustration*
*about snake charmers*

**"Snake Dancers of Africa,"**
*12 x 18 in. (305mm x 457mm),*
*Liquitex acrylics on Crescent*
*cold-press illustration board,*
*Iwata HP-B and Iwata HP-C*
*airbrushes. Combined with*
*handbrushed stippling.*

◄
**Artist:** *Wil Cormier*
*Altadena, California, USA*

**Client:** *Signet Books*
*New York, New York, USA*
*Book cover for a suspense*
*thriller,* Next

**"Next,"** *12 x 18 in. (305mm x*
*457mm), Liquitex acrylics on*
*Crescent cold-press illustration*
*board, Iwata HP-B and Iwata*
*HP-C airbrushes. Combined with*
*handbrush work.*

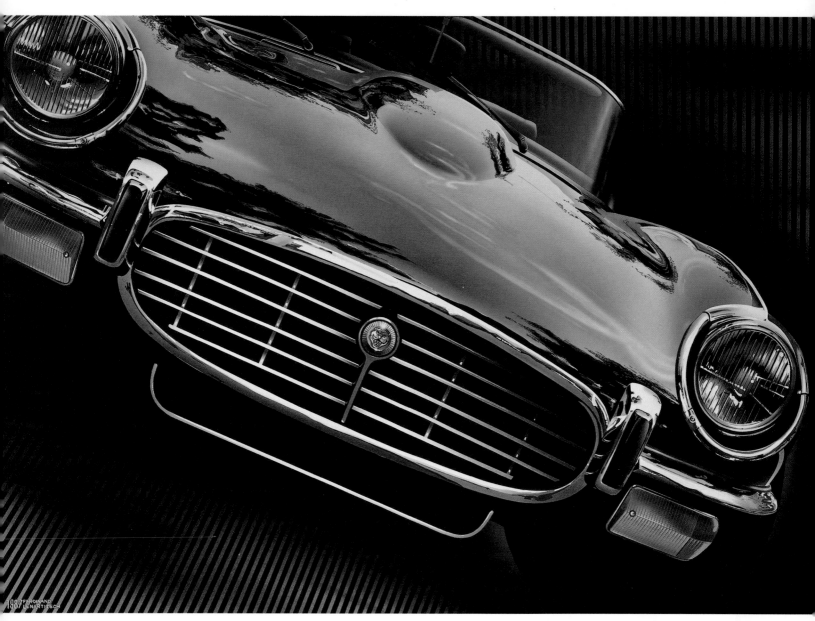

▲ ▶

**Artist:** *Ferdinand Lenartitsch*
*Heimschuh/Unterfahrenbach,*
*AUS*

**Client:** *AVL Research Center*
*Graz, AUS*
*Calendar illustrations*

**"Oldtimer Zyklus"** *(Oldtimer*
*Cycle), 39 1/2 x 27 1/2 (1000mm x*
*700mm), Schmincke Aerocolor*
*on Zanders Parole illustration*
*board, Iwata HP-C airbrush.*
*Combined with colored pencils,*
*oil crayon, acrylics, white*
*opaque, and Dr. Martin's*
*watercolors.*

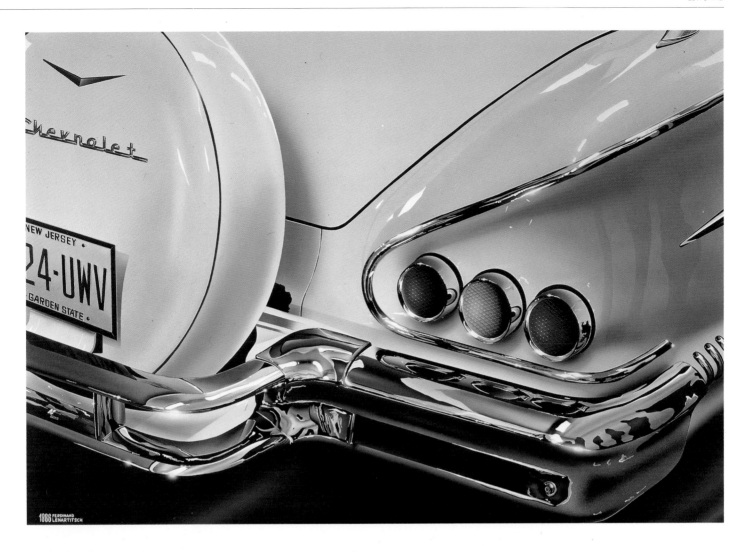

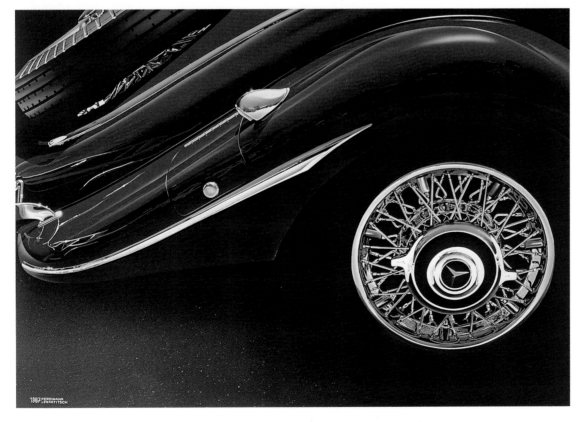

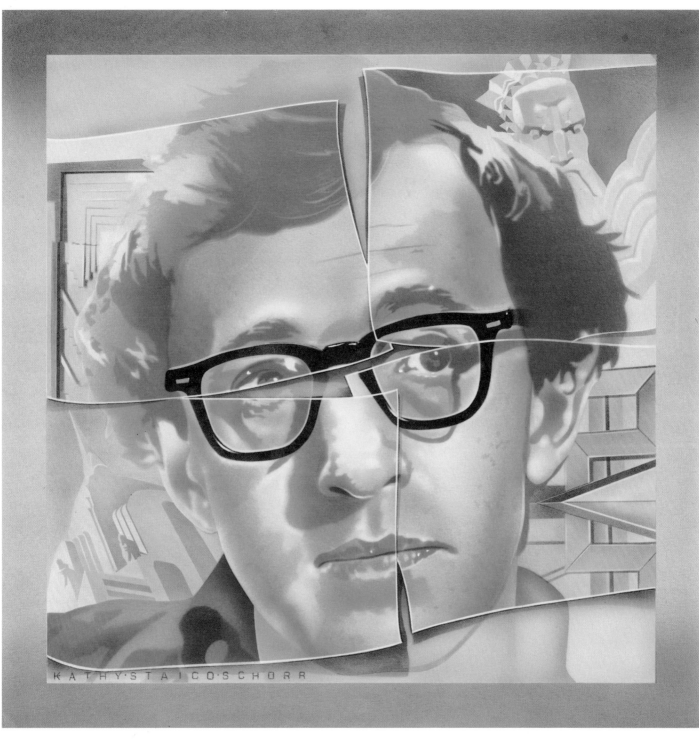

KATHY·STAICO·SCHORR

**Artist:** Kathy Staico Schorr
Roxbury, Connecticut, USA

**Client:** Brad Benedict
Los Angeles, California, USA
Book illustration for Fame, a
book on famous people

**"Woody Allen,"** 13 x 13 in.
(330mm x 330mm), Dr. Martin's
dyes on Crescent illustration
board, Thayer & Chandler
airbrush.

**Artist:** Guy Billout
New York, New York, USA

**Client:** Discover
New York, New York, USA
Magazine cover

**"Warming of The Earth,"**
9 1/8 x 9 1/4 in. (232mm x
235mm), Winsor & Newton
watercolor on artist bristol
vellum finish, Iwata HP-B
airbrush.

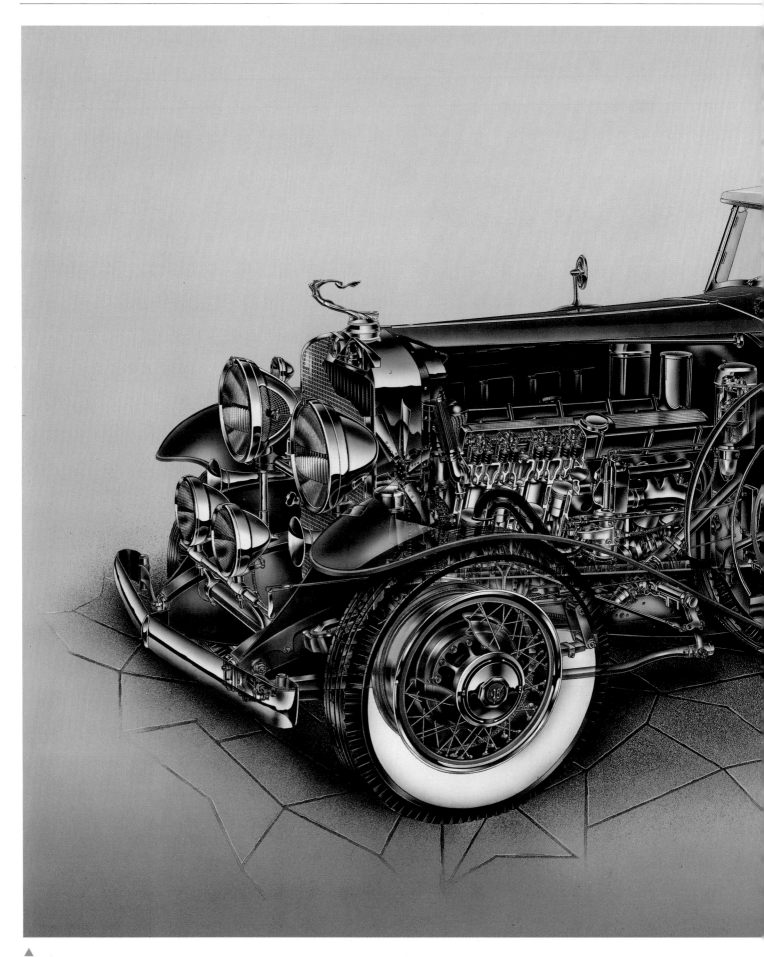

**Artist:** *David Kimble*
*Burbank, California, USA*

**Client:** *Bob Larivee, Sr.*
*Pontiac, Michigan, USA*
*Private commission, later*
*published by* Automobile
Quarterly *as print for sale*

**"1931 V-16 Cadillac,"** *24 x*
*46 in. (609mm x 1168mm),*
*Winsor & Newton gouache on*
*film positive, Iwata HP-SB and*
*Iwata RG-2 airbrushes.*

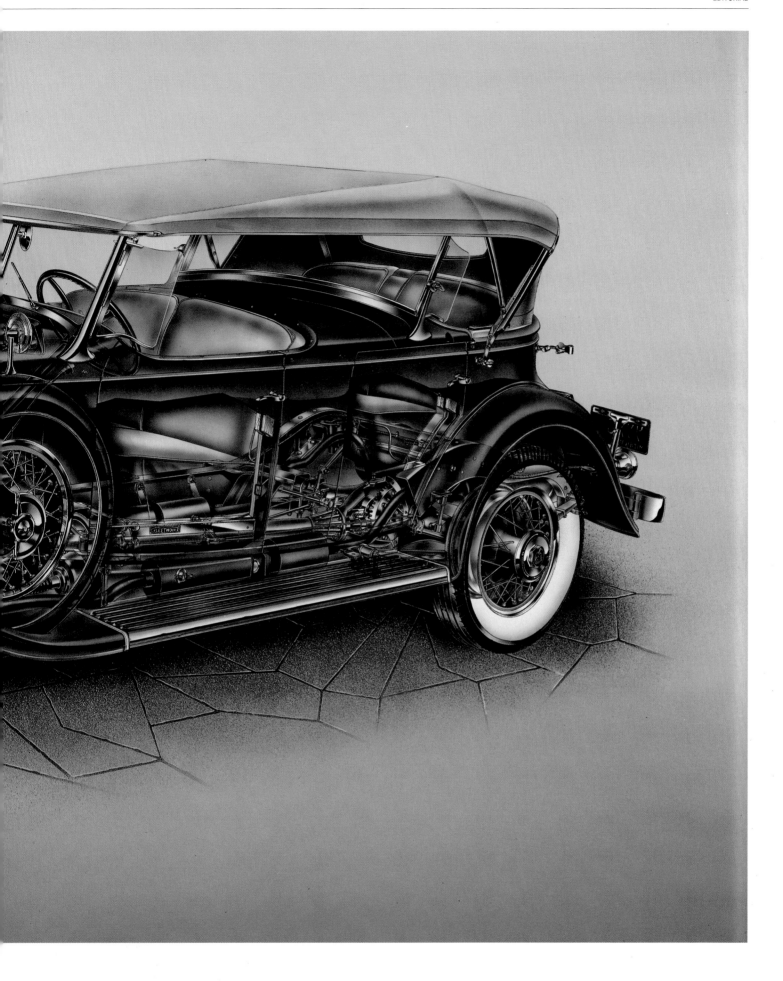

▶

**Artist:** Carl-W. Roehrig
Hamburg, W. GER

**Client:** Ringier Verlag
Hamburg, W. GER
Cover for Natur magazine

**"Eva,"** 20 x 28 3/4 in. (510mm x
730mm), Schmincke DiaPhoto
retouching colors and
Schmincke Aerocolor on
Schoellershammer illustration
board, Grafo (0.15mm nozzle)
and Grafo (0.3mm nozzle)
airbrushes. Combined with
watercolor. X-Acto knife was
used to create scratched effect.

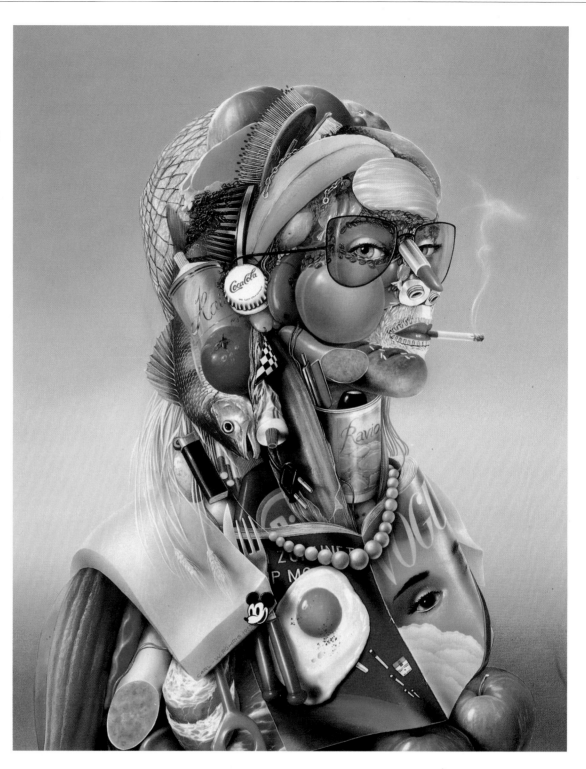

▶

**Artist:** Andreas Haerlin
Tuebingen, W. GER

**Client:** Belin/Rogner
Mougins, FRC
Poster for young people

**"Hot Air,"** 19 3/4 x 27 1/2 in.
(500mm x 700mm), gouache,
and Schmincke DiaPhoto
retouching colors on
Schoellershammer 4G-thick
illustration board, EFBE
(0.15mm and 0.3mm nozzles)
airbrush. Combined with
handbrush work, tempera,
watercolor, colored pencil, and
scratching and erasing.

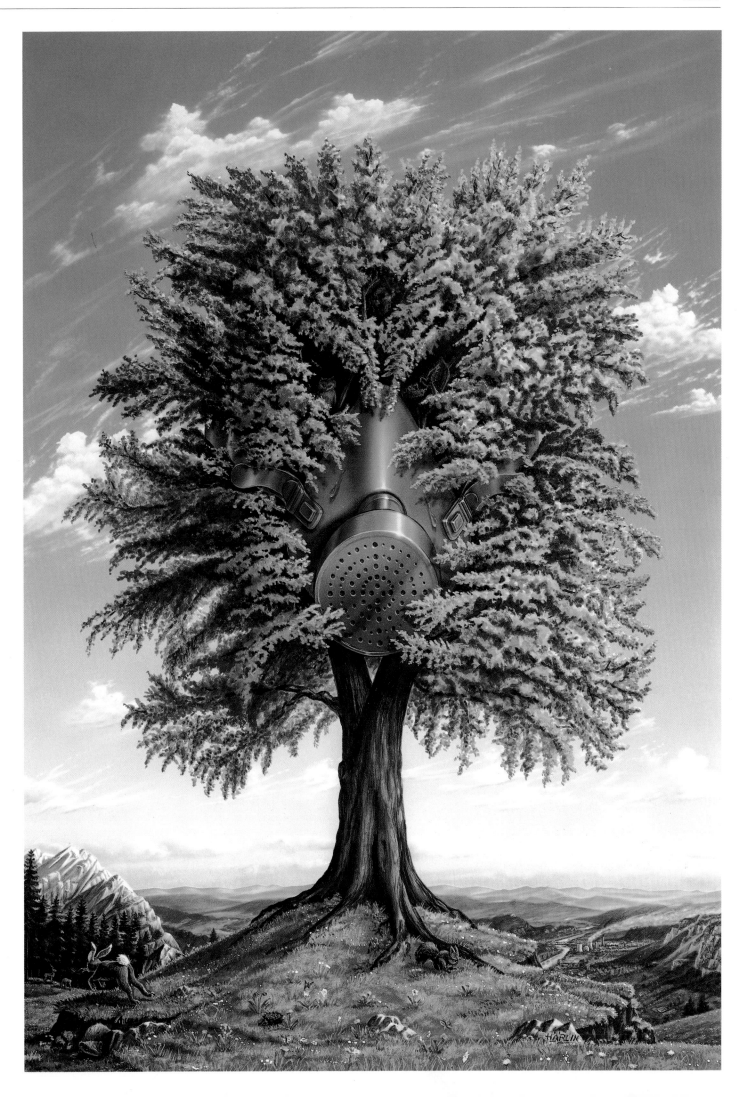

# SELF PROMOTION

SELF PROMOTION

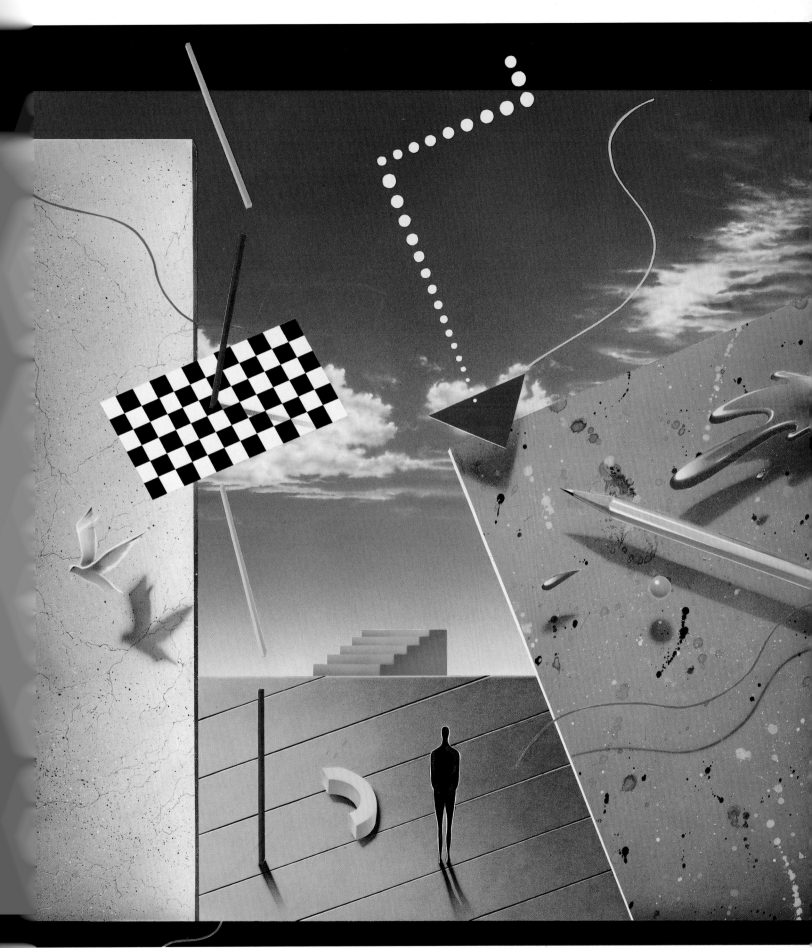

▶

**Artist:** *Robert Craig*
*Greensboro, North Carolina,*
*USA*

**"Robert Craig,"** *22 x 33 in.*
*(558mm x 838mm), Dr. Martin's*
*acrylics on Crescent 201*
*illustration board, Iwata HP-B*
*airbrush.*

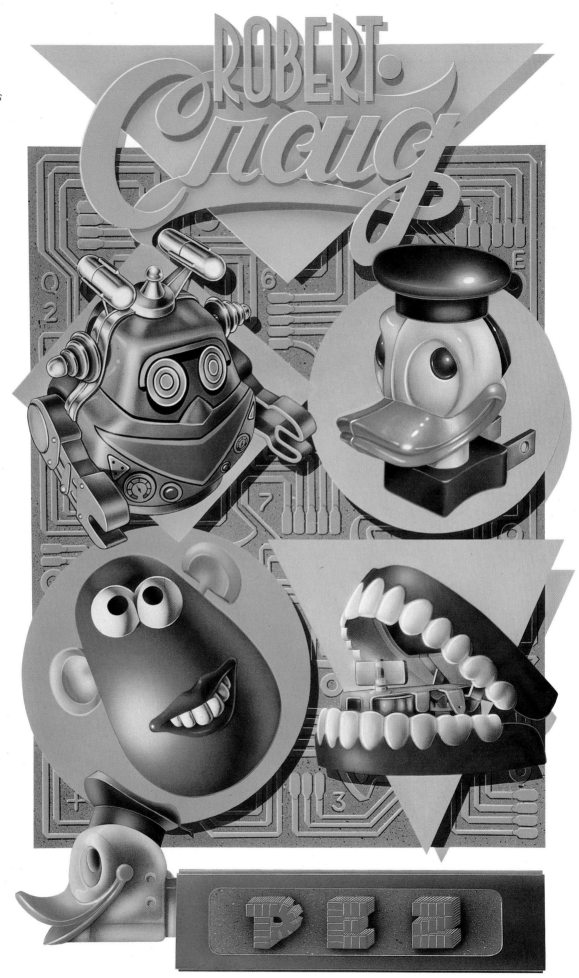

◀

**Artist:** *Dickran Palulian*
*Rowayton, Connecticut, USA*

**Untitled,** *18 x 19 in. (457mm x*
*482mm), Winsor & Newton*
*gouache on Letramax 2000*
*illustration board, Thayer &*
*Chandler Model A and Iwata*
*airbrushes.*

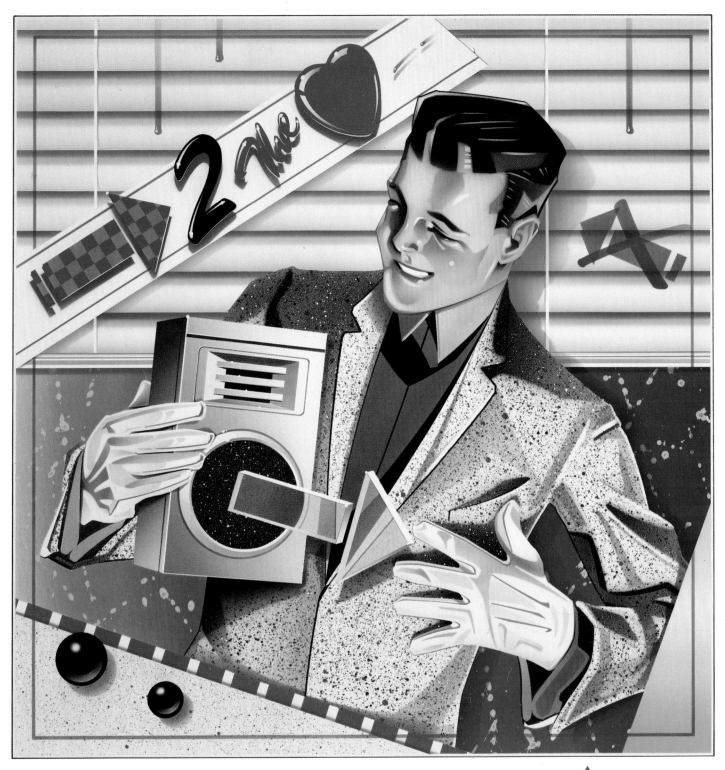

▲
**Artist:** *Peter Owen*
*Leamington Spa, GBR*

**"Straight to the Heart,"**
*13 1/2 x 13 1/2 in. (340mm x 340mm), Pelikan ink on Frisk CS10 illustration board, Iwata HP-B airbrush. Combined with spattering and some handbrush work.*

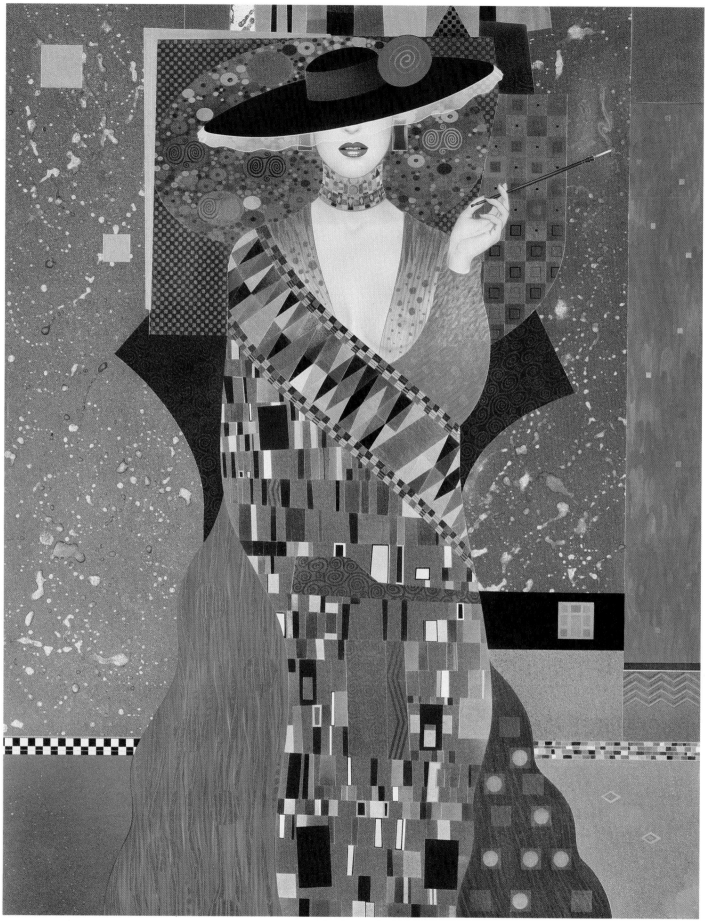

© 1983 Brian Zick.

**Artist:** Brian Zick
Los Angeles, California, USA

**"Klimt Knock Off,"**
15 x 19 1/2 in. (381mm x
495mm), gouache, acrylics, and
dyes on illustration board,
Thayer & Chandler Model A
airbrush.

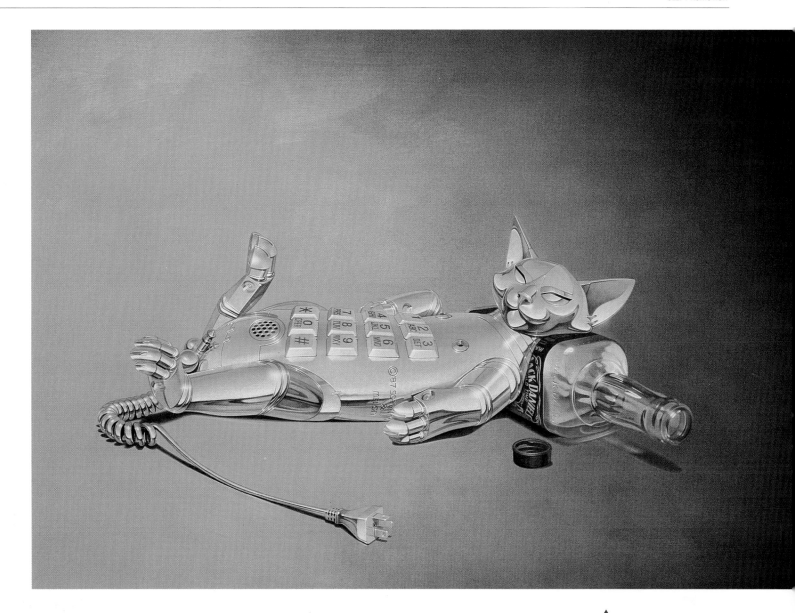

▲
**Artist:** *Hajime Sorayama*
*Tokyo, JPN*

**Untitled,** *14 1/4 x 20 1/4 in.*
*(364mm x 515mm), Liquitex*
*acrylics on Crescent 200*
*illustration board, Olympos*
*Special SP-A airbrush.*
*Combined with handbrush work.*

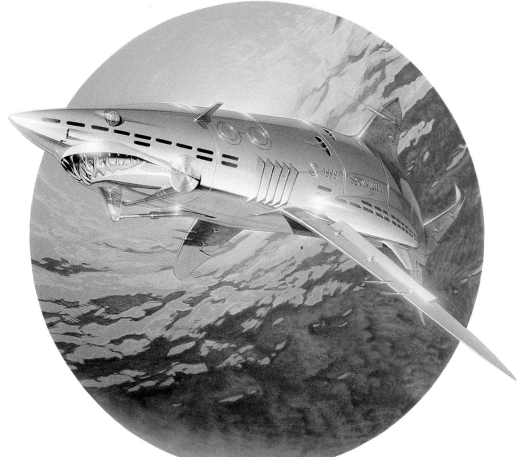

◄
**Artist:** *Hajime Sorayama*
*Tokyo, JPN*

**Untitled,** *14 1/4 x 20 1/4 in.*
*(364mm x 515mm), Liquitex*
*acrylics on Crescent 200*
*illustration board, Olympos*
*Special SP-A airbrush.*
*Combined with handbrush work.*

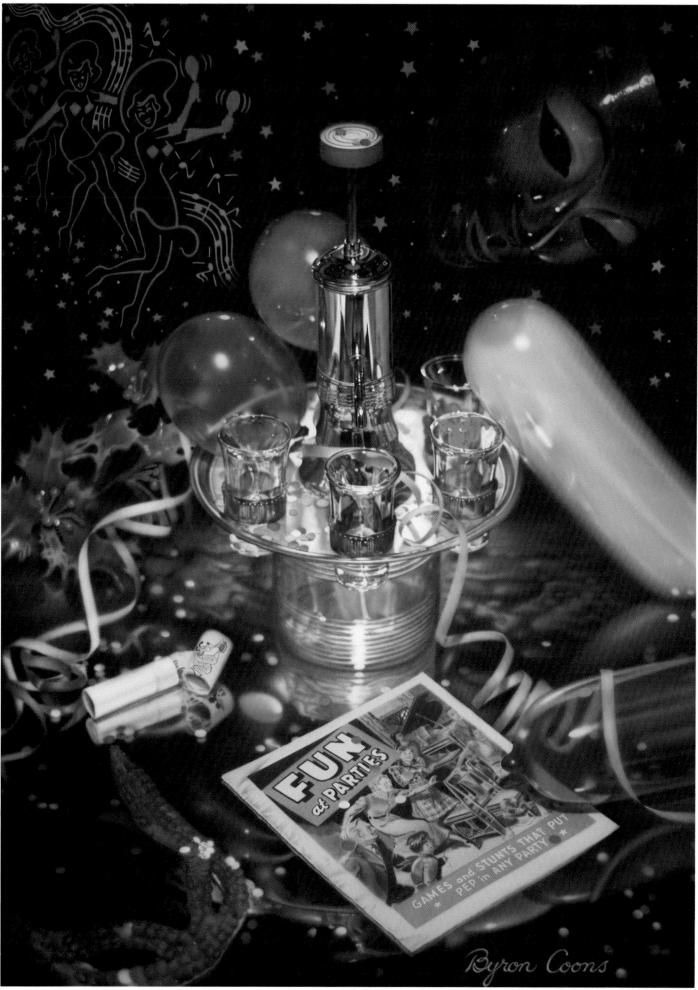

© 1988 Byron Coons.

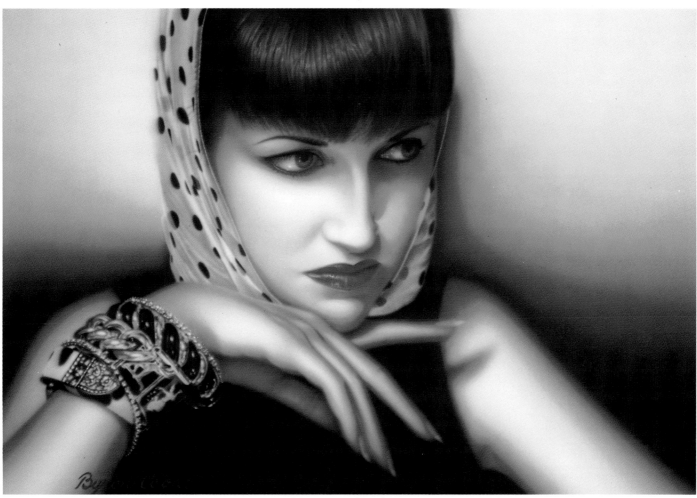

© 1989 Byron Coons.

▲
**Artist:** Byron Coons
Palo Alto, California, USA

**"Cafe,"** 20 x 28 in. (508mm x
711mm), Liquitex acrylics on
Crescent 200 hot-press
illustration board, Paasche AB
and Iwata HP-B airbrushes.

◄
**Artist:** Byron Coons
Palo Alto, California, USA

**"Fun At Parties,"** 30 x 40 in.
(762mm x 1016mm), Liquitex
acrylics on Crescent 200 hot-
press illustration board, Paasche
AB and Iwata HP-B airbrushes.

▶

**Artist:** *Peter Kraemer*
*Duesseldorf, W. GER*

**"Tuer Nr. 90"** *(Door No. 90),*
*49 1/4 x 35 1/2 in. (1250mm x*
*900mm), Magic Color acrylics*
*on Zanders Parole G extra thick*
*illustration board, EFBE B1*
*(0.15mm nozzle) and Harder &*
*Steenbeck Ultra G (0.3mm*
*nozzle) airbrushes.*

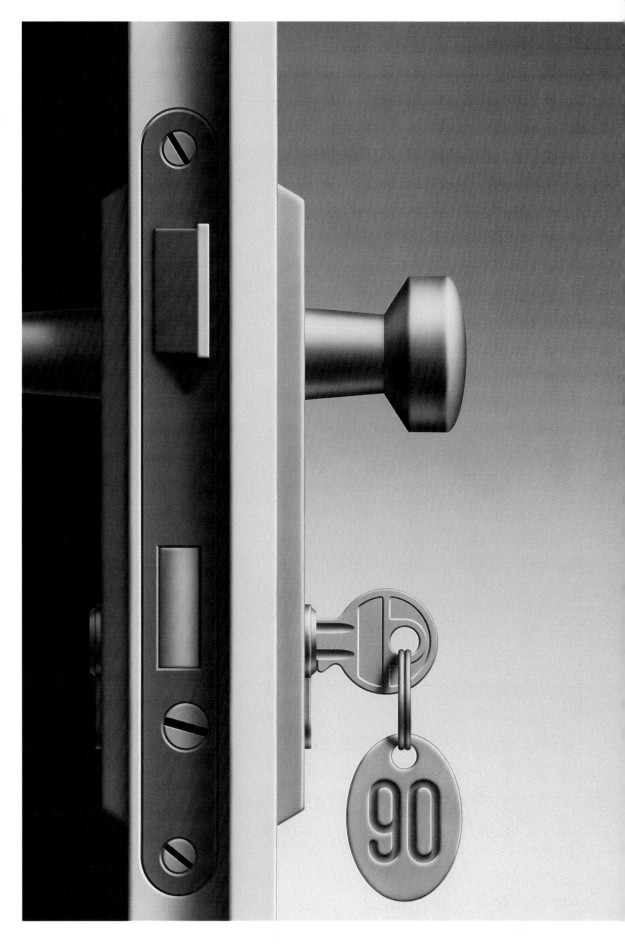

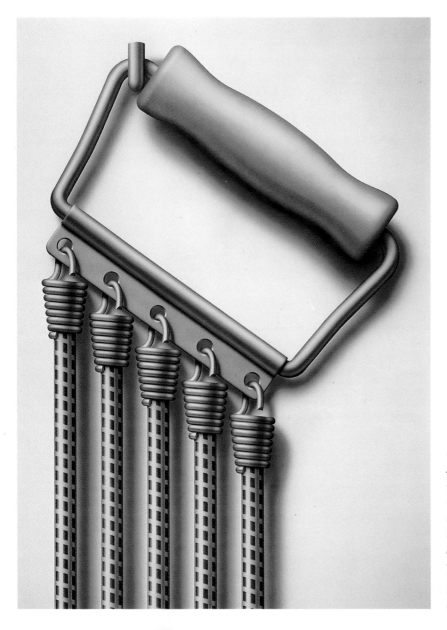

◄
**Artist:** *Peter Kraemer*
*Duesseldorf, W. GER*

**"Expander"** *(Chest Pull),*
*49 1/4 x 35 1/2 in. (1250mm x*
*900mm), Magic Color airbrush*
*paint and Liquitex acrylics on*
*Zanders Parole G extra-thick*
*illustration board, Grafo 1 and*
*Harder & Steenbeck Ultra G*
*airbrushes.*

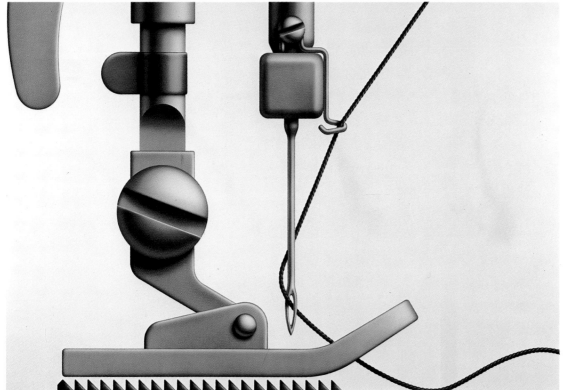

◄
**Artist:** *Peter Kraemer*
*Duesseldorf, W. GER*

**"Naehmaschine"** *(Sewing*
*Machine), 49 1/4 x 35 1/2 in.*
*(1250mm x 900mm), Magic*
*Color airbrush paint on Zanders*
*Parole G extra-thick illustration*
*board, EFBE Model B1 and*
*Grafo 1 airbrushes.*

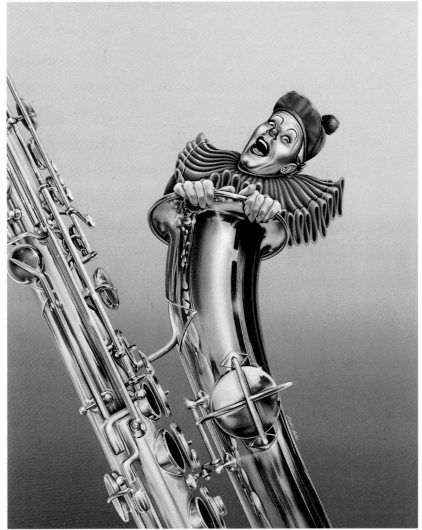

▲

**Artist:** Chris Hopkins
Edmonds, Washington, USA
New address announcement

**"Moving from L.A. to the Northwest,"** 15 x 20 in. (381mm x 508mm), Liquitex acrylics on Crescent 100 cold-press illustration board, Iwata HP-C airbrush. Combined with brown line print, Prismacolor colored pencils and Chromatec dry transfer colors.

◄

**Artist:** Leslie Bates
Oceanside, New York, USA

**"The Clown,"** 12 1/2 x 15 1/2 in. (317mm x 394mm), Liquitex acrylics on gessoed Masonite, Paasche AB and Iwata HP-C airbrushes. Combined with handbrush work.

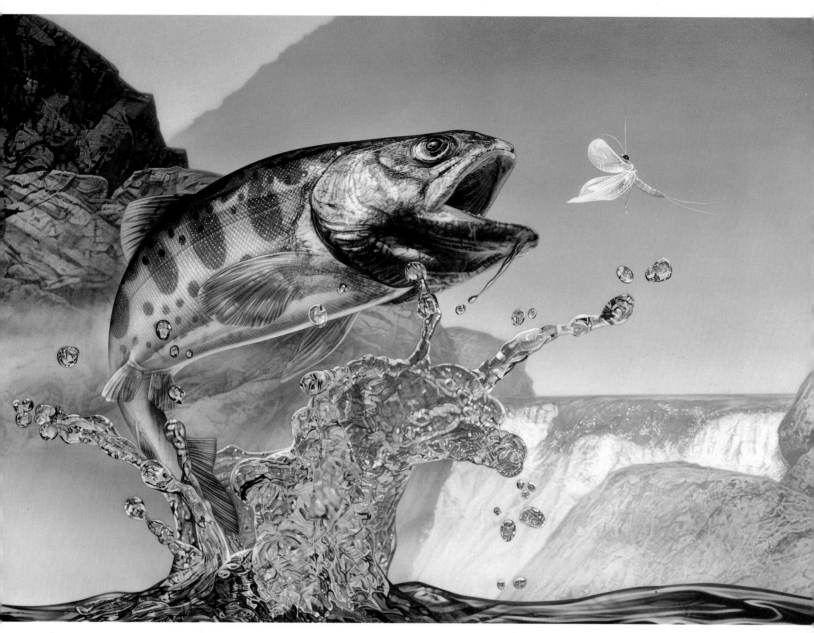

▲
**Artist:** *Toshikuni Okubo*
*Shinjuku-ku, Tokyo, JPN*

**"Fish in a Torrent. Fish in a
Mountain Stream,"** *14 1/4 x
20 1/4 in. (364mm x 515mm),
Holbein watercolors and Bonny
acrylics on Crescent illustration
board, Hohmi Y-1, Hohmi Y-3
and Hohmi Y-5 airbrushes.*

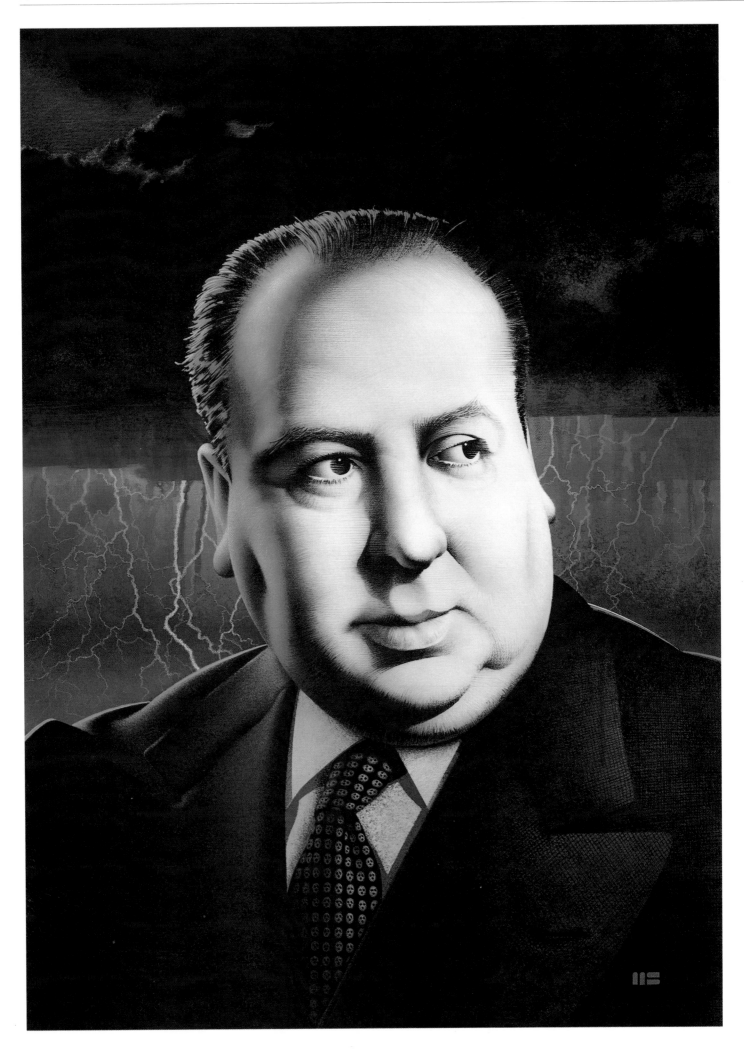

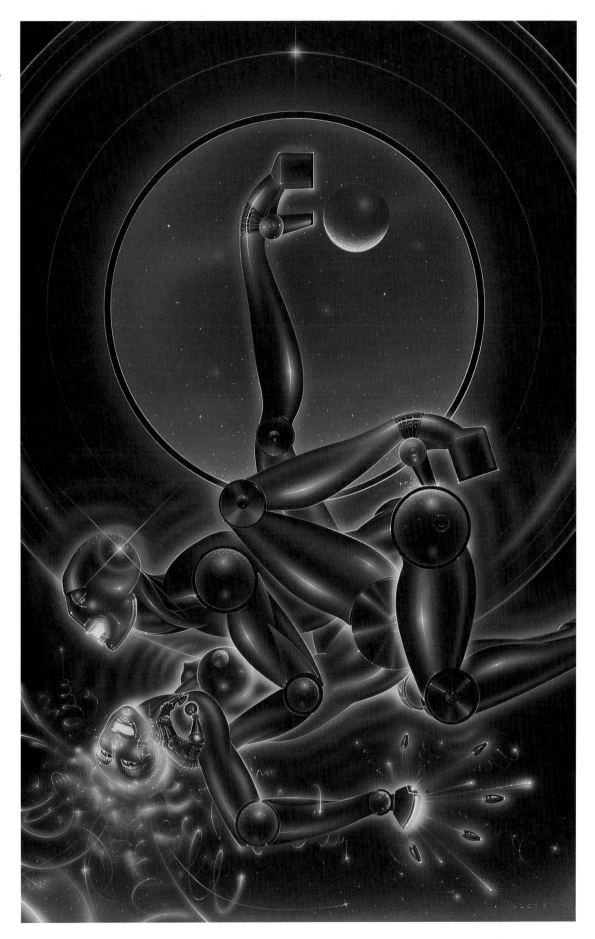

**Artist:** Mark Smollin
Los Angeles, California, USA

**"Hitch,"** 18 x 24 in. (457mm x 609mm), Liquitex acrylics on canvas, Paasche VL airbrush. Combined with colored pencil and graphite.

**Artist:** Peter Lloyd
Taos, New Mexico, USA

**"Space Lovers,"** 18 x 31 in. (457mm x 787mm), Nova acrylics and Rotring opaque ink on Crescent 3-weight hot-press illustration board, Paasche V#1 airbrush.

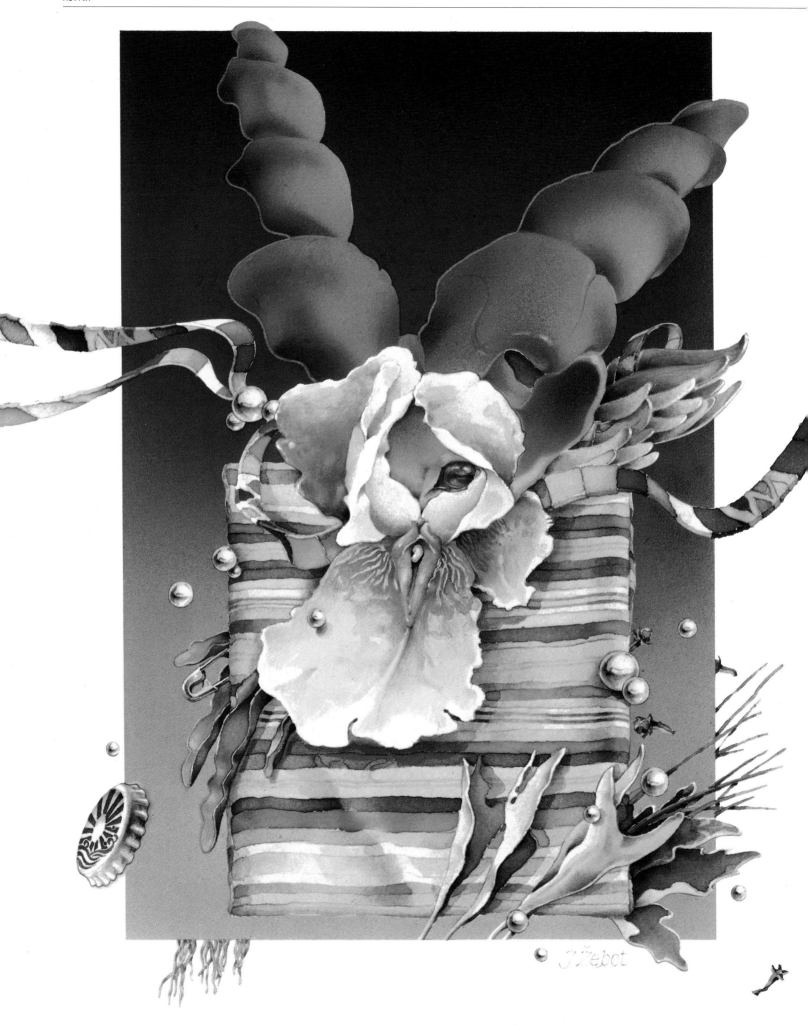

▲
**Artist:** Manfred Kranz
March, W. GER

**"Gira,"** 11 3/4 x 7 3/4 in. (300mm
x 200mm), Magic Color on
Schoellershammer 4G-thick
illustration board, Fischer
(0.2mm nozzle) airbrush.
Combined with colored pencil.

◄
**Artist:** George Jurij Zebot
Laguna Beach, California, USA
New address announcement

**"Shaman Series #1—
Androgynous Healing,"** 10 x
13 in. (254mm x 330mm),
Winsor & Newton gouache and
Luma dyes on Crescent hot-
press illustration board, Iwata
HP-SB and Thayer & Chandler A
airbrushes. Combined with
Prismacolor colored pencils.

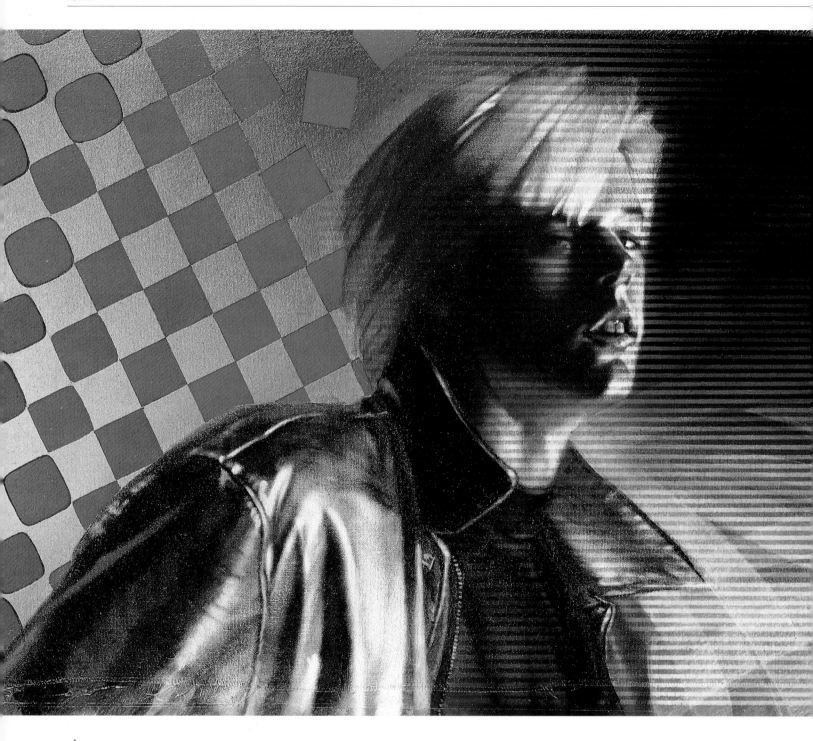

▲
**Artist:** Rob Barber
Concord, California, USA

**"Freddie,"** 16 x 12 in. (406mm
x 305mm), Liquitex acrylics on
muslin canvas gessoed to board,
Paasche VL airbrush. Combined
with handbrush work to enhance
video monitor illusion.

▶
**Artist:** Yu Kasamatsu
Fuchu-shi, Tokyo, JPN

**"Bird,"** 28 3/4 x 20 1/4 in.
(728mm x 515mm), Liquitex
acrylics on Crescent 310
illustration board, Olympos
Handicon airbrush.

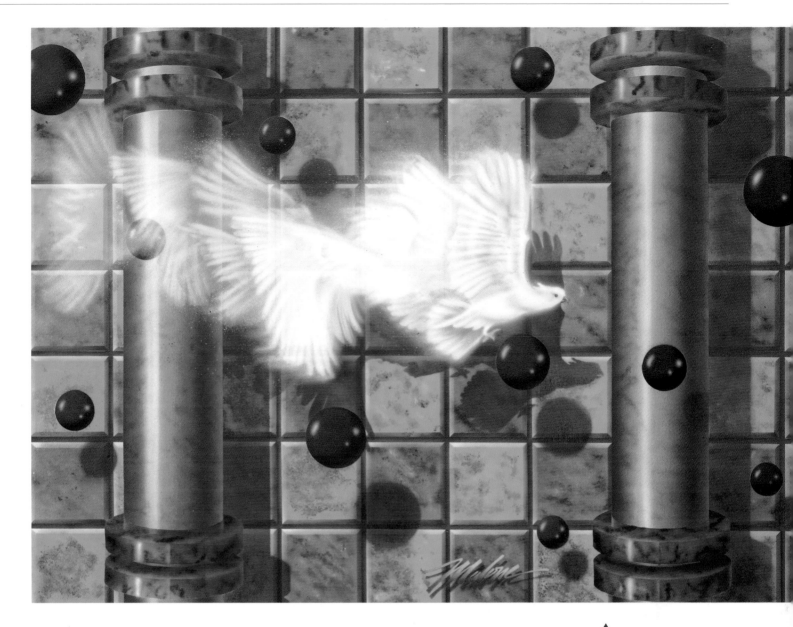

▲
**Artist:** Dave Malone
Portland, Oregon, USA

**Untitled,** 30 x 40 in. (762mm x 1016mm), Com-Art airbrush colors on canvas, Iwata HP-C and RG-2 airbrushes.

◄
**Artist:** Robert Evans
San Francisco, California, USA

**Untitled,** 24 x 28 in. (609mm x 711mm), Liquitex acrylics on Crescent cold-press illustration board, Iwata HP-SB airbrush. Combined with colored pencil.

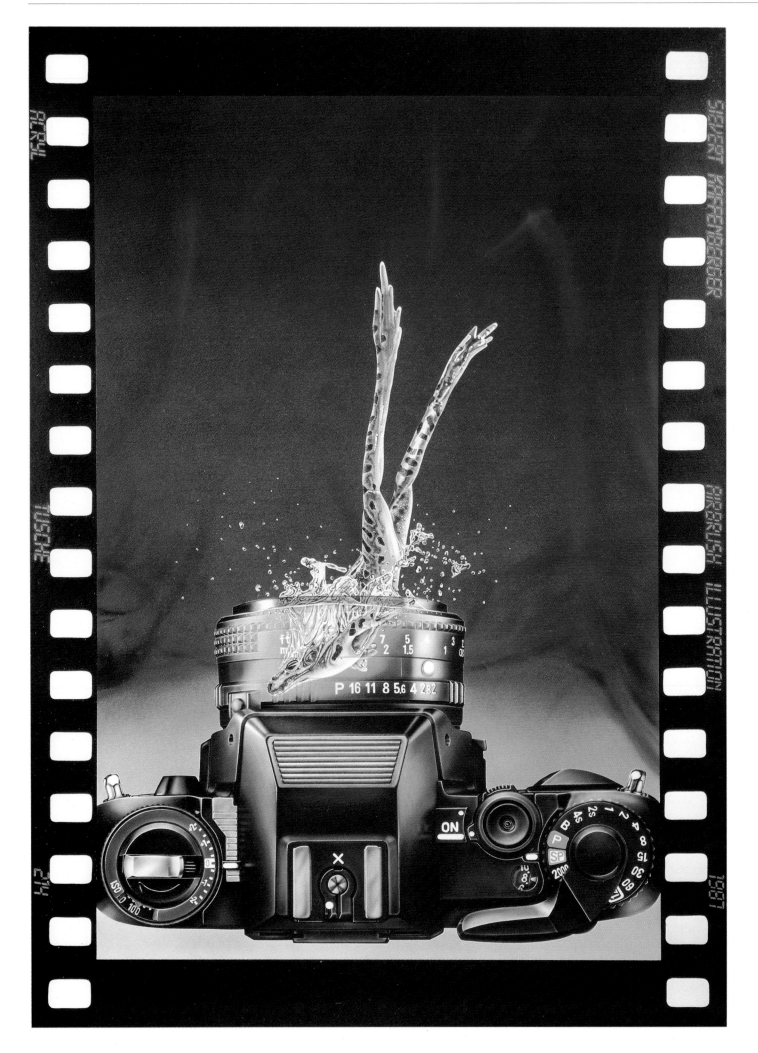

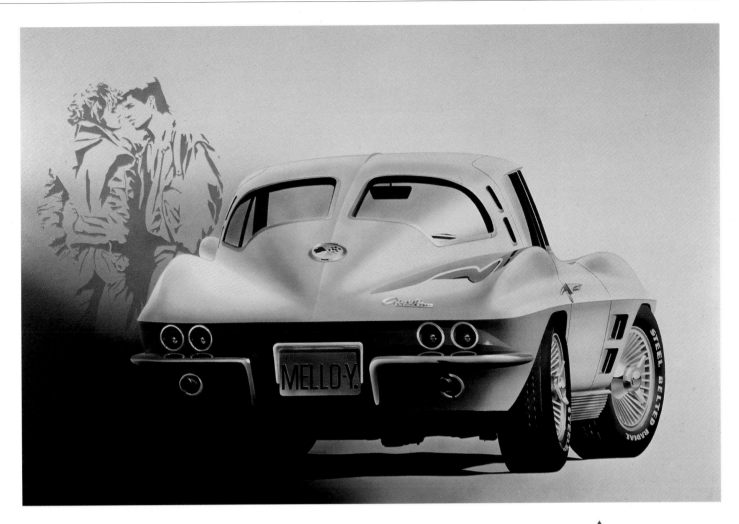

▲
**Artist:** Klaus Wagger
Bad Haering, AUS

**"Chevrolet Corvette
Stingray,"** 39 1/2 x 27 1/2 in.
(1000mm x 700mm), Schmincke
Aerocolor on Zanders Parole
illustration board, Iwata HP-B
airbrush.

◄
**Artist:** Sievert Kaffenberger
Mutlangen, W. GER

**"Airbrush Illustration
1987,"** 28 3/4 x 20 in. (730mm x
510mm), Liquitex acrylics and
Rotring India ink on
Schoellershammer 4G-thick
illustration board, DeVilbiss
Aerograph Sprite airbrush.

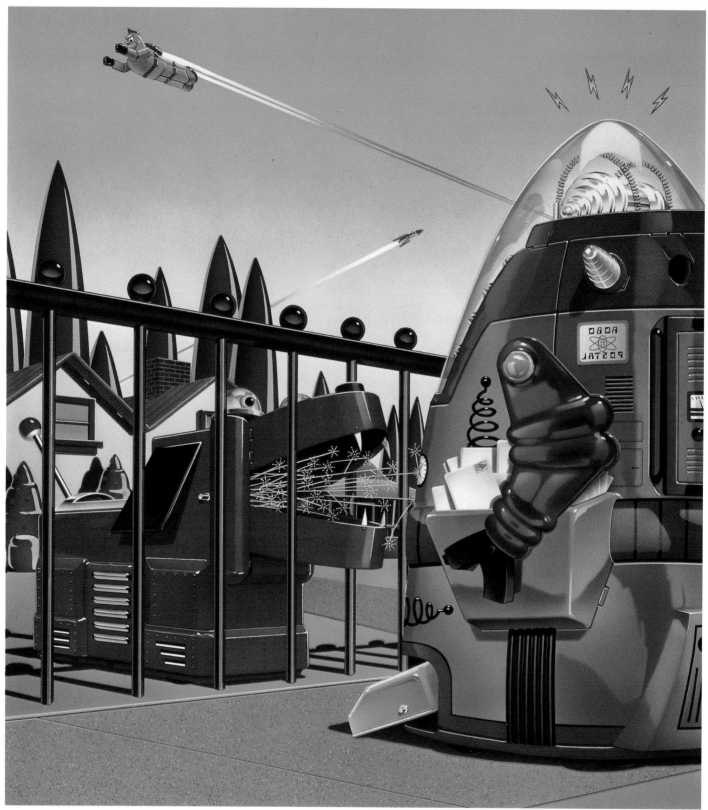

**Artist:** David M. Davis
Portland, Oregon, USA

**"Robo Postal,"** 17 1/2 x 19 in.
(444mm x 482mm), Winsor &
Newton and Maimeri gouache on
Strathmore 2-ply 100% rag
medium surface, Iwata HP-B
airbrush.

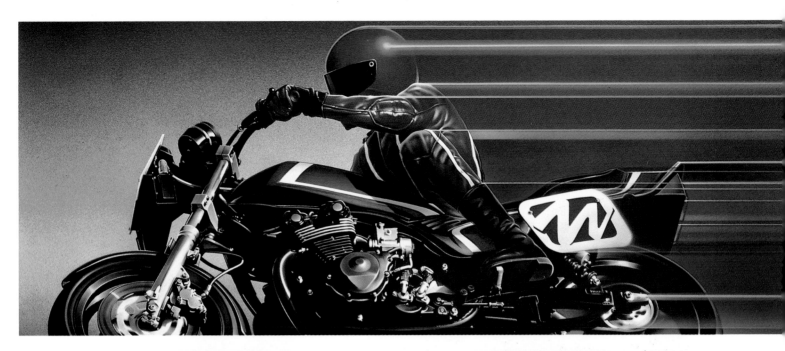

▲
**Artist:** Wayne Watford
Phoenix, Arizona, USA

**"Motorcycle,"** 28 x 12 in.
(711mm x 305mm), Liquitex
acrylic on Frisk CS10 illustration
board, Paasche AB and Iwata
HP-C airbrushes.

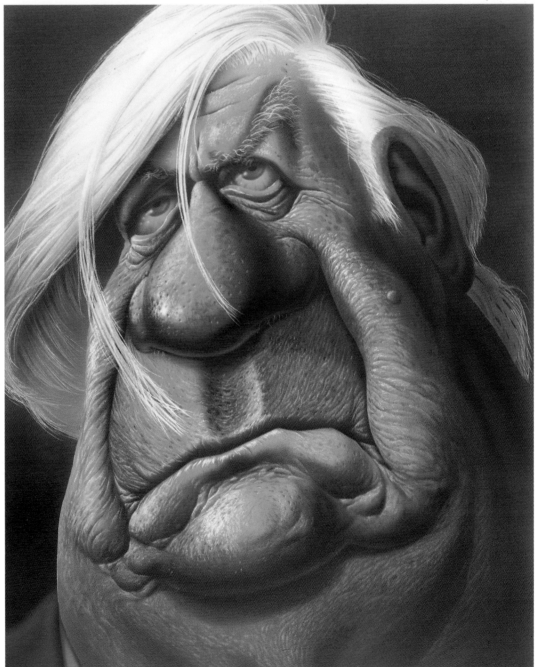

▶
**Artist:** Ken Westphal
Prairie Village, Kansas, USA

**"Tip O'Neill,"** 9 1/2 x 12 in.
(241mm x 305mm), Dr. Martin's
Spectralite acrylics and Badger
Air Opaque Airbrush Colors on
Crescent 215 illustration board,
Iwata HP-B, Paasche AB, and
Thayer & Chandler A airbrushes.
X-Acto knife used to create
scratched effects.

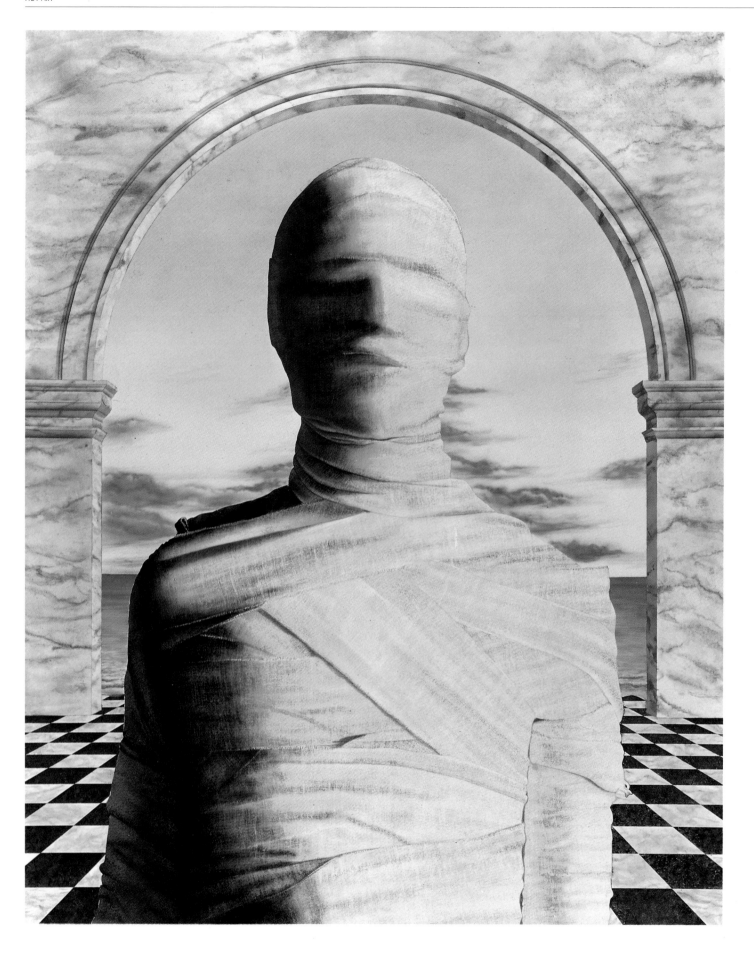

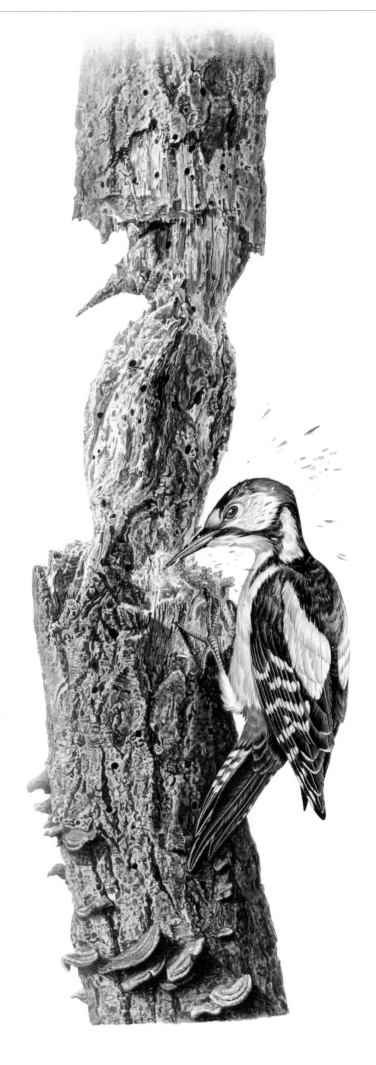

◄
**Artist:** *Yu Kasamatsu*
*Fuchu-shi, Tokyo, JPN*

**"Bird,"** *20 1/4 x 14 1/4 in.
(515mm x 364mm), Liquitex
acrylics on Crescent 310
illustration board, Olympos
Handicon airbrush.*

◄
**Artist:** *Michael Albers*
*Dortmund, W. GER*

**Untitled,** *25 1/4 x 31 1/2 in.
(640mm x 800mm), Magic Color
and Lascaux acrylics on
Schoellershammer illustration
board, Paasche AB and Iwata
HP-C airbrushes. Gauze used as
stencil to create texture on
mummy.*

149

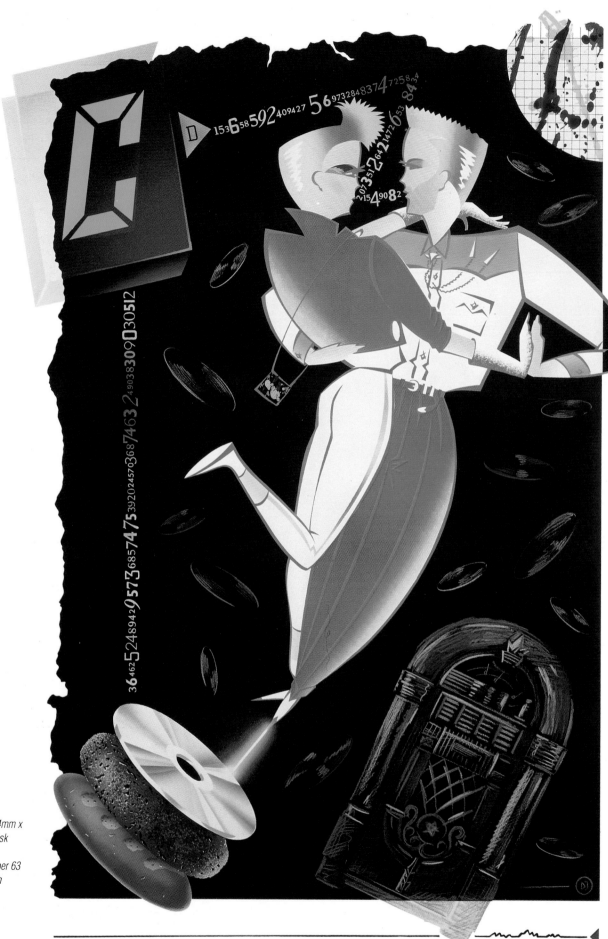

**Artist:** David Juniper
London, GBR

**"C.D.,"** 10 x 15 in. (254mm x 381mm), gouache on Frisk CS10 illustration board, DeVilbiss Aerograph Super 63 airbrush. Combined with colored pencil.

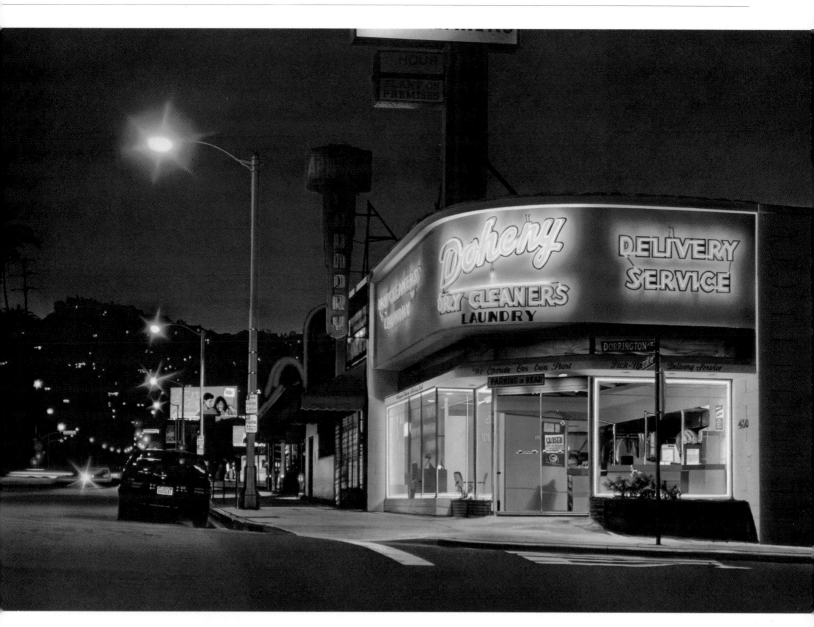

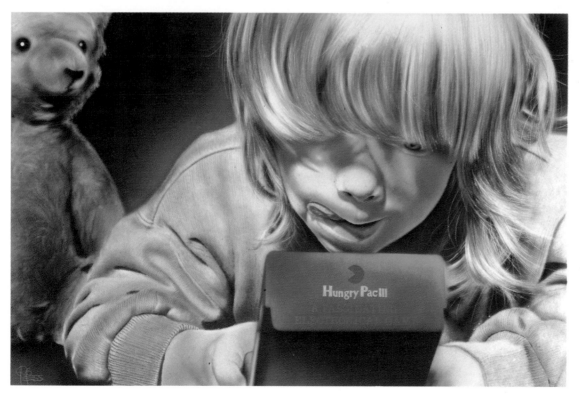

▲
**Artist:** *James Ibusuki*
*Sylmar, California, USA*

*"Dorrington & Doheny,"* *17 x 26 in. (431mm x 660mm), Liquitex acrylics on Crescent 110 illustration board, Iwata HP-B and Paasche VL-1 airbrushes.*

◄
**Artist:** *Michael Riess*
*Nuernberg, W. GER*

*"Die Droge wirkt"* *(The Drug Works), 17 x 11 in. (430mm x 280mm), Schmincke watercolors on Schoellershammer 4G-thick illustration board, DeVilbiss Super 63A airbrush.*

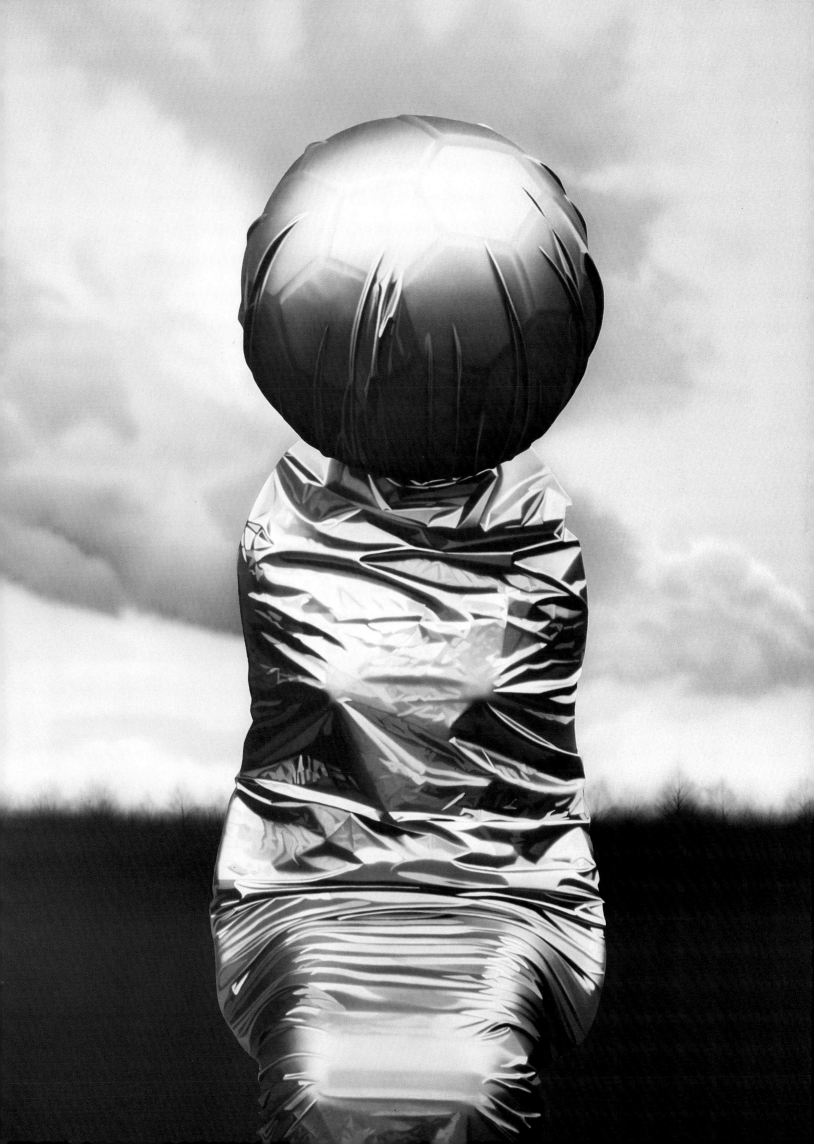

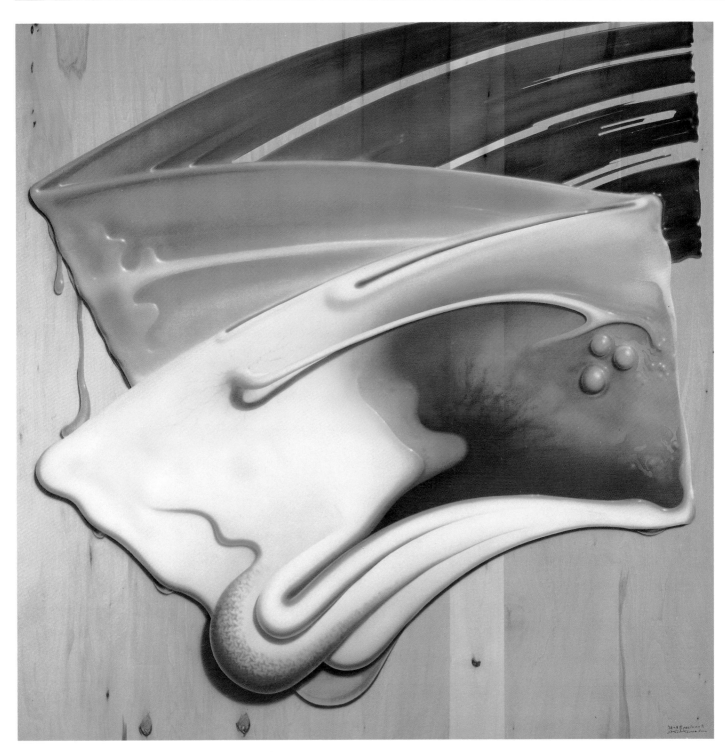

◄
**Artist:** Yoichi Hatakenaka
Kawasaki-shi, JPN

**"A Total Eclipse,"** 63 3/4 x
76 1/2 in. (1620mm x 1940mm),
Liquitex acrylics on Funaoka
acrylic canvas, Gunpiece Rich
GP1 airbrush. Airbrushing on
polished, gessoed canvas.

▲
**Artist:** Katsutaro Hanada
Fukuoka, JPN

**"88-3 Specimen A,"** 63 3/4 x
63 3/4 in. (1620mm x 1620mm),
Liquitex acrylics on wood panel,
Iwata HP-BE1 and Olympos
HP-101 airbrushes. Airbrushing
done on polished ground of
gesso, modeling paste, and
gloss polymer medium.

▶
**Artist:** Sievert Kaffenberger
Mutlangen, W. GER

**"Hanne,"** 28 3/4 x 40 in.
(730mm x 1020mm), Liquitex
acrylics on Schoellershammer
4G-thick illustration board,
DeVilbiss Aerograph Sprite
airbrush. Textures created using
sponge, rag, and sandpaper.

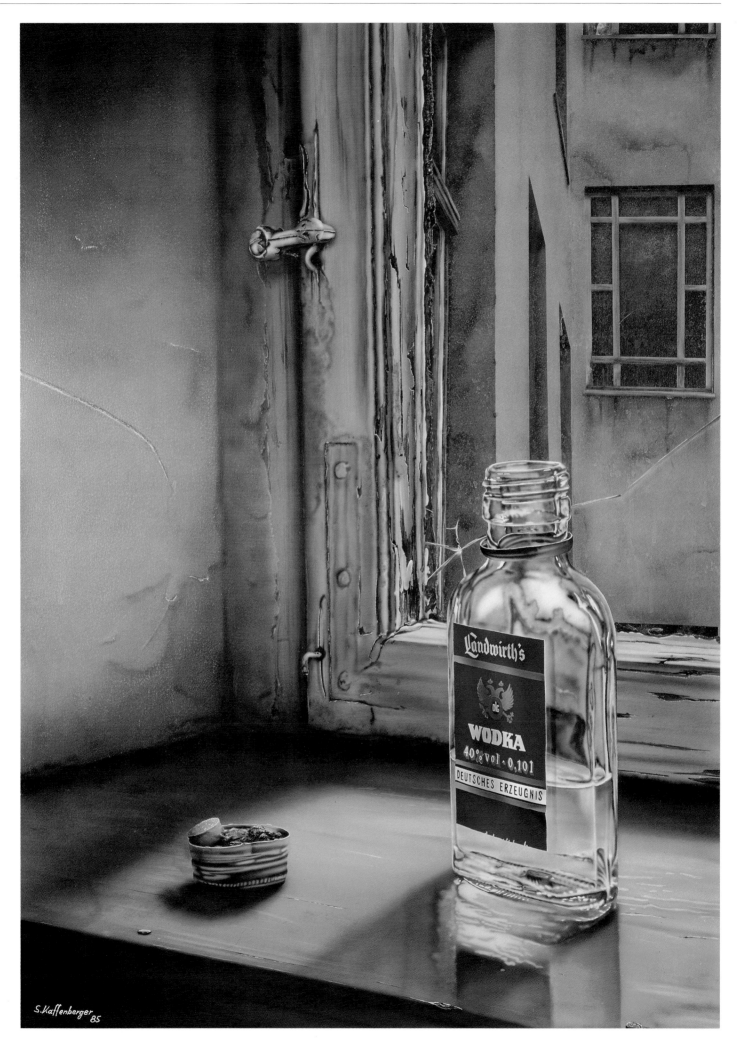

S.Kaffenberger 85

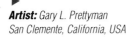

**Artist:** Gary L. Prettyman
San Clemente, California, USA

**"Stretching,"** 50 x 72 in.
(1270mm x 1829mm), Liquitex
acrylics on canvas, Badger 150
airbrush.

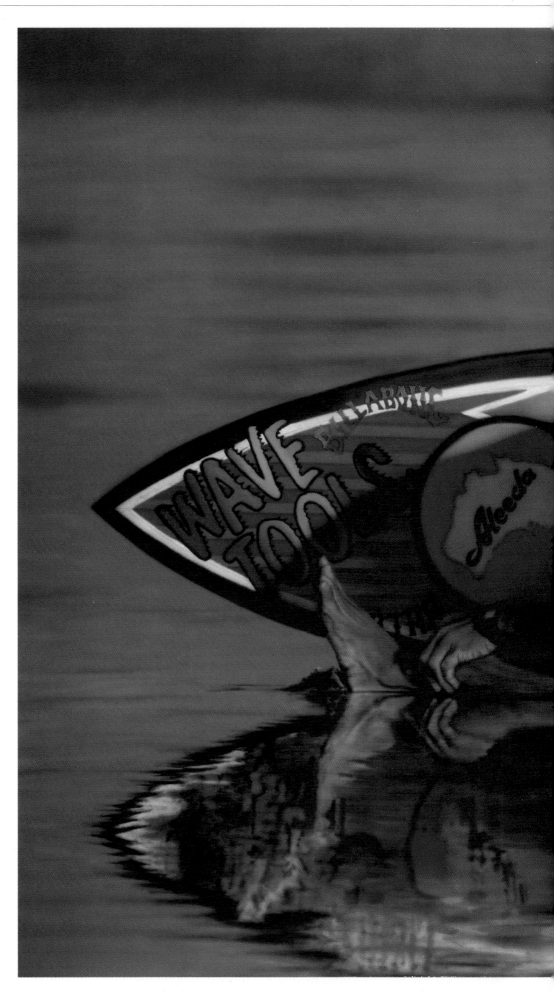

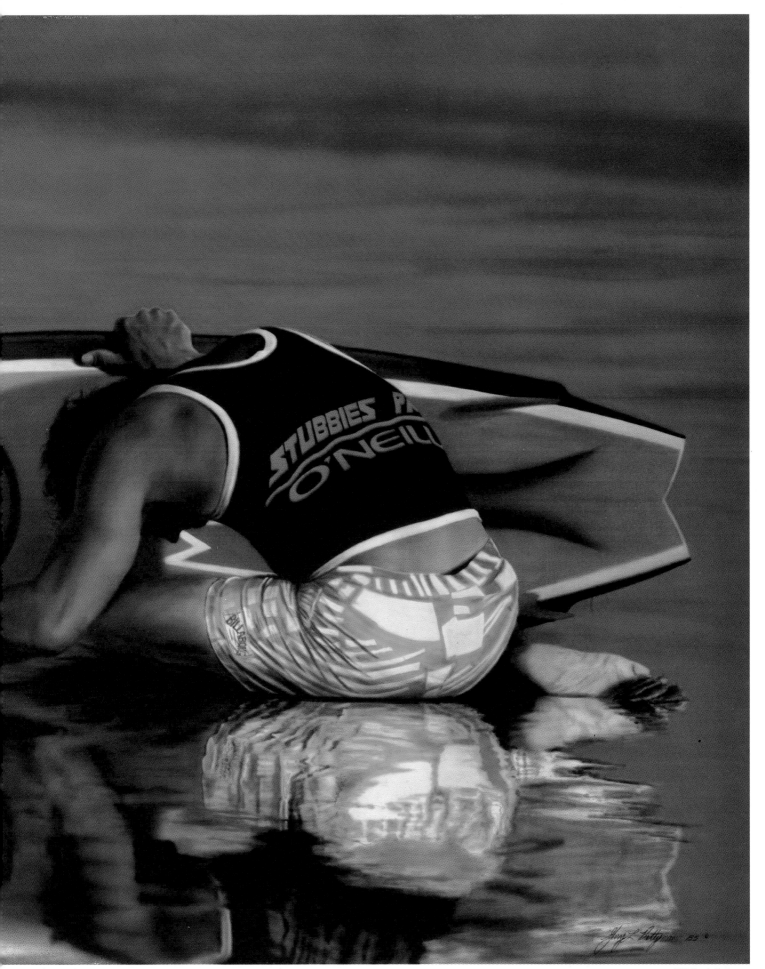

▶

**Artist:** Takashi Ohno
Tokyo, JPN

**"Match,"** 19 3/4 x 25 1/2 in.
(500mm x 650mm), Liquitex
acrylics on canvas, Olympos HP
100A airbrush.

© Takashi Ohno.

Photo © 1985 D. James Dee.

▲
**Artist:** Szeto, Keung
New York, New York, USA

**"The Measurement of
Sensitivity,"** 36 x 57 in.
(914mm x 1448mm), acrylics on
linen, Binks airbrush.

◀
**Artist:** Szeto, Keung
New York, New York, USA

**"Old Brush,"** 38 1/2 x 50 3/4 in.
(978mm x 1289mm), acrylics on
linen, Binks airbrush.

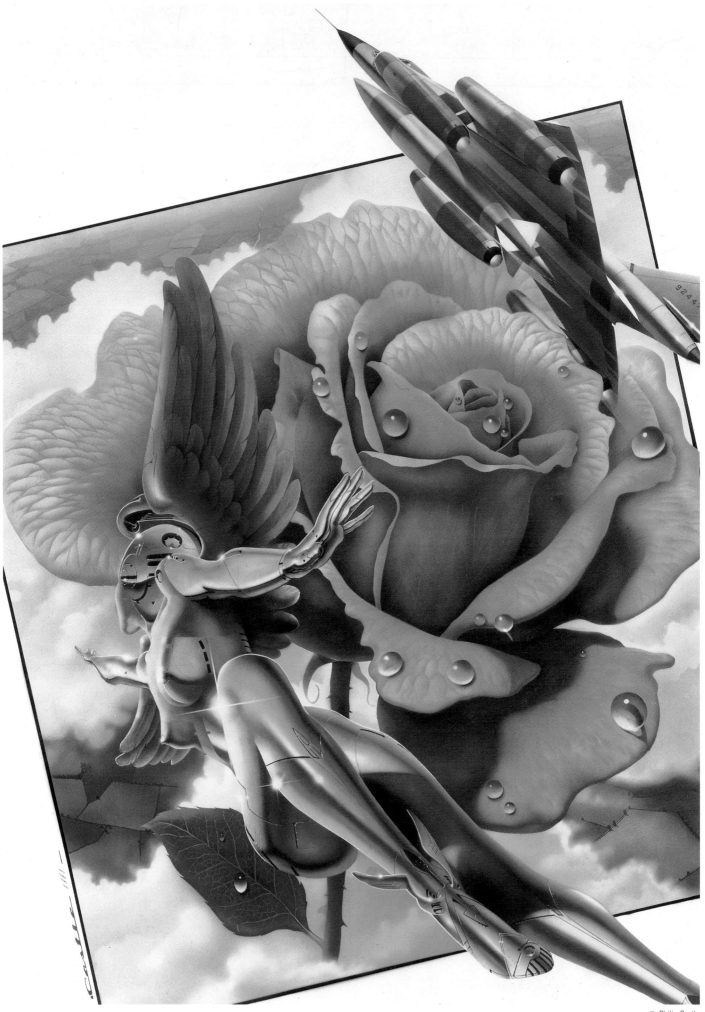

© Philip Castle.

◄

**Artist:** Takashi Ohno
Tokyo, JPN

**"Aluminum Can,"** 12 3/4 x
14 3/4 in. (325mm x 375mm),
Liquitex acrylics on Crescent
205 illustration board, Olympos
HP-100A airbrush.

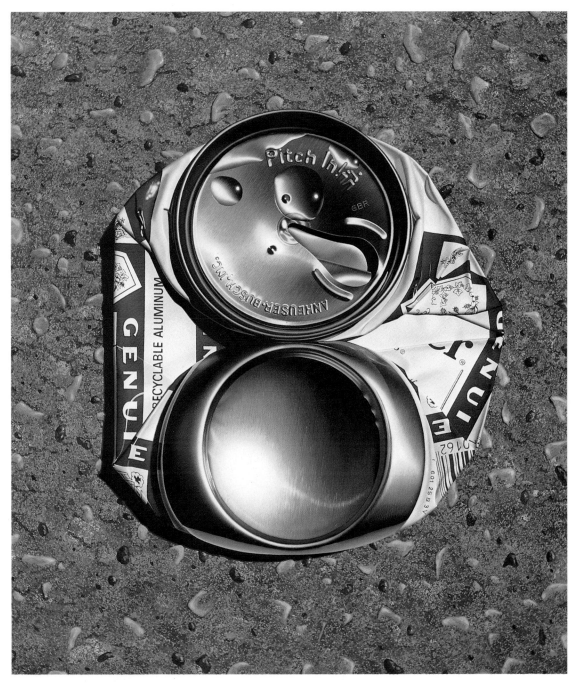

◄

**Artist:** Philip Castle
London, GBR

**"High T,"** 30 x 40 in. (762mm
x 1016mm), Academy Line
water-based airbrush color on
Oram & Robinson illustration
board, DeVilbiss Aerograph
Super 63 airbrush. Combined
with Prismacolor colored
pencils.

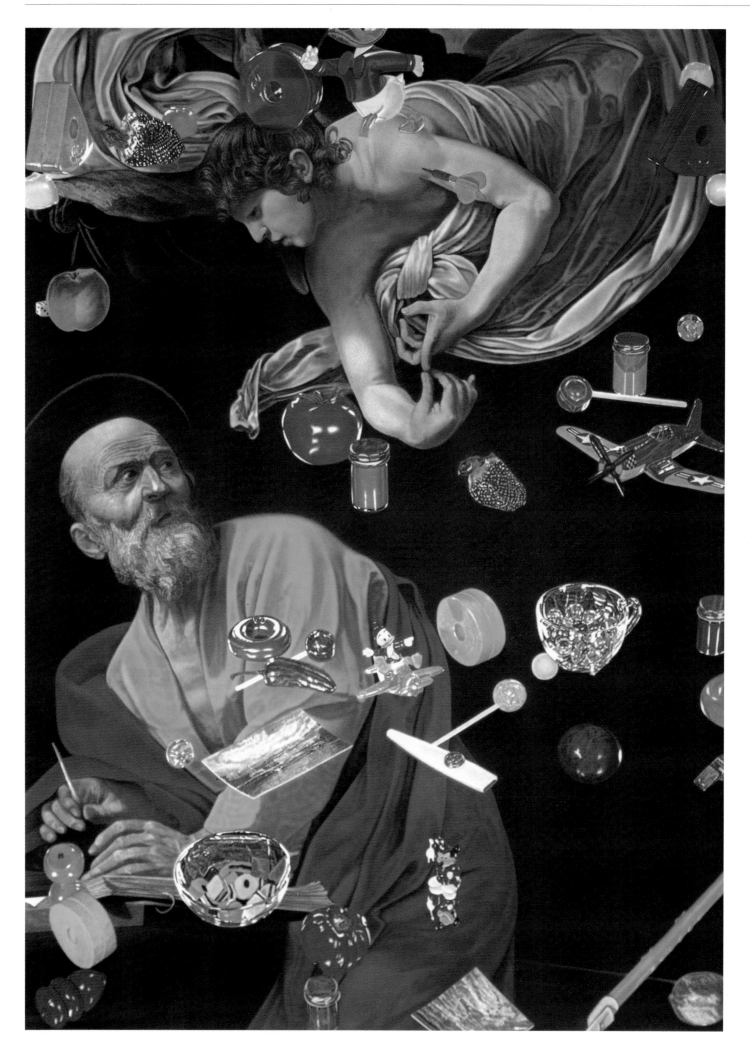

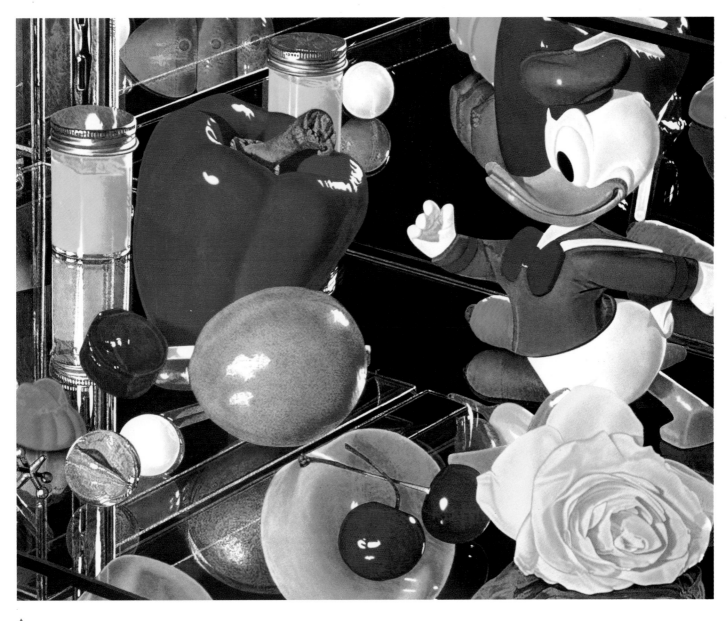

▲
**Artist:** Don Eddy
New York, New York, USA

**"Dreamreader's Cabinet V,"**
*38 x 30 in. (965mm x 762mm),*
*Liquitex acrylics on canvas and*
*cotton duck cloth.*

◄
**Artist:** Don Eddy
New York, New York, USA

**"Matthew's Dilemma,"** *40 x*
*56 in. (1016mm x 1422mm),*
*acrylics on canvas, Paasche H#1*
*airbrush.*

▲
**Artist:** Martin Mull
Los Angeles, California, USA

**"Moving Day,"** 48 x 36 in.
(1219mm x 914mm),
acrylics on canvas.
Collection of the artist.

▶
**Artist:** Martin Mull
Los Angeles, California, USA

**"Saturday Night,"** 68 x 41 in.
(1727mm x 1041mm),
acrylics on canvas.
Private collection, Los Angeles.

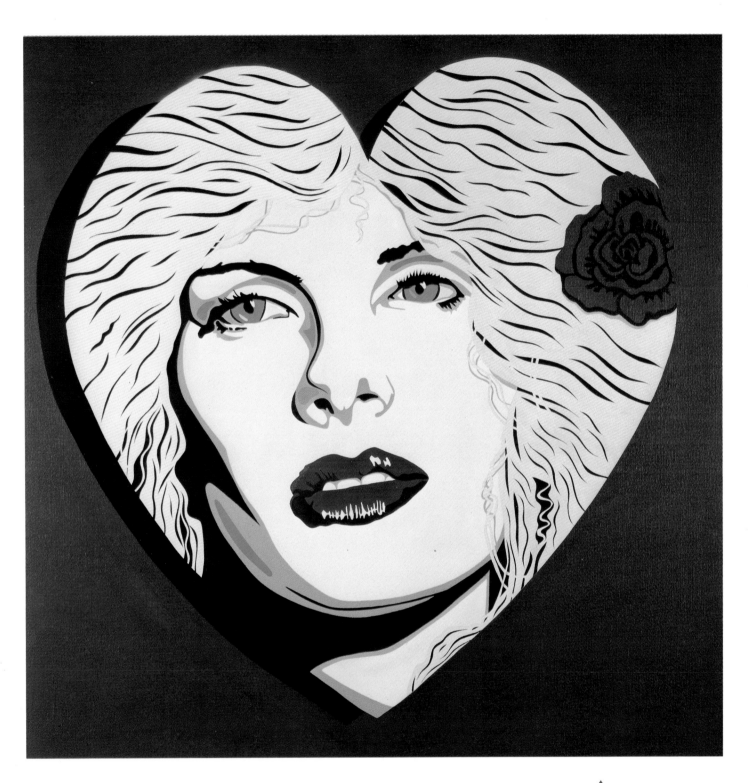

▲
**Artist:** *Zox*
*Encino, California, USA*

**"René,"** *36 x 36 in. (914mm x 914mm), Liquitex acrylics on primed canvas, Paasche H#1 airbrush. Combined with handbrushed underpainting.*

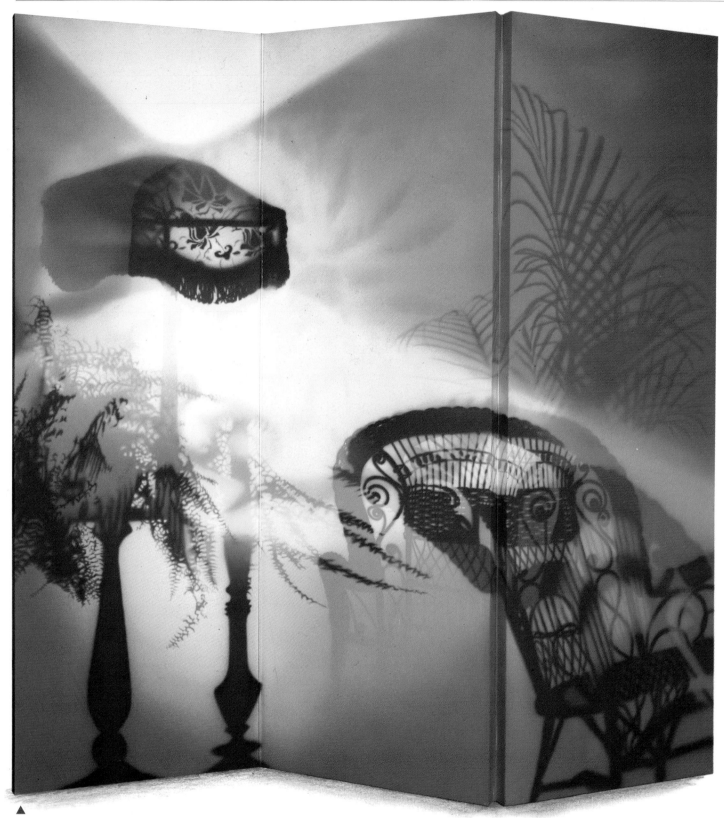

▲
**Artist:** *Jack Radetsky*
*Sunderland, Massachusetts, USA*

**"*Victorian Shade,*"** *83 x*
*84 in. (2108mm x 2133mm),*
*acrylics on canvas.*

© *1983 Jack Radetsky.*
*Photo © D. James Dee.*

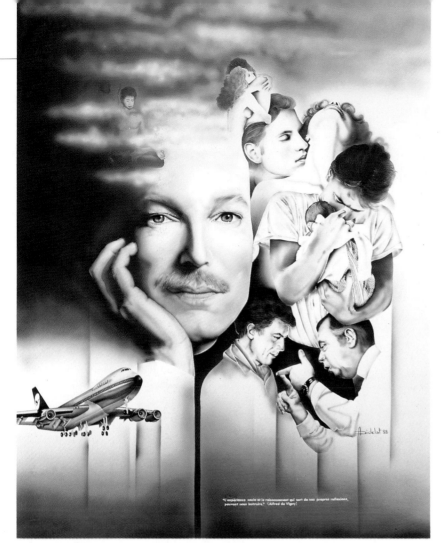

**Artist:** *Anne Didelot*
*Leonberg, W. GER*

**"Nur die Erfahrung und die Urteilskraft die unseren eigenen Gedanken entspringen, koennen uns lehren"** *(Only the experience and the judgment which derive from our own thoughts can teach us), 27 1/2 x 35 1/2 in. (700mm x 900mm), Rotring Artist Color and Magic Color and Schmincke Aerocolor on Schoellershammer illustration board, Fischer A 01 airbrush.*

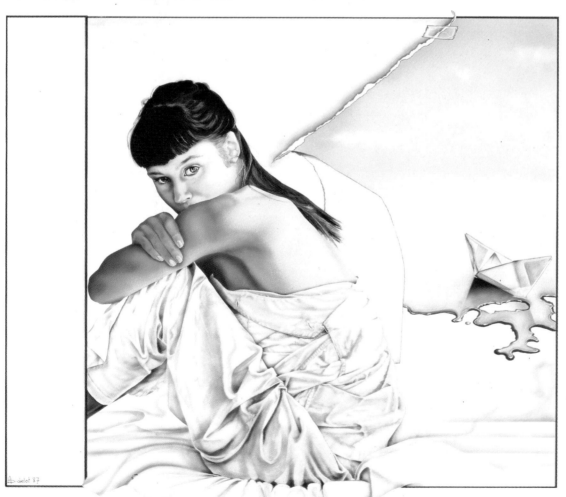

**Artist:** *Anne Didelot*
*Leonberg, W. GER*

**"Ein bisschen Traum"** *(A Bit of Dream), 27 1/2 x 23 1/2 in. (699mm x 597mm), Rotring Artist Color and Magic Color on Schoellershammer illustration board, Fischer A 01 airbrush.*

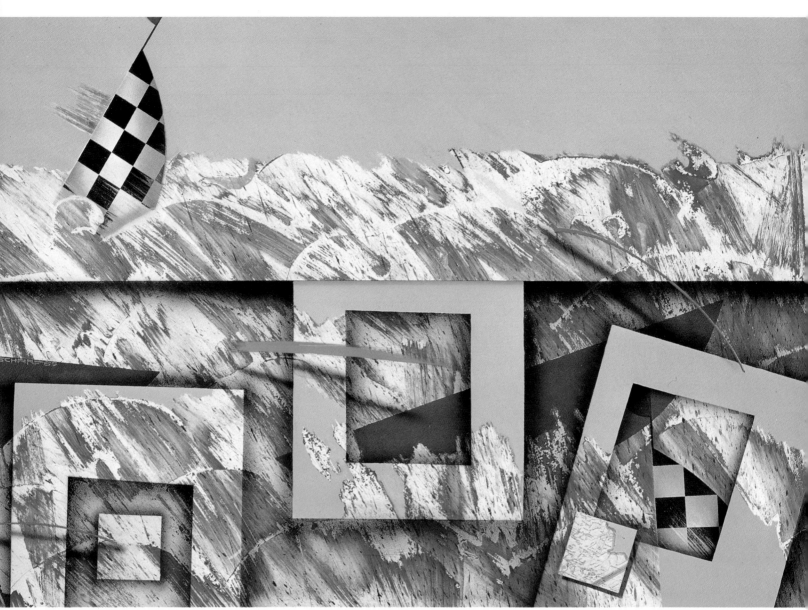

© B.W. Scharf. Collection of the artist.

▲
**Artist:** Barry W. Scharf
Los Angeles, California, USA

**"Two Buoys,"** 33 x 44 in.
(838mm x 1117mm), Liquitex
acrylics on Arches paper, Iwata
HP-B airbrush. Combined with
wet-into-wet handbrush work.

▶
**Artist:** Carl-W. Roehrig
Hamburg, W. GER

**"Der Gluecksuchende"**
(Seeker of Luck), 28¾ x 40 in.
(730mm x 1020mm), Schmincke
Aerocolor and Schmincke
DiaPhoto retouching color on
Schoellershammer illustration
board, Grafo (0.15mm and
0.30mm nozzles) airbrushes.
Combined with watercolor
handbrush work.

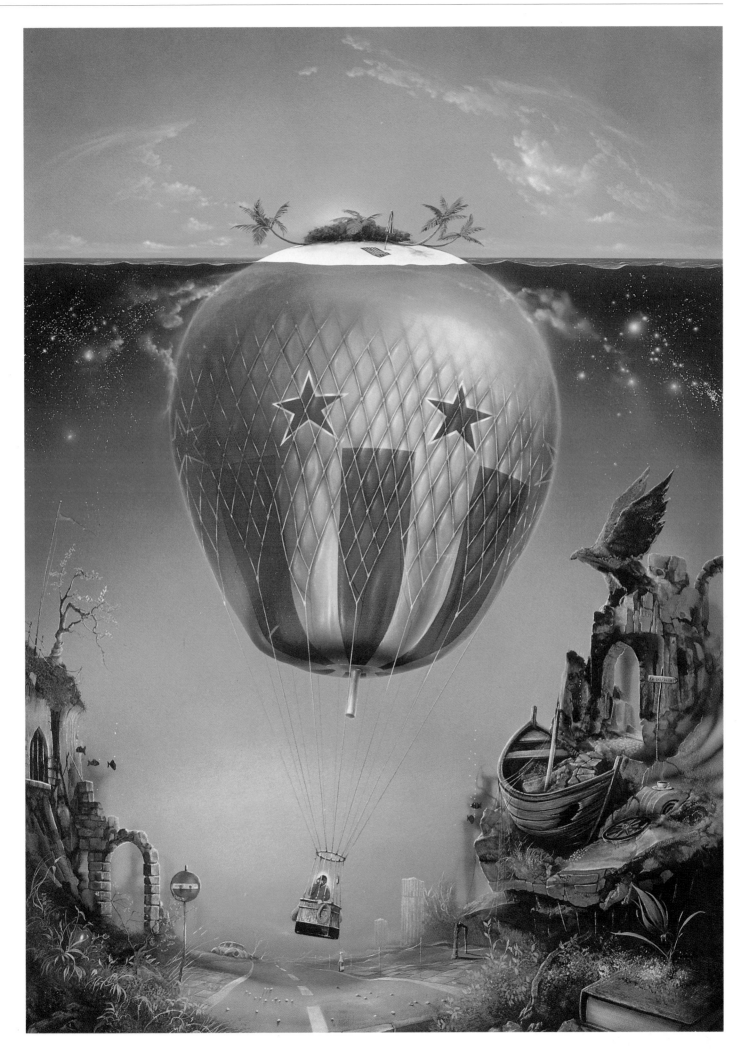

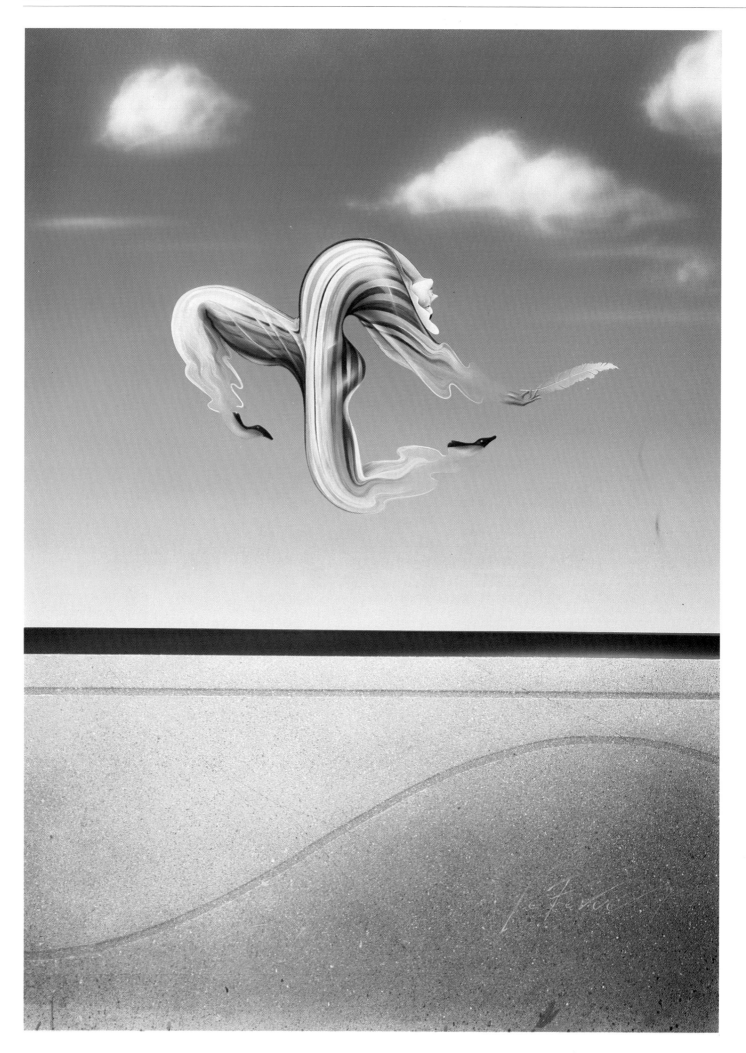

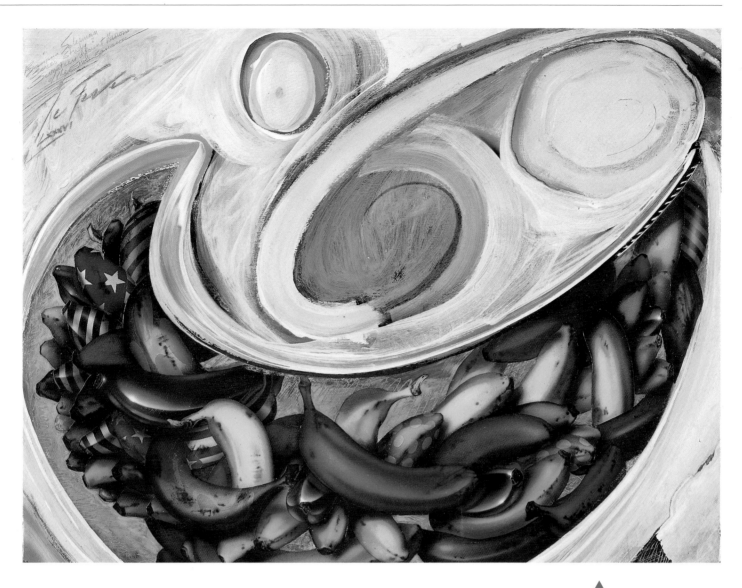

▲
**Artist:** *Jeff LeFever*
*Laguna Beach, California, USA*

**"Study for the Banana
Salesman #3,"** *Liquitex
acrylics, Marcus Art pigments,
Com-Art transparent and
Maimeri airbrush paints on
Masonite, Olympos Micron
MP-200B airbrush. Vine
charcoal, handbrush, tooth-
brush, stick, and fingers
also used.*

◀
**Artist:** *Jeff LeFever*
*Laguna Beach, California, USA*

**"Flight of The Wall
Dancer,"** *48 x 55 in. (1219mm
x 1397mm), Liquitex acrylics
and Com-Art on Masonite, Iwata
HP-C airbrush. Handbrush and
toothbrush also used.*

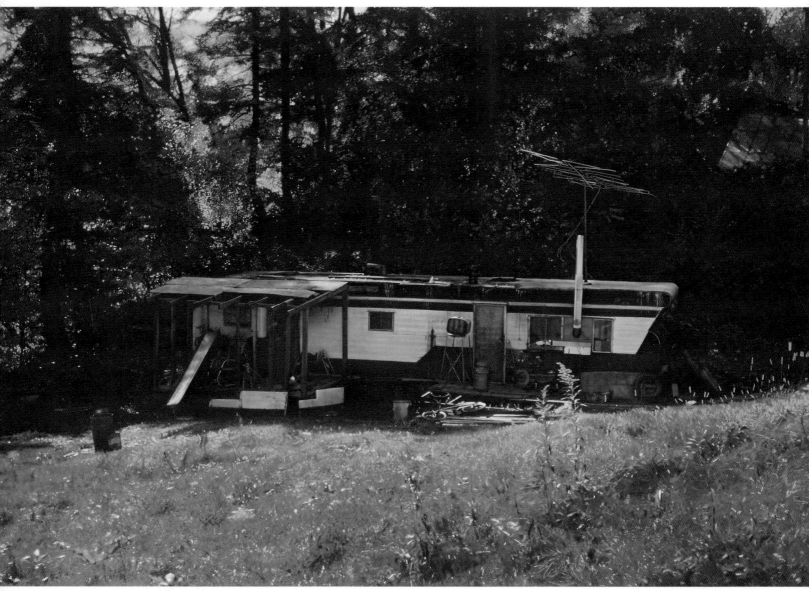

Photo © 1986 D. James Dee.

▲
**Artist:** John Salt
Sallop Bucknell, GBR

**"Trailer House,"** 42 x 63 in.
(1067mm x 1600mm), oil on
canvas.

▶
**Artist:** Olivia DeBerardinis
Malibu, California, USA

**"Bella Donna,"** 40 x 60 in.
(1016mm x 1524mm), Winsor &
Newton acrylics on linen canvas,
Paasche AB airbrush.

© Olivia DeBerardinis. Used with
permission of Ozone Productions, Ltd.

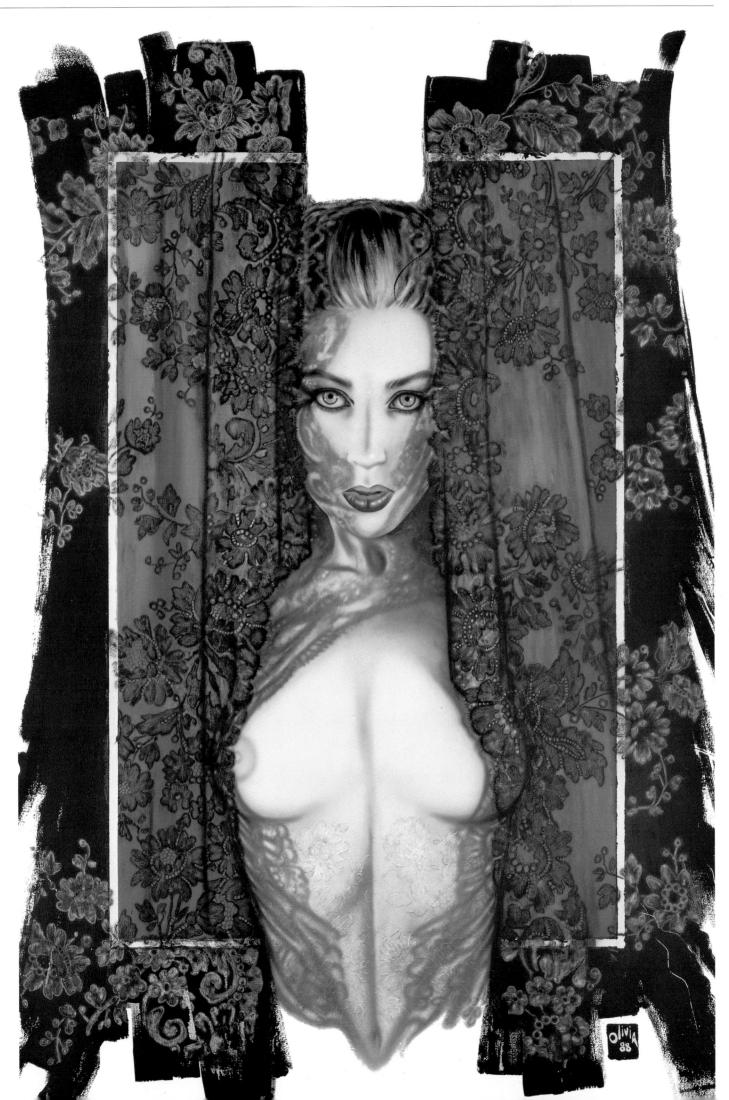

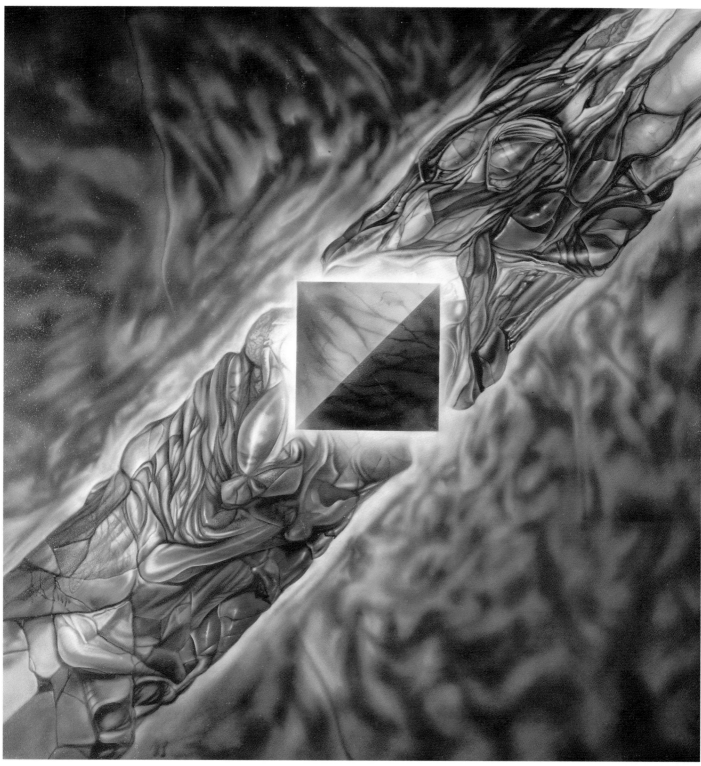

© T. Clauson.

**Artist:** *Thierry Clauson*
*Geneva, SWI*

**"Le mystere de la pyramide"** *(The Mystery of the Pyramid), 59 x 59 in. (1500mm x 1500mm), Winsor & Newton acrylics on Bois de Chassis (wood panel), Paasche V#1 airbrush.*

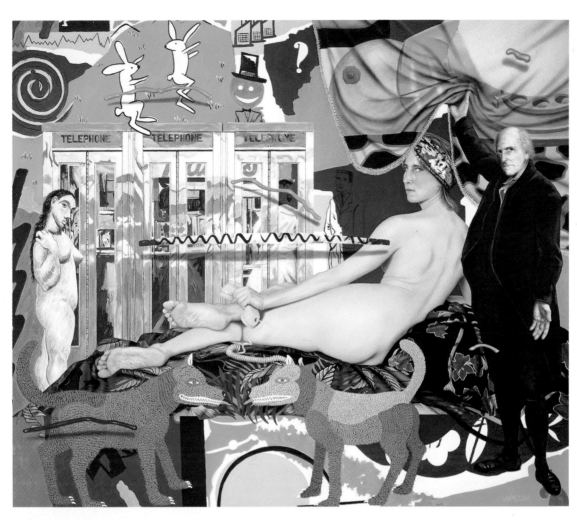

Artist: Robert Anderson
Bloomfield, New Jersey, USA

"Call Waiting," 56 x 48 in.
(1422mm x 1219mm), Liquitex
acrylics on canvas, Badger 100-
LG airbrush used to render nude.
Remaining imagery created with
handbrush work.

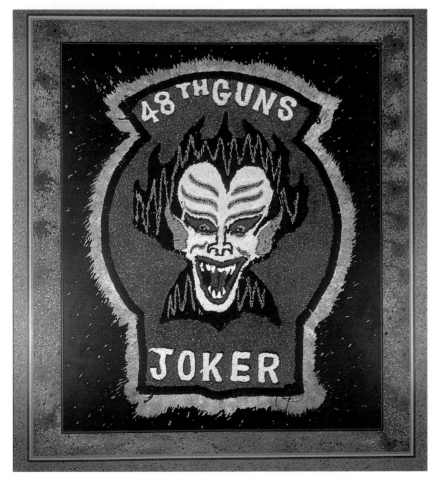

Artist: Peter West
Claysville, Pennsylvania, USA

"48th Guns-Joker," 45 x
60 in. (1143mm x 1524mm),
Liquitex acrylics and Hunt
acrylic silkscreen paint on
Fredrix canvas, Badger 350
airbrush. Silkscreen stencil
created photographically.
Collection of the artist.

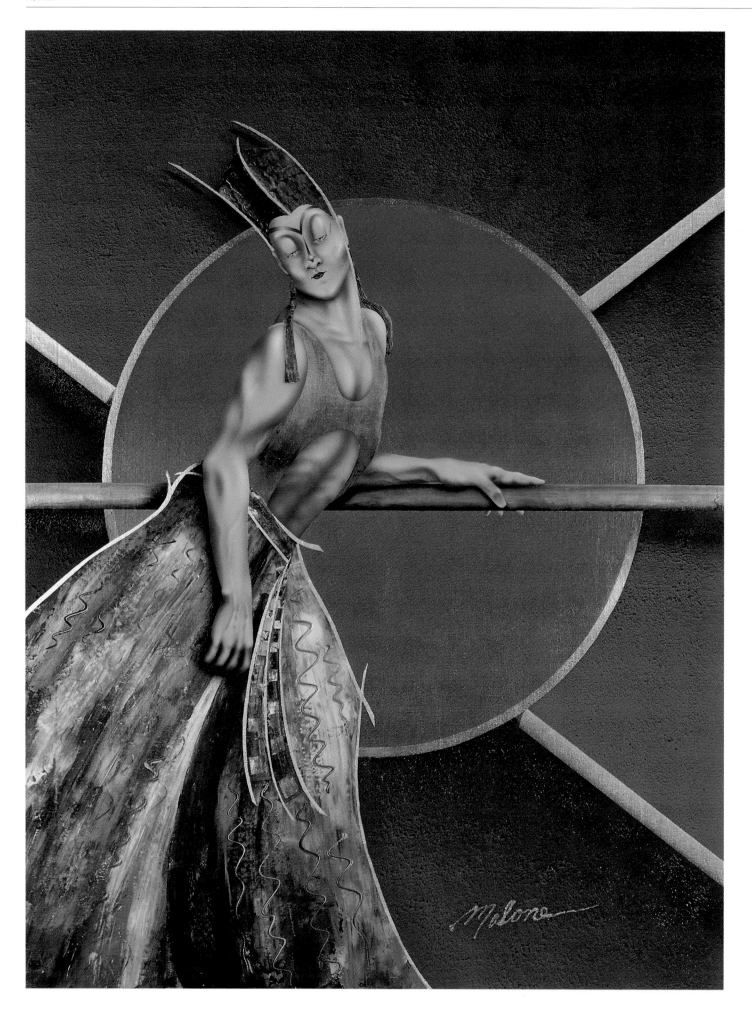

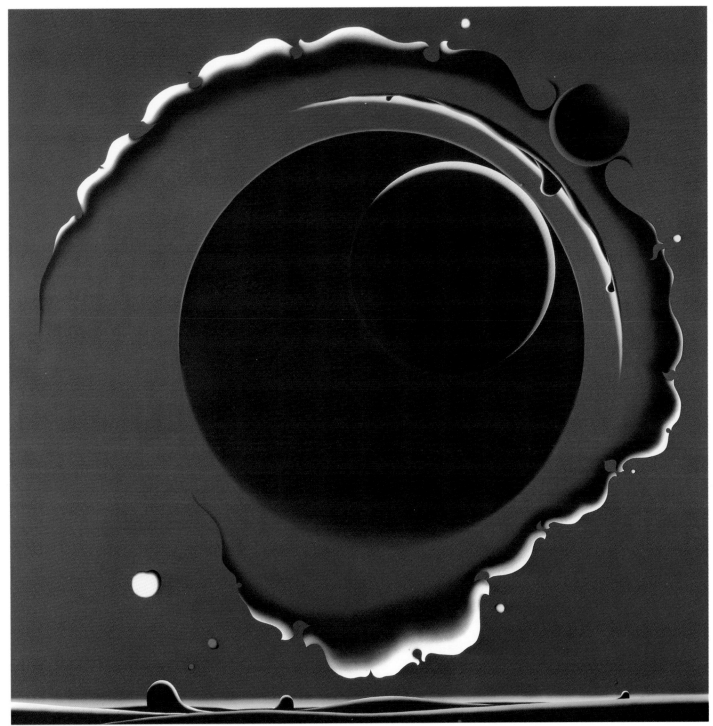

© Shuji Tanase.

▲
**Artist:** Shuji Tanase
Chiba, JPN

**"Black Space in -KATACHI
(Shape)- 2,"** 89 1/2 x 89 1/2 in.
(2273mm x 2273mm), gesso
and Liquitex acrylics on canvas,
Rich RS-507 airbrush.

◄
**Artist:** Dave Malone
Portland, Oregon, USA

**Untitled,** 30 x 40 in. (762mm x
1016mm), Com-Art airbrush
colors and Createx pure pigment
and interference colors on
canvas, Iwata RG-2 and Olympos
Micron MP-200C airbrushes.

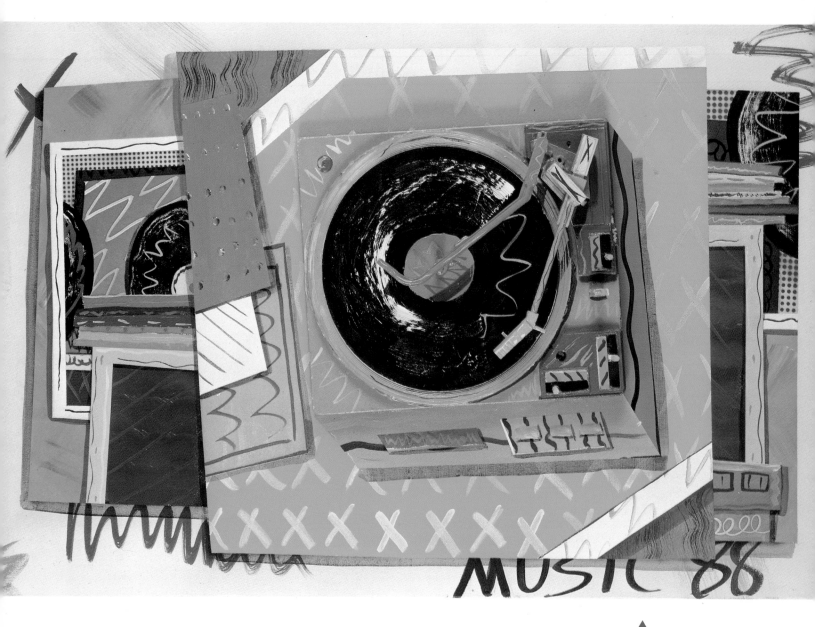

▲
**Artist:** *Robert W. Paschal*
*Beacon, New York, USA*

*"**Music '88,**" H24 x W36 x
D5 1/2 in. (H609mm x W914mm
x D140mm), Liquitex and Badger
Air Opaque Airbrush Colors on
canvas, metal and plastic,
Badger 350 and Badger 400
Detail airbrushes for gessoing,
Badger 100LG-XF and Badger
150IL airbrushes for painting.
Paint pads also used.*

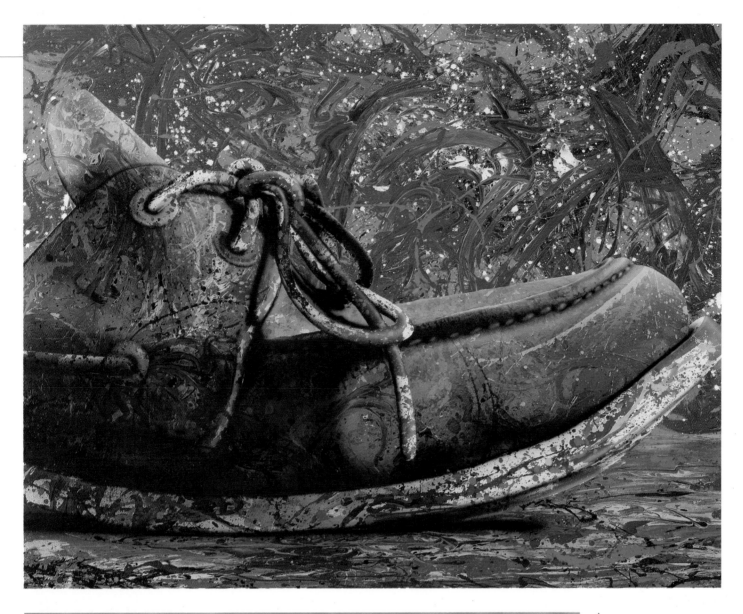

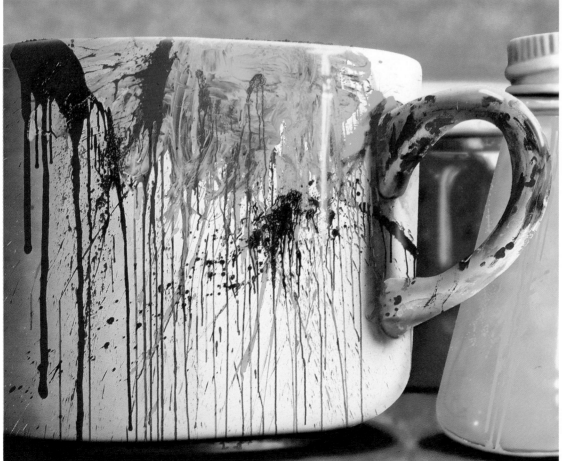

**Artist:** *Oscar Lakeman*
*Miami Beach, Florida, USA*

***"Shoes #15,"*** *60 x 48 in.*
*(1524mm x 1219mm), Liquitex*
*acrylics on canvas, Iwata HP-BC*
*airbrush.*

*Photo © 1987 D. James Dee.*

**Artist:** *Oscar Lakeman*
*Miami Beach, Florida, USA*

***"Containers #17,"*** *48 x 58 in.*
*(1219mm x 1473mm), Liquitex*
*acrylics on canvas, Iwata HP-BC*
*airbrush. Combined with*
*Japanese handbrush work,*
*fingerpainting, and action*
*painting.*

*Photo © D. James Dee.*

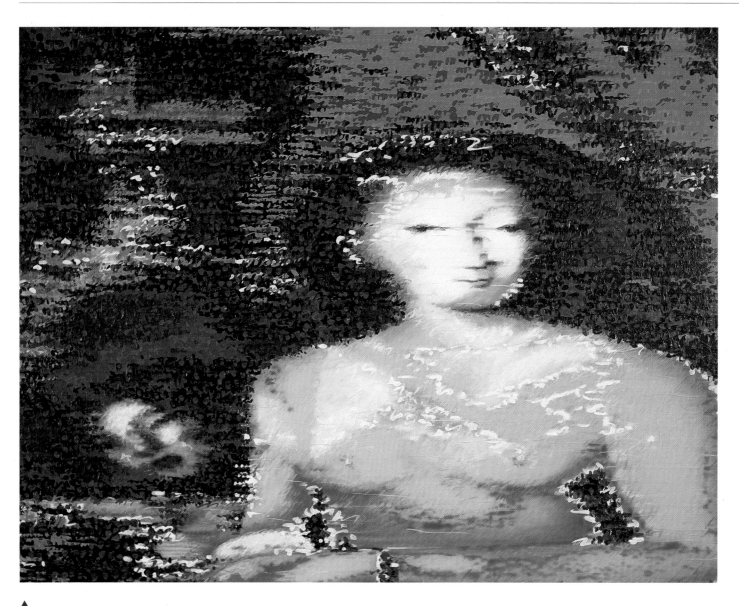

▲
**Artist:** *Robert Anderson*
*Bloomfield, New Jersey, USA*

**"Lisa, Lisa,"** *36 x 46 in. (914mm x 1168mm), Liquitex acrylics on canvas, Badger 100-LG airbrush. Combined with handbrush work. Image was a combination of historical artworks fed into a graphics computer, processed, photographed, and painted using the photograph as a guide.*